The
MYCENAEANS

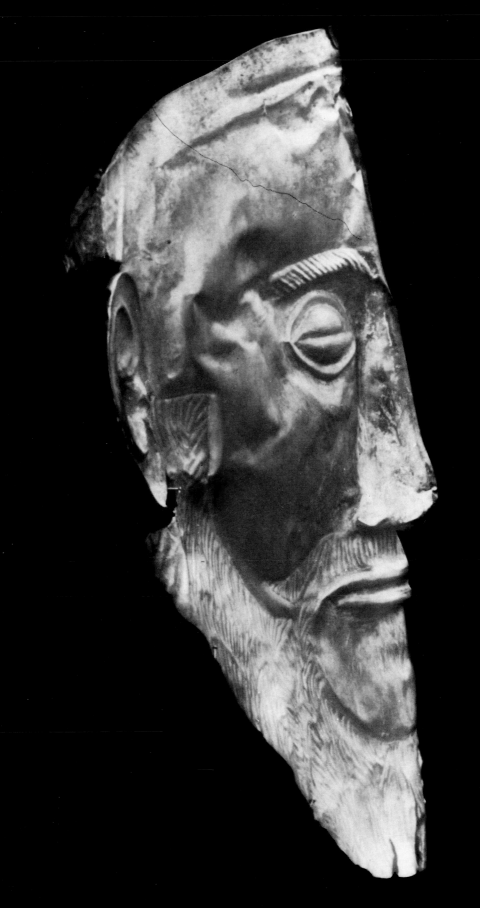

Lord William Taylour

The
MYCENAEANS

Revised edition

WITH 151 ILLUSTRATIONS

Thames & Hudson

Ancient Peoples and Places
FOUNDING EDITOR: GLYN DANIEL

Frontispiece: Gold funeral-mask, thought by Schliemann to be that of
Agamemnon. Ht 26.7 cm.

Revised edition first published in the United States of America in 1983
by Thames & Hudson Inc., 500 Fifth Avenue,
New York, New York 10110

First paperback edition 1990
Reprinted 1999

Library of Congress Catalog Card Number 82-50813
ISBN 0-500-27586-6

Printed and bound in Singapore

Contents

Preface to the first edition

The task of producing this book proved greater than I had expected and was subject to frequent interruptions, of which the most insistent was my annual commitment to excavate in Greece each summer, and all the preparations and aftermath that these undertakings entail. But what I have found most daunting is the task of compressing into 40,000 words the story of one of the great civilizations of history, on which many erudite tomes have appeared, not to mention works on such special aspects as art, religion, or the epics. More recently a rich literature has been occasioned by the decipherment of the Mycenaean script known as Linear B. C. Tsountas and J.I. Manatt, writing in the late nineteenth century and at the dawn of Mycenaean archaeology, produced an admirable work called *The Mycenaean Age* which ran to some 110,000 words. It described itself as 'A Study of the Monuments and Cultures of pre-Homeric Greece'. Much of what is written there is still valid, but much is now perforce out-of-date. The present work covers the same kind of material but cannot for a moment claim to be as comprehensive. With the vast increase in later discoveries this book has to be selective and the selection called for may not always meet with general approval.

A latecomer in the field, I have been fortunate in serving my apprenticeship in excavations under two of the most distinguished of Mycenaean archaeologists, Professor A.J.B. Wace and Professor C.W. Blegen. I owe them an incalculable debt. To the great loss of archaeology, Professor Wace died in 1957 and I have been deprived of his expert advice in writing this book; Professor Blegen has generously assisted me in countless ways. He has allowed me to use the material and photographs from his excavations in which I had the honour to take part, and he has afforded me valuable counsel and criticism on those parts of the text that have been submitted to him. But my grateful thanks are not only due to him but to those who have spared of their time to read and comment on those aspects of the book on which they are acknowledged experts: Dr J. Chadwick, Mr Vincent R. d'A. Desborough, Mrs E.B. French, Professor W.K.C. Guthrie, the Reverend V.E.G. Kenna, Dr F.H. Stubbings, and Mr Charles K. Williams. I am particularly indebted to Dr Chadwick and Dr Stubbings. The former read much of the text, the latter all of it. I also wish to thank my friend, Mr B.H.I.H. Stewart, for his many practical and informed suggestions. I have not succeeded in doing justice to all the opinions and criticisms offered to me and in some cases I have gone against them. Particularly has this been the case where the evidence allows of more than one interpretation; obviously in a book of this circumscribed nature it has not been possible to discuss differing theories adequately.

Acknowledgment of permission to use plates and text-figures has been made elsewhere in this book, but I should especially like to thank Mrs Helen Wace for her kindness in allowing me to reproduce plates and figures from her excellent *Mycenae Guide*. Others who have placed me in their debt by the considerable trouble they have taken to obtain the necessary illustrative material for me are Professor C.W. Blegen, Professor J.L. Caskey, Miss Alison Frantz, Professor Jessen, Mr Robert McCabe, Miss Marion Rawson, Mr E. Stikas, Dr F.H. Stubbings, Thames and Hudson, and Dr N. Verdelis. Many of the text-figures have had to be specially drawn. This work, with the exception of one drawing by Mr M. Spink, has been carried out by Mr M.L. Rowe. Two maps have been drawn by Mr H.A. Shelley. To them I wish to express my best thanks for their excellent work and, not least, to Mrs Ruth Daniel who went to so much trouble in organizing these tasks for me. Through the generosity of Señor F. Collantes de Teran I have been allowed to include information from his interesting excavation of the Dolmen of Matarrubilla, near Seville. I am most grateful to him for his co-operation. I am indebted to Mr D.A. Theochares for information about the Karditsa tholos tomb. Finally, I should like to thank Dr Glyn Daniel and the publishers for the encouragement they have given me and for the patience they have exercised in waiting so long for the writing of this book.

Preface to the second edition

It is nearly twenty years since the first edition of this book appeared and in the intervening period much new information on the Mycenaean civilization revealed through excavation and research has rendered a revision necessary. Much of what was written previously remains unchanged or requires only minor modification, but there is a great deal that has had to be added and I have endeavoured to incorporate this information in the present work.

Various important surveys of different regions of Greece have added considerably to our knowledge of the economics, social structure and manner of life of the inhabitants, and recent studies in Mycenaean geography have demonstrated the geophysical effects for better or worse on the productivity of the land. Excavations have contributed to a clearer understanding of pottery styles and their development, particularly for the late Middle Helladic and early Mycenaean period and the importance of Minoan influence at that time. Clearer chronological divisions are now possible for the later Mycenaean period. Considerable progress has been made in the interpretation of the Linear B tablets and this has added to our knowledge of the Mycenaean social structure. In the field of architecture Dr Catling's excavations have revealed a proto-palatial building near Sparta and Professor Mylonas's and my own excavations have revealed new aspects of building techniques. The recent discoveries of an increasing

amount of Mycenaean pottery in the Central Mediterranean and for the first time on a site in Sardinia have led to a reassessment of the importance of Mycenaean influence in that area and of the contribution of the native cultures with which they came in contact. Copper and tin must have played a vital role in these trade relations and Professor J. Muhly's study of the source and history of these metals is a valuable contribution to the background of the subject. All of this recent research has been incorporated in the new edition but naturally, owing to the circumscribed size of this book, in an abbreviated form.

One of the most important revelations of recent years has been the new light thrown on Mycenaean religion as a result of my excavations in conjunction with the Greek Archaeological Society at Mycenae in 1968 and 1969, and the no less outstanding discoveries of Professor G.E. Mylonas in subsequent years. Perhaps I may be forgiven if I have given special emphasis to this aspect of Mycenaean civilization and most if not all the new illustrations are devoted to this subject. I am particularly grateful to Professor A.C. Renfrew for allowing me to reproduce the unique idol found in his important re-excavation of the site of Phylakopi, which is of the same kind as those that were found at Mycenae earlier on. As a consequence of these finds my chapter on religion has been expanded considerably and my previous discussion of the burial customs under this heading has been made into a new chapter, which includes an account of the tholos tomb and a brief reference to the tumuli that have been uncovered in recent years. I have been persuaded by Professor O. Pelon's magisterial work on these tombs to alter my opinion on the origin of the tholos.

I wish once more to express my gratitude to all those who have helped me in the writing of this book. Many unfortunately are no longer with us. Professors Blegen and Caskey have departed this life and I have to mourn the loss of two Greek scholars who have helped me in the past, Dr Verdelis and Dr Theochares. Mrs Helen Wace, through whose kindness I have been allowed to reproduce several of the illustrations from her excellent guide to Mycenae, has recently died. Once more I am glad to acknowledge the very valuable help I have received from Dr Chadwick and Dr Stubbings who have read the revised script and made many valuable and useful suggestions and criticisms. I am specially grateful to Dr E. French for her helpful advice on the pottery. Mr H.A. Shelley has redrawn the two maps to include the latest data. Mr R.S. Kentish has adapted the plan of the Mycenae acropolis to include the houses uncovered in the joint excavation undertaken by the Greek Archaeological Society and myself. To them I owe a sincere debt of gratitude. I am particularly grateful to Mrs D. Sawford who has spent so much time typing and retyping the revised script. Finally, my special thanks are due to Professor Glyn Daniel for inviting me to produce a new edition of this book and to Thames and Hudson for their forbearance in waiting so long for the completion of the work.

The Mycenaeans is not a designation that will be found in the Classical authors. To the Greeks their earliest ancestors were known under several names. Homer refers to them variously as Achaeans, as Danaans, and as Argives. What the Greeks themselves knew about their early history had come down to them in the form of epic and of numerous legends that were often contradictory. And legendary their remote past remained as late as the middle of the nineteenth century. One of the centres of these legends was Mycenae, the ancient capital of Greece and city of Agamemnon, the most powerful of the Greek kings in the Homeric epic of the *Iliad* and leader of the Achaean hosts against Troy. In 1876 legend became history.

Heinrich Schliemann, a retired German merchant, who had amassed a great fortune, decided to employ his wealth in proving a long-cherished theory, namely, that the *Iliad* was not pure fiction, as was often maintained by the Classical pundits of his day, but was historic fact. If Mycenae was indeed Agamemnon's city, some material remains must have survived to demonstrate it. A single campaign of eleven weeks produced sensational results, the unearthing of royal burials accompanied by a wealth of funerary equipment in gold, silver, bronze, ivory, pottery, with gold predominating. Schliemann very naturally recognized in these burials the mortal remains of Agamemnon and his followers, but in this he was mistaken. He could not know at that time that he had uncovered the tombs of a royal dynasty that reigned some 300 years before the Trojan War.

His mistake is understandable for he was relying on an account given by Pausanias, an indefatigable Baedeker of the second century AD. Pausanias visited Mycenae and was shown the alleged tombs of Agamemnon and of those who were massacred with him. These were said to have been buried within the citadel walls while Clytemnestra and her paramour, Aegisthus, were interred without the walls, for they were not considered worthy to be buried within the citadel. And to this day the story is perpetuated in the names given to two great vaulted monuments near the citadel, the one datable to the fifteenth century and known as the 'Tomb of Aegisthus', and the other to the thirteenth century and called the 'Tomb of Clytemnestra'. The tombs obviously have no connection with the legend or the local tradition.

But if Schliemann's identifications were at fault, he rightly claimed that he had discovered a new world for archaeology. Through his enterprise a forgotten civilization was reborn and took its name from the city that contained, and now revealed to posterity, the manifold secrets of its history, the epitome of an era that came to be known as the Mycenaean Age. Later research and excavation showed that this civilization pervaded not only the Greek mainland but the Aegean

islands and countries bordering on the central and eastern Mediter-
ranean. Sir Flinders Petrie in his excavations at Tell el-Amarna in
Egypt had already unearthed a non-Egyptian style of pottery, which
with prophetic insight he had labelled 'Aegean'. With Schliemann's
discoveries it could now be placed in its proper context. But though
Mycenae might be the most important city in Greece at this time, it
must not be supposed that there were not other centres of consequence
on the mainland and elsewhere that shared the same culture but were
nevertheless largely independent. This was to become apparent as later
work in the field progressed.

50, 51 Schliemann's campaigns at Mycenae were largely confined to the
79, 80 Grave Circle, source of the fabulous treasures referred to above. At
nearby Tiryns he uncovered, with the able assistance of the architect,
Dr W. Dörpfeld, the foundations of a Mycenaean palace. He also dug at
Orchomenos and in Ithaca. All these place-names occur in the *Iliad*,
and, as the last-named was the home of Odysseus, much was expected
from it; but the results were disappointing. The Greek Archaeological
Society, which had already worked at Mycenae in 1840, continued
Schliemann's work. C. Tsountas, a most distinguished and gifted
21 archaeologist, uncovered the bare remains of a ruined palace on the
peak of the acropolis that at one time had housed the royal state of
Agamemnon. He excavated houses within the walls of the citadel and
the graves of the mighty outside it, including some of the nine tholoi, or
vaulted tombs of kings, that have so far been discovered at Mycenae,
and the chamber tombs of their wealthier subjects; unfortunately, the
majority had been robbed in antiquity.

In the 1920s the British School at Athens under the inspired
direction of Professor A.J.B. Wace carried out many fruitful campaigns
both within and without the citadel. His scientific approach enabled
him to cast new light on old problems; the results of his work,
particularly in connection with the chamber tombs that he dug,
contributed to the creation of a sound Mycenaean chronology. In
evolving this time-sequence he collaborated with Professor Carl W.
Blegen, another great Mycenaean archaeologist. Other contributions
by Professor Wace in later years were the excavation of the prehistoric
cemetery outside the walls (of which Schliemann's Grave Circle was at
85 one time a part), and a number of houses in the lower town, several of
which yielded magnificent ivories, finely carved stone vases, and clay
tablets inscribed in Linear B (see Chapter 2). But one of the most
thrilling events of recent times was the finding of a second Grave
Circle, this time outside the citadel, which came near to rivalling in the
wealth of its grave furniture Schliemann's original discovery. Grave
52 Circle B, as it is called, was excavated by the Greek Archaeological
Society under the direction of the late Dr John Papademetriou with
great precision and care, which helped towards the solution of certain
problems raised by Schliemann's excavation.

The archaeological schools of many countries have helped towards
elucidating the many and varied aspects of the Mycenaean Age
(*c.* 1550–1100 BC). Sometimes this was the main object of an excavation,
at other times it was the by-product of a campaign primarily concerned
with earlier or later periods, as for instance in the American excavations

of the Athenian agora. Most of the work of the foreign schools has been concentrated in the Peloponnese, the home of so many of the heroic legends. Apart from Mycenae the British School has excavated in Laconia, Ithaca, and northern Greece (Macedonia and Thessaly). The Americans have been active in Corinthia, the Argolid, and notably in Messenia where Professor Blegen uncovered the best-preserved of the Mycenaean palaces, the palace of the Homeric hero, sage Nestor, king of Pylos. More recently Professor W.A. McDonald uncovered an important settlement in the eastern part of that province, and rich tombs of the early Mycenaean period were excavated by the late Professor Spyridon Marinatos.

75

The French School, long established in Greece, is principally known for its magnificent campaigns at Delphi and Delos, devoted to the later historic period, but at these places Mycenaean remains have also been found. Purely Mycenaean have been its excavations of a palace at Gla in Boeotia and chamber tombs near Argos. The Germans conducted, and are continuing to conduct, many campaigns at Tiryns and smaller excavations in other parts of Greece: Attica, Aegina, Salamis, western Messenia, Orchomenos, and north Thessaly. Important work has been carried out by the Swedish School in Messenia, but particularly in the Argolid: Asine, Midea (Dendra), Berbati. Other foreign schools that have established themselves in Greece are the Australian, Austrian, Belgian and Canadian. The Greek Archaeological Service has naturally played the dominant role in the archaeological field. Its activities need no enumeration as they cover the whole of Greece and the islands.

92

The Italians have made valuable contributions to the archaeology of the Greek Islands and in their own country have uncovered Mycenaean pottery in Sicily and south Italy, in many of the regions in fact that were to form what later came to be known as Magna Graecia in the great colonization period of the eighth–sixth centuries BC. In Greek territory they have excavated in Lemnos, Crete, and Rhodes. Rhodes was an important Mycenaean centre but up till now most of the finds from there have been from tombs. Only one settlement, Triandha, has been dug. The British had actually discovered several tombs on the island before the Italians were established there, in fact before Schliemann started excavating at Mycenae, but at that time the true significance of the pottery was not realized. A similar situation existed in Cyprus in the middle of the nineteenth century. That island is honeycombed with tombs and Mycenaean vases were often found in them, though local wares formed the greater part of the grave furniture. In recent years our knowledge of Mycenaean Cyprus has been considerably increased by excellent work carried out by several nationalities: Cypriot, French, Swedish, British, and American. Important towns and settlements are being, or have been, uncovered: Enkomi (Cypriot and French), Kition (Cypriot), and Vouni (Swedish). Among the other Greek islands that have been explored by foreign schools particular mention should be made of Melos, where the British carried out an important campaign in the early part of this century at the site of Phylakopi; excavations have latterly been resumed there under the direction of Professor A.C. Renfrew. Valuable archaeological work has been done on Chios and Kythera (British), Samos (German), and Keos (American).

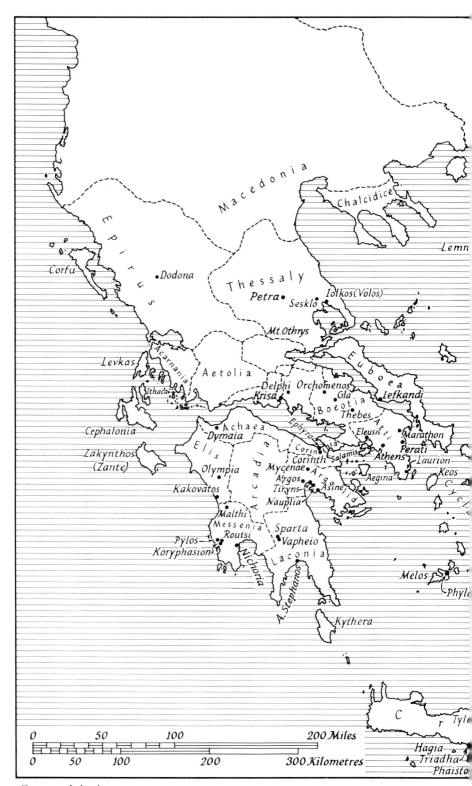

Epirus

Macedonia

Chalcidice

Lemn

Corfu

•Dodona

Thessaly

Petra• •Sesklo Iolkos(Volos)

Mt.Othrys

Levkas

Acarnania

Aetolia

Euboea

Ithaca

Delphi Orchomenos

Krisa

Gla lefkandi

Boeotia

Thebes

Eleusis Marathon
Perati

Cephalonia

Achaea

Dymaia

Ephyra

Corin ia

Corinth Salamis

Athens Laurion

Zakynthos
(Zante)

Elis

Arcadia

Mycenae• Argo a Keos

Argos Asine Aegina

Olympia

Tiryns

Kakovatos

Nauplia

Malthi

Messenia
Routsi

Sparta

Vapheio

Pylos
Koryphasion

Nichoria

Laconia

A. Stephanos

Melos

Phyl

Kythera

0 50 100 200 Miles

0 50 100 200 300 Kilometres

Hagia
Triadha
Phaisto

1 Greece and the Aegean.

12

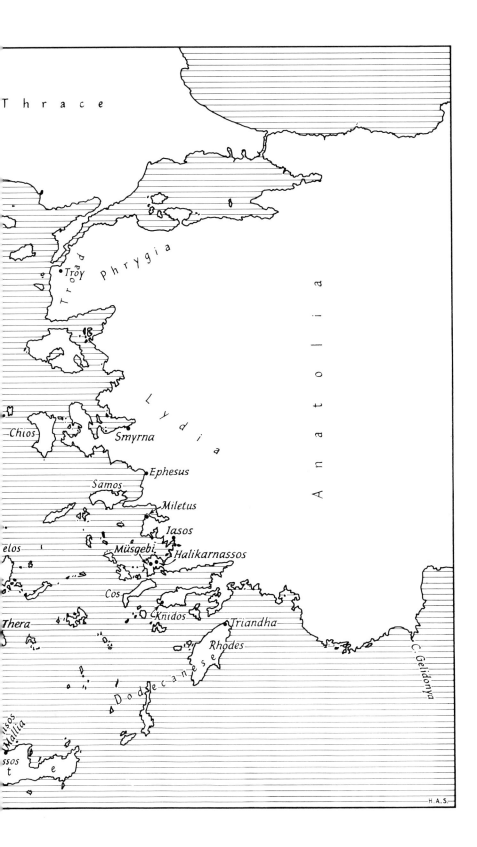

Thrace

Troad

Phrygia

Troy

Lydia

Chios

Smyrna

Ephesus

Samos

Miletus

Iasos

Müsgebi Halikarnassos

elos

Anatolia

Cos

Knidos

Triandha

Thera

Rhodes

Dodecanese

ios
Mallia

ssos
t

e

C. Gelidonya

H.A.S.

13

Excavators in Greece have not failed to avail themselves of the latest developments in other branches of science, such as geology, zoology, palaeobotany and soil analysis. From geology we learn that there has not been much change in the coastal line of Greece since ancient times. Sea level has risen about 1 metre per millennium in the last 6,000 years. The plains and river valleys, however, show big changes in the past 2,000 years, having received a much richer deposit of sediment soils than those previously laid down during the last Ice Age. Before Roman times, therefore, the soils in the plains were less fertile than they are today, the richer soils apparently being confined to the upland areas, and these considerations affected the settlement pattern in Mycenaean times. The history of the forests in Greece comes under palaeobotany. Pollen analysis has shown that there has not been much deforestation in Greece throughout its history except in the past 150 years; and where it has been practised in earlier times it has been for the purpose of developing arable land. All these factors are taken into consideration in archaeological studies and many more besides, such as the study of animal bones, shells and seeds (where preserved), to give a few examples. One of the most ambitious schemes for combining the knowledge and techniques of different disciplines has been the survey undertaken by the University of Minnesota of the province of Messenia in the southwest Peloponnese.

The origins of Mycenaean civilization exercised archaeological minds at an early stage and interest naturally turned towards Crete which, according to Greek legend and tradition, had had long and intimate relations with the mainland in the heroic age. Schliemann himself had hoped to dig at Knossos, but this role fell to Sir Arthur Evans who in 1900 started his epoch-making campaigns there, which established Crete as one of the great powers of the Bronze Age in the Aegean. He was so struck by the markedly Cretan character of Mycenaean art in its early stages that he was led to believe that Greece, or at least the southern part of it, was at one time a Cretan colony. This theory, for long popular, has few adherents today. Evans's extensive and famous campaigns at Knossos have naturally tended to overshadow the work done by other foreign nationalities on the island, but the excavations of the Greeks, Americans, French, and particularly the Italians can hardly be said to have produced results of less value and importance.

A natural question that arose from all this archaeological activity was the identity and origin of the people who created the Mycenaean civilization. It was grudgingly admitted that they were the ancestors of the Greeks, but how Greek were they? What is certain is that during its whole history Greece has been subject to the influx of foreign peoples, more often coming with hostile intent. In Classical times the population was already mixed but, whatever the admixture throughout the course of centuries, the resulting culture has been purely Greek. Can one say that the Mycenaean Age marks the beginning of the 'Greek Miracle'? In a sense, yes. Archaeologically it can be demonstrated that there is a cultural continuity right through to the Classical period, but this unbroken continuity stretches backward in time also. The flourishing settlement of Early Helladic II at Lerna in the Argolid was

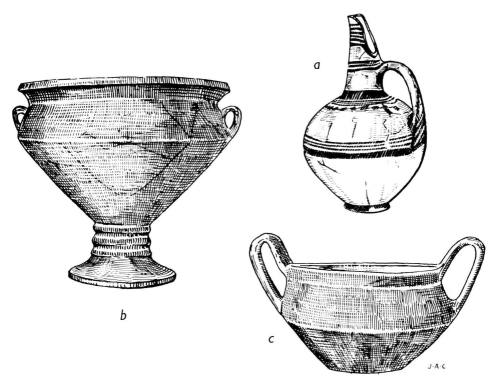

2 Middle Helladic pottery.
a matt painted jug from
Mycenae; *b, c* Minyan
ware from Korakou.

2b, c

violently destroyed about 2200 BC. Elsewhere there is no recognizable break until *c.* 1900 BC, and this is the approximate dating of the change from Early to Middle Bronze Age in Greece. Roughly at that time, but earlier at Lerna, a new and very distinctive type of pottery known as Grey Minyan Ware begins to appear over most of Greece (an unfortunate term as it bears no relation to the Minyan tribe of legend). This pottery is easily recognizable from all other grey wares by its superior quality and very special technique, a technique that the invaders, who seem originally to have been a nomadic tribe, either brought with them or started to produce at that time. The forms of the vases are thought to imitate metal ware and their texture suggests that they are copies of silver vessels, though this interpretation is rejected by some scholars. Now a ware very similar to Grey Minyan is also found in considerable abundance throughout the Troad (northwest Turkey) and is the distinctive pottery of Troy VI; it is indeed one of the criteria that signals the arrival of a usurping power in that city and the foundation of the Sixth Settlement in the nineteenth century BC approximately. The almost simultaneous appearance of this pottery in two separate but not far-distant areas suggests that the invaders of the Troad and Greece are related, and it is generally believed that they introduced a form of the Greek tongue into Greece at this time.

The linguistic evidence does not contradict the archaeological findings and indirectly supports them. It has long been recognized that

certain place-names ending in *-nthos*, *-ssos*, and *-ttos* such as Zakynthos, Parnassos, Hymettos are non-Greek, or rather pre-Greek. Such names are found not only in Greece but throughout the Aegean (including Crete and western Turkey), an area that was to a large extent culturally homogeneous during the Early Bronze Age. However, from the philological standpoint, the problem of the origin of the Greek language has to be tackled from the other end of the time scale, viz., from the data existing in the eighth century BC when the Greek alphabet first came into use. At that time there were four main groups of dialects of the Greek language: Aeolic, Ionic, Doric, and Arcado-Cypriot. The break-up into dialects from the mother tongue seems to have occurred, according to recent research, in Greec itself. A very old and firmly held Greek tradition relates that the Dorian tribes swept into the Peloponnese from the north in the latter part of the second millennium and thence penetrated to Crete and the Dodecanese, only touching the fringe of the islands in the central Aegean. This is all in accordance with the linguistic evidence that survives. But the central part of the Peloponnese was not affected by this invasion; some of the displaced population took refuge in mountainous Arcadia and there preserved their ancient tongue. What is of special interest and importance is that this language, the Arcadian dialect, is closely akin to that which was spoken in far-off Cyprus and, as will be shown later, this island came within the sphere of Mycenaean influence from the fourteenth century onwards. There is a strong probability therefore that Arcadian is a survival of the earliest form of the Greek tongue, the Mycenaean language.

3

The origins of Greek, then, can be traced back as far as the fourteenth century with a fair degree of certainty and, as the archaeological record shows no decisive break in culture till the nineteenth century, it is generally accepted that a population speaking an Indo-European dialect started to percolate into Greece from that time onwards; but the problem of the origin of this people still remains. Two theories are current. One of these suggests that they came from the north through the Balkans but, if so, they have left no trace of their passage and northern traits in their culture are negligible. The other, more plausible, theory would derive this people from the East and across the north Anatolian plateau to Troy, and a grey ware somewhat akin to Minyan is known in northeast Iran. The invaders brought with them a new instrument of war, the horse, which no doubt was a decisive factor in their conquest. Bones of horses are found for the first time in Troy VI along with Minyan ware, and it is probable that the wave of invaders that passed into Greece introduced the horse there also. But it is maintained that the transport of this animal across the difficult straits between Europe and Asia would have been a hazardous, if not impossible, operation. For that reason an alternative land route has been suggested via the Caucasus and the north coast of the Black Sea. The fact is that we cannot be sure at this stage whence the Greeks came and by what route they entered Greece, or whether they came by land or sea. Minyan ware is found as far north as Greek Macedonia and Chalcidice but not in Thrace. It is known from most sites on the mainland and from some of the islands in the Aegean.

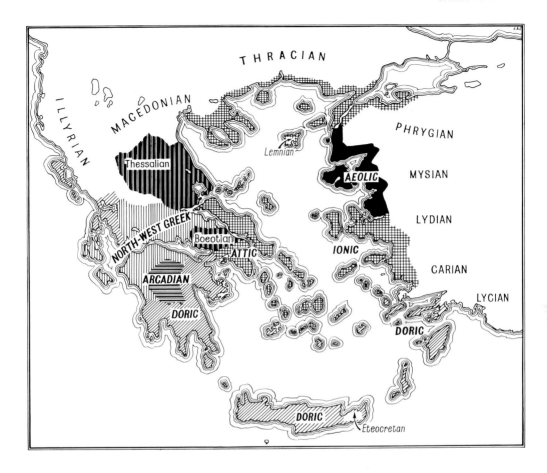

3 Greek dialects about 400 BC.

The conquest of Greece was no doubt a lengthy process, accomplished by several waves of invasion and extending over a long period of time; the mountainous terrain would ensure that. Pillage and arson followed in its wake but not all Early Bronze Age sites were destroyed and nearly all of them were reoccupied. During the next two centuries or so the invaders consolidated their position, absorbed and integrated with the existing culture which was superior to their own. Their outlook was insular at first, but with the passage of time they became more receptive to outward influences and took an ever-increasing and active part in foreign trade. This seems to have contributed to a spectacular increase of wealth and power, which was no doubt helped by piracy and 'protection' money. In the early part of the sixteenth century there is increasing evidence of the civilizing influence of Crete on their culture and what is known as the Mycenaean Age may then be said to have begun. The Mycenaean kingdoms as remembered and described in the *Iliad* start to take shape: Iolkos in Thessaly, Thebes and Orchomenos in Boeotia, Athens (though a very minor kingdom) in Attica. But the greatest concentration of Mycenaean power was in the Peloponnese, with Pylos ruling Messenia and the assemblage of strongholds in the Argolid dominated by Mycenae.

Laconia, which lies in between these two, has been little explored and its Mycenaean capital has not yet been discovered. All these kingdoms, it should be noted, occupy fertile plains or uplands, the few that Greece has to offer; and they are separated from one another by high mountain ranges, so that communication was sometimes more practicable by sea. The northwest region of Greece is almost entirely mountainous and it is not surprising therefore that that area plays an unimportant part in Mycenaean history.

In the succeeding chapters an account, necessarily brief, will be given of the achievements of this Mycenaean civilization with a short historical résumé as epilogue; but before the central theme can be broached two important subjects, chronology and the written sources, need to be discussed.

1
The pottery and chronology

The dating of events in modern times offers us no problems. We have a calendar that has been in existence for hundreds of years; but the further one goes back in time, the greater the complexities that arise, the greater the uncertainties. In Classical times, different systems were used of varying reliability. But going further back still, to the time of the great riverine civilizations of Egypt and Mesopotamia, one meets with increasing problems. There is no fixed date of some great event, like the first Olympiad or the traditional founding of Rome, from which the years may be counted. The only events that were considered of importance were recorded as taking place in a certain year of the reign of a king. At a much later date lists of dynasties of kings and the lengths of their reigns were made, but these were often inaccurate and duplications frequently occurred. The resource of scholars has created order out of the confusing and often chaotic systems, so that there is general agreement to within ten to twenty years for the dating of events in Egypt and Babylonia as far back as 2000 BC. For anything that occurred between 2000 to 3000 BC there is far less measure of agreement and there may be differences of as much as 300 years between the findings of one method of reckoning and those of another. The system of radiocarbon dating (provided suitable samples are found) can hardly help here, as it does not claim greater accuracy than plus or minus 150 years for periods so far back in time.

But how can one devise a system of dating for a civilization, such as the Mycenaean, which can produce no written record of events occurring in the reign of one of its kings and no kings lists? The only answer to that problem is to ascertain what contacts, if any, that civilization had with Egypt and Babylonia, for which a fairly reliable system of chronology has been evolved. Fortunately those contacts existed, but only in a very few cases can a reasonably close date be given to them, and a close date in this context means within 20 or 30 years. The dating of these contacts, however, would be of little value if some form of development within the Mycenaean civilization itself could not be recognized. It must have a beginning, a middle, and an end and, if further evolution within those three divisions can be traced, so much the better; one can then speak in terms of subdivisions within each group. Such a development can in fact be recognized in what has survived of the buildings and tombs, and in the many and varied

artifacts of metalwork, ivory, jewellery, and pottery. Some evolution, in one direction or another, can be traced in all of them – and it is a correlation of the studies of these progressions or regressions that provides the structure of what is termed a relative chronology. This would be a flimsy structure indeed and capable of varying interpretations if it was not checked and modified by the evidence afforded by archaeological excavations. Broadly speaking, a succession in time is shown in the construction of one building on the ruins of another. Many such building periods can often be distinguished in one excavation and the true chronological relationship between the objects found in the different strata can be established, those belonging to the lowest stratum being normally the earlier. A similar relationship between what is earlier and what is later can sometimes be demonstrated in the excavation of tombs.

The most valuable indicator of the passage of time is the potsherd. This humble relic of the past is found in abundance and bears witness to an industry that was one of the mainstays of daily life. Almost alone of all the creations of man pottery has the capacity of resisting time. Clay that is well-fired in the kiln is to all intents and purposes indestructable. More than any other objects surviving from the past, pottery exhibits changes in style, particularly when it is decorated. Because of its fragility it was constantly being broken. The broken piece, the potsherd, can therefore be regarded as almost contemporary with its production. Such a claim cannot always be made for the complete vase, and still less for any objects of obvious value like jewellery, which could so often be heirlooms. Likewise, tools and weapons are unreliable for dating, because they show little change in design over a period of decades.

Before we can approach the established chronologies of Egypt and Babylonia for guidance, it will be necessary to bring some order into the Mycenaean ceramic household. A definite change in the pottery style can be discerned at the beginning of the Mycenaean era, and this provides a convenient point to differentiate it from the preceding age, known as the Middle Helladic period. Similarly, the end of the era is signified by the introduction of an individual type of pottery called Protogeometric. The use of these terms calls for some explanation. As there is no absolute chronology for any area in Europe before the Classical period, a system of relative chronology had to be devised and this has been based on the observed succession of the use of various basic materials in the history of mankind, namely, stone, bronze, and iron. This system is not altogether satisfactory but it has become hallowed by long usage. The Stone Age (Neolithic) of Greece concerns us only indirectly. The Bronze Age can be divided into three periods based on three manifestly different styles of pottery. To distinguish the Bronze Age of peninsular Greece – or Hellas, as it is called by the Greeks – from Bronze Ages in other areas, it is called Helladic. The three divisions are therefore known as Early, Middle, and Late Helladic (hereafter frequently abbreviated to EH, MH and LH). It is with the Late Helladic (the Late Bronze, or Mycenaean) Age, that we are concerned. The Classical period falls within the Iron Age and it is preceded by the Geometric period (its name betraying the style of

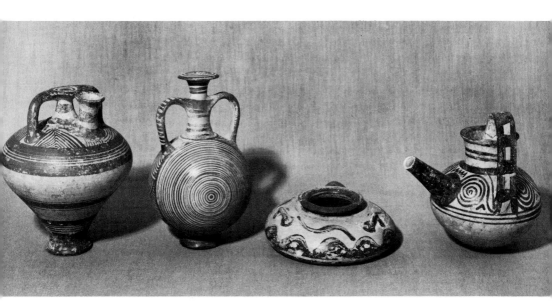

pottery used to define it). The beginning of the Iron Age is generally identified with the Protogeometric period, although in fact a little iron was already in use at the end of the Bronze Age.

The wealth of archaeological material from the Late Helladic period is considerable and in excess of anything found in the preceding Early and Middle Helladic periods. Different styles of pottery can be clearly distinguished, and it is therefore possible to subdivide the period into three sub-periods known as LH I, II and III (or Mycenaean I, II and III). The last sub-period is more abundant in material than those that go before it and permits of further sub-division into LH IIIA, IIIB, and IIIC. A similar system of relative chronology has been worked out for the areas bordering on the mainland to the south and to the east, namely, Crete and the Cycladic Islands. Their Bronze Ages are referred to respectively as Minoan (from Minos, their legendary king) and Cycladic. These are divided into three periods, which are more or less contemporary with those on the Greek mainland, and the Late Minoan Bronze Age is sub-divided into Late Minoan I, II and III (LM I, II, III), sub-periods that correspond in time very closely to LH I, II, III.

To understand the development in style in Mycenaean pottery it is necessary to have some knowledge of that which immediately preceded it and from which it derived, that is to say, the pottery in vogue during the last phase of the Middle Helladic period. One class of vases of that period is known as Matt-painted Ware, matt paint being used on a light background; the patterns were predominantly geometric in inspiration. Lustrous paint of a red or black hue is substituted for matt paint towards the beginning of LH I, the patterns become less formal, and fresh designs and a naturalistic element are introduced. This change in style is clearly to be traced to Crete. The forms of the vases mostly follow the Middle Helladic tradition, but new types are added to the repertory; conspicuous among these is the alabastron. This vase takes

4 Stirrup-jar, pilgrim flask, alabastron, spouted jug. LH IIIA. The stirrup-jar was probably used for oil and unguents. The pilgrim flask was very popular in the Near East.

2a

4

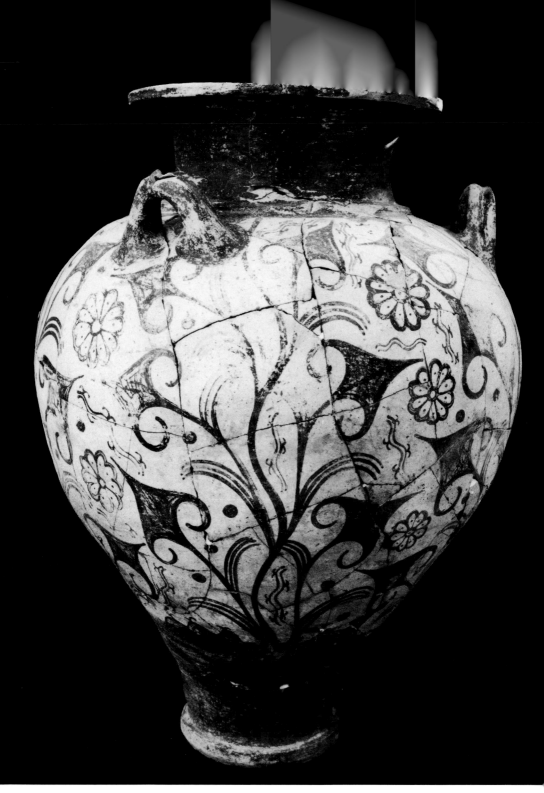

5 Palace Style jar from a tholos tomb in the neighbourhood of the Palace of Nestor in Messenia. Ht 77.5 cm. Vases decorated in this florid style are described as being in the Palace Style.

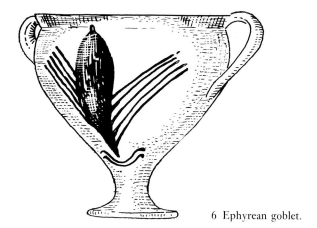

6 Ephyrean goblet.

its name from a bag-like type of vessel manufactured in Egypt in alabaster. The Mycenaean vase is a squatter, and more elegant, version in clay and can claim descent from the Middle Helladic squat one-handled jar. The Mycenaean alabastra were exported to Egypt and Syria. Such vases found in those countries therefore provide important dating evidence, which will be considered later. This type of vessel was less popular in Crete except to a limited extent round Knossos.

Another vase that is illustrated in Egyptian tombs and which occurs in a reliably datable context there is the so-called Vapheio cup (named after the village, just south of Sparta, near which the famous gold cups were found). The terracotta version of this cup has a long Cretan history dating back to early Middle Minoan times (*c.* 2000 BC). Copies of it in Greece start to appear towards the end of the Middle Helladic period (seventeenth/sixteenth centuries) and their metallic derivation is already apparent in the modelling. The Vapheio cup represents one of the commonest types of vase in use during LH I and II.

In LH II Mycenaean pottery is still strongly influenced by Crete. The inspiration is freer and more abandoned, and it is the great age of the Palace Style Jar, so called from large but elegant storage-jars, decorated in a florid style, that were the fashion at the Palace of Minos at Knossos in LM II. Although these jars originated at Knossos, they were more popular on the Greek mainland and were also produced there. Greece was learning much from Crete, but already at this period the native genius felt sufficiently confident of itself to give its own individual form to the influences that it had absorbed. The Ephyraean style is an example of a disciplined treatment of a familiar Minoan motive; a somewhat stylized flower painted on one face of the vase which was usually a goblet. ('Ephyraean' takes its name from Ephyra, a legendary city founded by Sisyphos of Corinth. Vases of this style were first found in the presumed region of this city.) The Mycenaeans had inherited from their Middle Helladic forbears this form of goblet and it remained popular with them throughout the whole of their history. It underwent various changes in style but remained essentially the same, a stemmed bowl. In the early stages it naturally resembled its Middle

113

5

6

2b

7f, h, 8

Helladic parent, a deep bowl with a very short stem on a pedestal. In succeeding periods the bowl becomes smaller in relation to the stem and in the final phase the slender stem is often as tall as, and sometimes taller than, the bowl. At this stage of its development it is not unlike a champagne cup. The name, kylix, is taken from a similar, but very much more sophisticated and elegant vase of the Classical period.

The tendency to order and symmetry in design becomes increasingly manifest in the succeeding period (LH III). The old Middle Helladic tradition reasserts itself. Geometric patterns come once more to the fore and whatever is retained of foreign invention is recast in abstract form; and so is born the true Mycenaean rhythm and style, known, admired, and sought after in the ancient civilized world. The forms of the pottery were largely drawn from a well-tried, if rather stolid, Middle Helladic stock, but more elegant shapes and new styles of vases

4

7c, d

were taken over from Crete, among them the stirrup-jar, which underwent a varied and characteristic Mycenaean transformation. A few examples of this vase had been imported during LH II; in LH III it became one of the most popular vases in the Mycenaean repertory. Its main advantage seems to have been the slow rate of flow from the pouring funnel (the side-spout). The jar was produced in all sizes from the large coarse-grained, plainly decorated, vessel used for olive oil to the tastefully painted, smaller model, which probably contained unguents and perfumes.

The standard of production during the LH III period was of the highest order. The clay was selected with care, levigated, and fired to a hardness that gives a clear clink when struck. The pots were sometimes covered before firing with a slip of the same fine clay to make them impermeable. The colour of the vase resulting from the firing was normally buff. Against this background the patterns showed up in a luxuriant paint of red, brown, or black. The style of decoration was standardized by LH IIIA. Almost inperceptibly this phase merges into LH IIIB. It is not always easy to distinguish the difference between the two groups, but it is during IIIB that the Mycenaean style becomes fully established and shows little variation during the whole of that period, although it is usually possible to distinguish an earlier and a later phase. The art of the potter has attained a mechanical perfection and the pottery is mass-produced not only for the home market but for export to the East and Central Mediterranean. The vases of this period that have come down to us can be numbered in literally thousands. The

4

7

repertory includes three-handled jars, stirrup-jars, alabastra (both the rounded and the angular form), small jugs, large bowls (called kraters after the later Classical type), small bowls, kylikes, cups. The decoration, usually a recurring stylized motive, is normally confined to the shoulder or handle-zone on closed vessels. The rest of the vase is painted with bands of circumcurrent lines enclosed by horizontal stripes above and below; this is a conventional form of subsidiary decoration used very widely on Mycenaean pottery of all shapes and is easily recognizable. On open vessels the pattern is usually applied on the upper half of the vase. On certain kylikes the design takes a longitudinal form and occasionally one motive of this nature is selected, elaborated, and executed with great skill and artistry on one face of the

7 Mycenaean pottery. a–d, f LH IIIA; e, g–j LH IIIB. a, c, d stirrup-jars; b ewer; e ladle; f, h kylikes; g mug; j deep bowl.

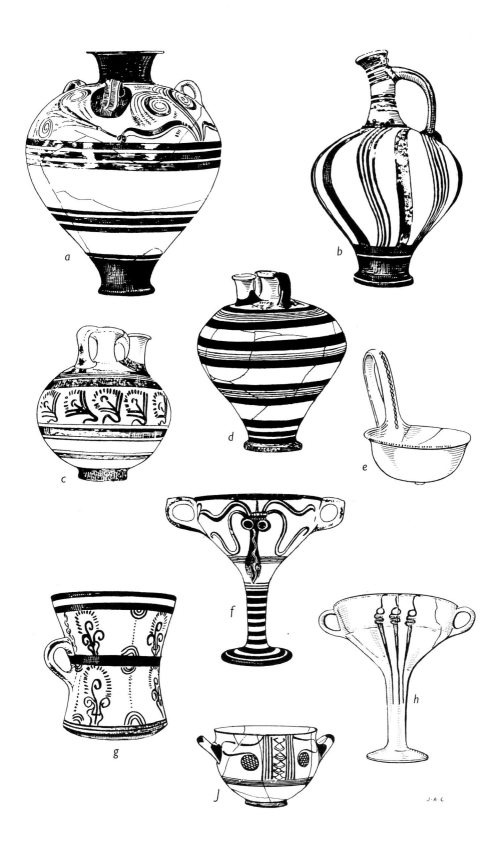

a

b

c

d

e

f

g

h

J

J·A·C

25

vase. It is known as the Zygouries style from the site where it was first discovered. In the latter part of IIIB kylikes are as a rule undecorated. At the same time the so-called deep bowl, which starts at the end of IIIA, is increasingly favoured, particularly at Mycenae. Two kinds of decoration are normally found: one of great economy consisting of a simple geometric motive placed sparingly round the central part of the bowl; the other, a panel style, that is, both sides of the bowl between the handles were divided into panels or metopes. The decoration is almost exclusively geometric. Panel style or deep bowls are noticeably rare at Pylos. At Mycenae they occur more frequently on habitation sites than in tombs. Besides the patterned vases, a considerable number – and at Pylos by far the greatest number – were unpainted or at most decorated with plain horizontal bands. Amphorae, hydriae (water-jugs), and jugs were often treated in this manner.

7j

One type of vase was especially popular in Cyprus and is more frequently found there than anywhere else. The earliest examples belong to LH IIIA. It is a krater painted on the outside with vivid, though stylized, scenes, commonly of chariots being driven to the chase or to war. Other popular subjects are fighting bulls, juxtaposed deer or birds, and other more formalized scenes. The antithetical subjects show obvious Eastern Mediterranean influence and these vessels were certainly exported to countries near Cyprus such as Syria and Palestine. Another vase that was also favoured in Cyprus – originally of Near Eastern derivation – was the pilgrim flask.

9

4

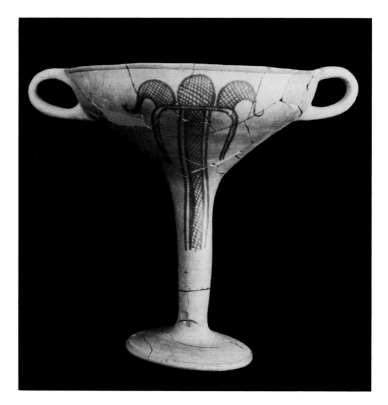

8 Kylix, Zygouries style. LHIIIB 1. A great many of these vases were found in the 'Potter's shop' at Zygouries. They are probably all by the same artist.

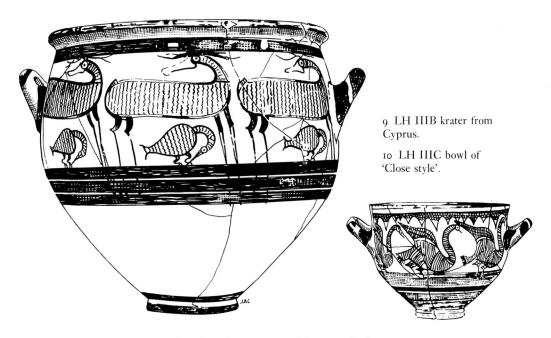

9 LH IIIB krater from Cyprus.

10 LH IIIC bowl of 'Close style'.

Mycenaean IIIC pottery is primarily represented by two distinct types of decoration, the Close Style and the Granary Style, but there is also a transitional phase following on IIIB which cannot always be clearly defined. The Close Style has been called the IIIC Palace Style and justifiably so. As its names implies, every available space is filled with some pattern, often of a complicated and finical character. The Granary Style, so called from the large number of pots with this type of decoration found when the Granary at Mycenae was excavated, is the antithesis of the Close Style. Decoration is kept to a minimum. The simplest motives are used, very often one or two wavy lines only. Large parts of the vase are painted in one colour, usually black or brown; sometimes the whole of the pot is painted, leaving but a reserved, horizontal band in the middle that may or may not be filled with some simple geometric motive. The origins of the succeeding Proto-geometric pottery are here foreshadowed. Deep bowls occur very frequently in the IIIC repertory and are painted in both styles. A famous krater belonging to this period is the 'Warrior Vase'. Towards the end of the period the quality deteriorated, the brushwork was often careless, and the paint is notable for its metallic lustre.

During this period (LH IIIC) local characteristics in style, scarcely noticeable earlier, become more marked and in this connection particular mention should be made of a type of stirrup-jar frequently found in the island of Rhodes. Its inspiration was Cretan. A motive popular in Late Minoan art was the octopus. Many stylized versions of this denizen of the deep were created, but it is in Rhodes that the most complete examples are to be found. A stylized octopus is represented in

10

129

11

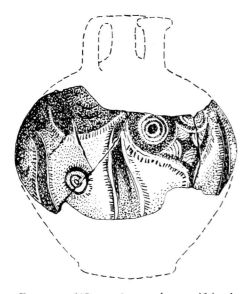

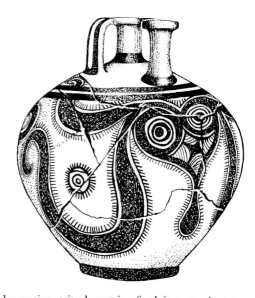

11 Fragment of 'Octopus' stirrup-jar from Taranto, Italy, and restored design.

a rather terrifying but decorative attitude putting forth its tentacles into every vacant surface of a stirrup-jar. Like the Chariot Vases, these stirrup-jars (the octopus is almost exclusively confined to this type of vessel) had a wide distribution. They were accepted on the mainland and reached even as far afield as south Italy. Another product of Rhodes was also exported to south Italy, a perforated vessel of coarse clay on three legs ending in scrolls. It is a common type of Mycenaean vessel (sometimes called an 'incense burner'), but only in Rhodes are the legs treated in this peculiar manner; normally the legs end in straight stumps.

12

Recent studies by several scholars based on later excavation reports have made it possible to work out refinements to the various phases outlined above. These have modified the original, basic scheme proposed by Arne Furumark. The excavations at Ayios Stephanos in southern Laconia, a site that was almost certainly on the sea in Mycenaean times, provide valuable information of Minoan influence during the transition period MH/LH. Minoan vases, though few, are imported and the local pottery exhibits features derived from Crete, an influence that, if not direct, was no doubt transmitted via the nearby island of Kythera, a Minoan colony at that time. The implications of this are made clear by Rutter in his monograph. The evidence seems to suggest that Minoan influence on LH I/II pottery came via the southern Peloponnese, rather than direct to the northeast (Mycenae). Oliver Dickinson has made a special study of this period and redefined the phases of LH I and II. Mrs E. French has done the same in great detail for LH IIIA and IIIB pottery and has given useful guide lines for LH IIIC. Mrs E.S. Sherratt has devoted special attention to the last-mentioned phase (not yet published) and has written a useful article on the local (provincial) variations in style during LH IIIB. Recently Dr K.A. Wardle's excavations at Assiros, Macedonia, have produced important pottery evidence for the period of transition between the end of the Mycenaean and the early Iron Age.

12 'Incense burner' from Rhodes.

The successive styles outlined in this very brief summary of Mycenaean pottery provide the framework of a relative chronology which at some points can be linked with the absolute chronologies established for Egypt and Mesopotamia. The first point to fix is the beginning of the Mycenaean Age, which in terms of pottery styles is the transition period between MH and LH I. Here we have to rely primarily upon the relations between Minoan Crete and Egypt at this stage of history. In Crete a statue-base and other objects of the Hyksos period were found in association with Middle Minoan III pottery (corresponding with the end of Middle Helladic). The Hyksos domination of Egypt was brought to an end with the establishment of the Eighteenth Dynasty by Ahmose I in about 1570 BC. MM III (the end of MH) can therefore be placed earlier than this date. In the tombs of User-Amen and Rekhmere who were buried in the reign of Thothmes III of the Eighteenth Dynasty, that is, during the first half of the fifteenth century, Minoan envoys – the men of Keftiu (the Egyptian word for Crete) – are depicted bearing 'gifts' to the Pharaoh. Many of these 'gifts' are easily recognizable as metal prototypes of clay vases that were being produced at Knossos and Mycenae during LM II and LH II but not thereafter. It can be accepted therefore that LH II pottery was already being made during the first half of the fifteenth century. Consequently LM I and LH I pottery styles must come between the early fifteenth century and the end of MM III and of MH, that is, somewhere after 1570 BC. A round figure date of 1550 BC is thus normally given for the start of LM I and LH I.

144

Egypt also provides a date for the LH IIIA style of pottery. The 'heretic' Pharaoh Akhenaten moved his residence from the Eighteenth Dynasty capital of Thebes to a spot further down the Nile, the modern village of Tell el-Amarna. There he built a new city and encouraged artists from all lands to contribute to its embellishment. But his reign was short, his memory following his death was execrated, and his capital abandoned. It was not in existence for more than ten years (c. 1360–1350 BC), but during that period a quantity of Mycenaean pottery of advanced LH IIIA style was imported. It is clear that none of it can be later than 1350 BC. IIIA pottery, though in much smaller quantities, has also been found at Qatna on the Upper Orontes (Lebanon). This site was destroyed by the Hittites in 1375 BC. IIIA pottery consequently was being produced and exported before that date. When the civilization of Knossos was destroyed the LM II style of pottery was already giving way to LM IIIA, the early style of which is closely parallel to LH IIIA. The destruction of Knossos has therefore to be placed before 1350 BC and the round figure of 1400 BC is usually assigned to this event; 1370 BC could be nearer the mark. However it should be emphasized that this date is only approximate and some scholars would place the destruction late in the LH IIIB period or near the end of the thirteenth century.

The end of LH IIIA and the beginning of LH IIIB is approximately determined by another site in Egypt. Pottery that shows elements of both IIIA and IIIB styles has been found at Gurob in the Faiyum in association with Egyptian objects that were in fashion not long before Rameses II came to the throne in 1290 BC. Hence a convenient figure

for the start of IIIB is 1300 BC. The end of this period is not so easy to determine, as the traditional IIIB style may have lasted longer in some areas than others. However, the IIIC style very noticeably influenced Philistine Ware and it is known that the Philistines were established in Palestine in the early part of the twelfth century. A round date of 1200 BC is therefore generally accepted for the end of IIIB.

Suggested dates for the Fall of Troy range from 1270 to 1883 BC (a date favoured by the Greek historian Eratosthenes). From general considerations discussed in the final chapter a more judicious date would seem to be 1220/1210 BC.

There is even greater uncertainty over the end of LH IIIC, and therefore of the final close of the Mycenaean Age. But this was a period of decline, the beginning of a Dark Age, and information about it is naturally meagre. The start of the Protogeometric period is variously dated between 1050 and 1000 BC, depending on the interpretation of evidence which is outside our subject. Between the end of IIIC and the beginning of the Protogeometric there is a no-man's-land, where the pottery partakes of both styles, and this is called sub-Mycenaean. Quite arbitrarily it is allowed a period of fifty years. On such a basis the end of IIIC and of the Mycenaean Age is 1100/1050 BC. The result of our findings may therefore be set out in round figures as shown in the table below. For the sake of completeness the approximate dates of the ages preceding and succeeding the Mycenaean are also included.

Egypt	Crete	Date BC	Greek Mainland
III/VI Dynasties 2686–2181	Neolithic		Neolithic
↓	EMI	2500	EH
	EMII	2300	
	EMIII	2200	
Middle Kingdom 2133–1786	MMI	2150	↓
↓	MMII	1900	MH
	MMIII	1700	
New Kingdom 1567–1080	LMI	1550	↓
Thothmes III 1490–36		1500	LH I
	LMII	1450	LH II
Akhenaten 1367–50	LMIII A	1370 (Destruction of Knossos)	LHIII A
Rameses II 1290–24	LMIIIB1	1300	LH IIIB 1
Merneptah 1224–14		(Fall of Troy)	LH IIIB 2
	LMIIIB2	1200	LH IIIC sub-Mycenaean
Late New Kingdom 1080–664		1100	
		1050	Protogeometric
		950/700	Geometric
		776	First Olympiad
XXVI Dynasty (Saite Period) 664–525		700	Archaic
Late Period 525–332			↓
		500	Classical
		323	Hellenistic
		133	Roman occupation

2
Written sources:
Linear B and tradition

Civilization by definition in ancient history means a literate society. Indeed the very complexity of civilized society requires a discipline of records to function at all. The Mycenaean civilization was no exception to this rule, though earlier excavations had provided little evidence of the fact. Some knowledge of writing was inferred from curious signs painted on a certain number of Mycenaean stirrup-jars found at Mycenae, Tiryns, Eleusis, Orchomenos, and Thebes; but not until the excavations, begun at Pylos in 1939, produced hundreds of clay tablets inscribed with a similar script was it realized that the knowledge of writing may have been general and widespread in Mycenaean Greece. These clay tablets were not unique. They had already been found in Crete at Knossos as early as 1900 by Sir Arthur Evans, who from the first recognized their importance. Knossos has produced the largest number of such records, between 3,000 and 4,000, though many of them are fragmentary; but they have also been found elsewhere in that island in the palaces of Phaistos, Hagia Triadha, and Mallia. Pylos has the next largest number, just over 1,200. Mycenae so far has accounted for little more than 70; and the greater number of these come from houses outside the citadel. Recent finds have added a few more tablets to the total: 43 from Thebes and 6 from Tiryns.

It seems indeed strange that the dynamic centre and inspiration of the civilization which we call Mycenaean, should have produced so small a number. The explanation seems to be twofold: the perishability of the substance and perhaps the inability of the earlier excavators to recognize these rather undistinguished lumps of clay for what they were. The latter explanation is a fairly common one given by modern archaeologists, but I do not think that all tablets could have escaped the keen eye of Schliemann who prided himself upon the care with which he collected and preserved what, even to him, were the most insignificant objects. It is true that tablets are not easy to recognize. The so-called Linear B tablets – the only kind found on the Greek mainland – are oblong pieces of clay about 8 cm in length. Some are much larger and almost square; others are long, narrow, and tapering, like a palm-leaf. In the dust and dirt of excavation tablets could be taken for fragments of coarse pottery, except that one surface to the discerning eye would display incised markings. But, unlike pottery, they were not baked in a kiln, which would have rendered them almost indestructible. They were shaped out of ordinary clay, inscribed with a record when the clay was still soft, and then put out in the sun to dry. So

13

18

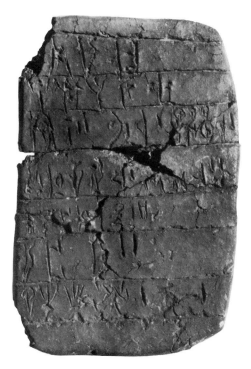

13 Tablet from the House of Sphinxes, Mycenae. 9.5 cm × 5.7 cm. Mid thirteenth century BC. Most of the tablets from this house deal with herbs, spices and condiments.

long as they were stored in a dry place they were likely to survive, but once subjected to the effects of water they quickly dissolved into a shapeless mass. (This unfortunate fate befell some tablets stored by Sir Arthur Evans in a shed with a leaking roof!) It is largely due to the violent destruction of a site that tablets have survived at all. The fierce fires burnt them to the hardness of pottery; even so, some of them are rather friable.

At Pylos the majority of tablets were concentrated in one area and in the course of excavation it became clear that these represented the palace archives. They were stored near the entrance to the palace in a small room with low benches that supported frames for shelving, or so it could be inferred from careful observation of the burnt debris filling the room. It could also be deduced that the tablets were kept in wicker baskets, as an impression of the wickerwork was preserved on several pieces of burnt clay found adhering to 'labelling' tablets, that is, tablets stating in an abbreviated form the subject of the contents. Another type of storage seems to have been wooden boxes. Within the citadel of Mycenae no archives have been found. A few tablets, eight in all, were recovered in 1960 during the excavation of a house within the citadel and near the Grave Circle, but they were very fragmentary. The circumstances of their finding suggest that they were but a remnant of a large hoard, which was all but annihilated by the devastating fire that destroyed the buildings in which they were housed. The surviving tablets were found embedded in conglomerate masses of molten stone, brick, and clay fused to the consistency and hardness of concrete. Spattered about in this rock-like, calcined debris were specks and

75Q

fragments of a reddish-brown substance, which could have been potsherds or bits of disintegrated tablets. If the latter, it would seem that the tablets in this case were stored in stone cupboards or containers. The very evident marks of the fire that destroyed the palace on the crown of the citadel show that here too the conflagration was of equal intensity and violence to the one farther down the slope of the hill. In this manner any archives that may have existed within the palace would have been obliterated or have left so little trace as to have eluded the vigilance of the excavators.

These records in clay from Greece and Crete, and a few from Cyprus, are practically the only written documents that have survived from the Aegean world of the second millennium. It may well be that other media for writing were used, substances such as wood, leather, parchment, palm leaves, or papyrus, none of which would survive under normal conditions. The conversion of the papyrus plant into a very adequate writing material was a specialized industry of Egypt and there is plenty of evidence of trade relations between the Aegean and that country. Writing in clay was the system adopted in Babylonia and neighbouring kingdoms – there the tablets were oven-baked – and an implement with a wedge-shaped end was used to reproduce the cuneiform script (*cuneus*=a wedge). A very sharp-pointed bone instrument was found in the excavation referred to above, and it may be that the more important documents were written on other materials more adapted to such an instrument. The tablets, on the other hand, which could be cheaply and easily produced on the spot, would serve for day-to-day business records, and that is in fact what they are.

How do we know this? So much was deduced by Sir Arthur Evans from pictorial signs on the Knossos tablets recognizable as horses, chariots, weapons, etc., but it was not until recent times, 1952 to be exact, that the many attempts at deciphering the script met with success. This was largely due to the genius, brilliance, and application of a young architect, Michael Ventris, assisted at a critical stage of his work by the Cambridge philologist, John Chadwick. To understand this colossal achievement one must appreciate that Ventris was attempting a far more difficult task than the problem that faced Champollion in solving the riddle of Egyptian hieroglyphics or Grotefend and Rawlinson in the decipherment of cuneiform. These early pioneers had bilingual or trilingual texts to help them and at least they knew the linguistic group to which the language belonged. Ancient Egyptian, though much modified, lived on in the Coptic tongue; Assyrian and Babylonian were related, it became clear, to ancient Hebrew and Semitic languages in general. But Ventris was faced with one script alone and without a clue as to what language it might stand for.

Many of course had preceded Ventris in the unrewarding quest. Sir Arthur Evans himself was a pioneer and laid the foundations for future research. He was able to demonstrate the different stages in the development of the script. First, the hieroglyphic signs that are mainly found on Cretan gems and seal-stones belonging to the first half of the second millennium; a few tablets with hieroglyphs are also known. Secondly, a cursive and simplified version of these signs, which Sir

Arthur termed Linear A; this was inscribed on tablets, vases, stone, and on bronze. Finally, a later and more advanced script, closely related to Linear A, which he called Linear B. No exact dates can be given for the periods in which these script were in vogue, but it can be said that Linear A overlaps the hieroglyphic script and may have started as early as the eighteenth century. It seems to have gone out of use in the early part of the fifteenth century. Linear B, which is almost exclusively recorded on tablets, begins just after 1400 BC. The latest tablets can be dated to around 1200 BC.

In his study of the material, Evans had established certain basic points: that the tablets were lists or accounts, that a numerical system was clearly recognizable, that some of the signs were ideograms (pictures of the objects designated), and that the other signs were most likely syllabic. This last he assumed because he had noted that groups of signs were separated from other groups by vertical strokes; hence each group probably represented a word of so many syllables. Beyond these general conclusions Evans was not prepared to commit himself. Many of his less cautious and immediate followers – and distinguished scholars among them – were to rely too much on guesswork, choosing a language that might be shown to have some affinity with the script and trying to make the two fit. Method was lacking in nearly all these schemes. Without a detailed analysis of the inscriptions there was little chance of success.

One of the few who adopted a methodical approach was the American, Dr Alice E. Kober. She was able to demonstrate by her analysis of the Linear B signs that it was an inflected language, that is, one in which words have varying suffixes added to denote gender, plural, etc. (as in Latin). For instance, she noted that the totalling

𝍩	MAN	𝍪	WOMAN
	HORSE		PIG
	TRIPOD		CUP
	AMPHORA		SWORD
	SPEAR		ARROW
	CHARIOT		WHEEL

14 Linear B. Some ideograms.

15 'Kober's triplets'.

TYPE A		TYPE B			C	D	E

Linear B	Cypriot	Value in Cypriot
⊢	⊢	*ta*
+	+	*lo*
Ŧ	Ŧ	*to*
⊔	⊔	*se*
⧾	⧾	*pa*
⊼	⊤	*na*
⟊	↑	*ti*

formula for men and a certain class of animals differed from that used for women and another class of animals and this suggested a distinction in gender. But her greatest contribution to the decipherment was her demonstration that certain words made up of two, three or more syllabic signs could have two variants by adding a different sign or by changing their terminal sign into another sign. (An example in English would be: wo-man; wo-man's; wo-men.) Such variations are referred to in linguistic circles as 'Kober's triplets'! Professor Emmett L. Bennett, Jr was also one of the few to use a methodical approach. Apart from elucidating the system of weights and measures used in the script, his most important contribution was the ordering and classification of the whole Linear B signary. The division of the signs into two classes, ideographic and syllabic, was clarified and from a detailed study of variants in the orthography (bad handwriting is nothing new) he was able to narrow down the number of syllabic signs to just short of 90.

There was one valuable, but deceptive, clue to attacking the problem of decipherment. A related script is found in Cyprus and is referred to as Cypro–Minoan. Only a few tablets have been found there, of which the oldest is said to date from the eleventh century and to have affinities with Linear A. Two features about these tablets call for special comment. A blunted stylus was used and the tablets were baked in fire. The technique is therefore different from the tablets we have been discussing and is more closely linked to that of civilizations to the East. This is not surprising in view of the geographical position of Cyprus. Yet another script, the Classical Cypriot script, was in use on the island from the eighth to the third or second century BC and is obviously related to Linear B. In most, if not all, cases Greek was written in it; hence decipherment was possible. Seven of the signs are similar to or can be equated with Linear B and the phonetic values of the Cypriot Syllabary are known. The signs represent either a vowel or a consonant plus vowel. As this is a syllabic and not an alphabetic script, difficulties

16 Comparison of signs in Linear B with Classical Cypriot.

15

16

occur in words where two or more consonants follow one another or where a word ends in a consonant. Using this syllabic script, '*pastor*' would be spelt *pa-so-to-re*.

The final vowel of *-re* would not be pronounced, neither would the *o* of *-so*; such would be regarded as 'dead' vowels. But the choice of the syllabic sign *-so* (from the five syllabic signs beginning with s: *-sa*, *-se*, *-si*, *-so*, *-su*) is governed by, and must conform to, the vowel of the syllabic sign following, in this case the *o* of *-to*. So for '*prison*' the spelling would be *pi-ri-so-ne* (the final 'dead' vowel is always *e*). Yet a further complication in the Cypriot Syllabary is that *n* before a consonant is not written. Thus '*contralto*' would appear as *co-ta-ra-lo-to*. It must be clear from these examples that the Syllabary would be a very clumsy method of writing English. It is even more so for Greek. The word *anthropos* 'man' has to be written *a-to-ro-po-se*. Now a very large number of Greek words end in *s* and, as the Cypriot syllabic sign *-se* is identical with one of the Linear B signs, it could easily be demonstrated whether Linear B was a likely candidate for Greek or not. It was found that the *-se* sign very rarely occurred as a terminal sign in the Linear B script. The natural conclusion therefore was that the language was not Greek.

The preliminary, basic, and essential work carried out by Kober and Bennett was invaluable to Ventris who now brought an added dimension to tackle the problem of decipherment, a certain knowledge of cryptography. In theory any code can be broken provided there is enough coded material to work on. A detailed analysis of the material should reveal certain recurring features and underlying patterns. We have already commented on those that had been noted by Dr Kober. Ventris was able to add to the number of pregnant observations. On the basis of the material available, considerably augmented by the publication in 1951 of Bennett's transcription of the tablets found at Pylos in 1939, he prepared statistical tables showing the over-all frequency of each sign. He was able to deduce – and here he had the collaboration of Bennett and the Greek scholar Kristopoulos – that three of these signs were probably vowels from the fact that they occurred predominantly at the beginning of sign groups. A suffix was provisionally identified as the conjunction 'and', used like *-que* in Latin. Other inflexional variations of words identifiable as nouns were noted and, as some of these occurred with the ideogram of man and woman, it could be seen that in such cases the inflexion was often one of gender rather than case.

17 The relative accumulated data were arranged by him in tabular form, in what he called the 'grid'. The grid was constantly being revised and re-arranged. In one of its latest forms it consisted in the main of 15 rows of consonants and 5 columns of vowels; as none of the values of the consonants or vowels was known, these were simply given numbers. Within these 75 spaces were arranged the most frequently recurring Linear B syllabic signs (51 out of a possible total of 90) on the basis of statistical data that had been assembled about them. If the system was sound and the data correctly diagnosed, signs in the same column should share the same vowel and signs in the same row should start with the same consonant. Therefore, if the phonetic values of but a few

LINEAR SCRIPT B SYLLABIC GRID
(2ND STATE)

Diagnosis of consonant and vowel equations in the inflexional materials from Pylos:

These 51 signs make up 90% of all sign-occurrences in the Pylos signgroup index. appended figures give each sign's overall frequency per mille in the Pylos index.

	"Impure" ending typical syllables before -ʔ & -Ɵ in Case 2c & 3	"Pure" ending typical nominatives of forms in Column 1	Includes possible "accusatives"	Also, but less frequently, the nominatives of forms in Column 1	
	These signs don't occur before -ß-	These signs occur less commonly or not at all before -Ɵ-			
	More often feminine than masculine?	More often masculine than feminine?		More often feminine than masculine?	
	Normally form the genitive singular by adding -ʔ	Normally form the genitive singular by adding -ß			
	vowel 1	vowel 2	vowel 3	vowel 4	vowel 5
---	---	---	---	---	---
pure vowels?	30·3				37·2
a semi-vowel?				34·0	29·4
consonant 1	14·8	32·5	21·2	28·1	18·8
2	19·6	17·5			13·7
3		9·2		3·3	10·0
4	17·0	28·6			0·4
5	17·7	10·3		4·1	10·2
6	7·4	20·5		14·8	14·4
7	4·1	44·0			
8	6·1	6·1		13·5	15·2
9		33·1		32·3	2·4
10	22·2		38·2	3·5	2·2
11	31·2	33·8	34·4	8·3	0·7
12	17·0			37·7	24·0
13		9·4	14·2		
14	5·0				
15	12·6				

17 Ventris's 'grid'.

syllabic signs could be established, the values of the others would automatically follow from the grid.

We have already mentioned that seven of the signs from the Cypriot Syllabary can be equated with Linear B signs; it was permissible therefore to experiment with the Cypriot phonetic value of these signs. At a later stage, when the decipherment appeared to be approaching a solution, Ventris decided to test his findings against the phonetic value of the Cypriot signs. He had concluded from the constantly recurring position of certain groups of signs in the tablets that these sign-groups represented the names of places. Working on these two suppositions he made tests with ancient place-names. For the Knossos tablets the choice was naturally made from Cretan names that were known in Classical times or mentioned by Homer – Knossos itself, Amnisos (a harbour town near by), and Tulissos; and they could be recognized in the following syllabic spellings: *ko-no-so, a-mi-ni-so, tu-ri-so*. These identifications were certainly valid on the Cypriot spelling convention, double consonants (*kn, mn*) being split into syllables. The *ri* instead of *li* in *tu-ri-so* (Tulissos) was not a difficulty. Ventris had already recognized that *r* and *l* were interchangeable, as they are in several languages, including Ancient Egyptian. One marked difference from the Cypriot is that final *s* is not written. Similarly *l, m, n, r, s* are omitted at the end of a word or when preceding another consonant, and there are other spelling rules imposed by the decipherment that do not correspond with the Cypriot conventions.

If the results of these tests were promising, they still did not provide any clue as to the language concealed in the script. Ventris's own opinion was that the language was Etruscan and to the very last he tried conclusions in that direction. It was only as 'a frivolous digression' (his own words) that in the final stages of the decipherment he experimented with Greek. To his surprise, with Greek many of the tablets made sense. Admittedly as many more remained incomprehensible, but if the language was indeed Greek, it would of necessity be a very archaic form of the tongue that was recorded in the Linear B script a full 500 years before Homer – and Homer's Greek is itself archaic. If the language was Greek, one would expect to find many of these Homeric archaisms foreshadowed in the Linear B texts and the fact that this was so contributed very largely to the favourable reception accorded by the majority of scholars to Ventris's revolutionary pronouncement. One has only to recall the contention and controversy that arose over the success claimed for the decipherment of cuneiform and Egyptian hieroglyphics to marvel at the comparative acquiescence and applause with which this far more spectacular and controversial achievement was received. Opposition to the claim there naturally was, but before it could become articulate a remarkable and dramatic piece of new evidence supervened.

About the same time that Ventris was reaching his solution of the Linear B problem, a tablet was being unearthed at Pylos that went far to confirm the correctness of his system. It was one of about 400 that were discovered during the 1952 excavations. Early in the following year they were being cleaned and studied in Athens by Professor Blegen, their finder. He tried out Ventris's syllabary on several of them, and on

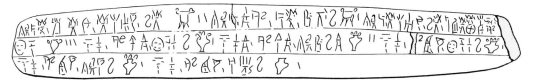

one with striking results. It was a tablet with an inventory of tripods and various kinds of vases, some with four handles, some with three, and one with none; the different ideogram used in every case made this clear. But each ideogram was preceded by a description and, although the meaning of every word in the description was not self-evident, some could be given the following phonetic values – and no other – according to the Ventris syllabary: *ti-ri-po*, *qe-to-ro-we*, *ti-ri-o-we*, *a-no-we*. The *ti-ri-po* word only appears with the tripod sign. Following the spelling convention previously demonstrated, it is clearly the Greek word *tripos*, a tripod. *O-we*, which occurs in the three other words given above, means 'eared'; the word 'ear' is regularly used in Greek for the handle of a pot. It is found above in combination with *quetro* (Greek *tetra*, Latin *quattuor*), *tri* (as in *tripos*), and *an*, the Greek negative prefix, i.e., no handles. That the above-given words should only occur with the ideograms to which they refer was beyond the possibility of coincidence. The basic soundness of the decipherment of Linear B as an archaic form of Greek was thereby established and the publication of this tablet in 1953 served to convince many who up till then were only partly converted. But it did not convince all, and to this day there is a small minority of scholars who will not accept the decipherment.

How is one to explain the opposition, however diminished, to the idea of Linear B being Greek? The objections concern admitted difficulties in translation. Many words still do not make sense and, on account of the great variety of possible alternative readings in certain cases, one cannot always be sure of the Greek form of these doubtful words. It is this very flexibility in the spelling convention that has been particularly under attack. It is argued that no scribe could make himself intelligible to another with such an elastic script. For instance, the sign for *ka* may represent as many as 70 different syllables: *ka, ga, kha, kai, kas, kan*, etc. This is so, but it is not true of all the syllabic signs; and signs are not read in isolation but in combination as words. Certain combinations occur again and again. A pictogram is often there to supplement a hesitant memory. But there are many cases in our own language where we have a choice between variant readings. A word like 'invalid' is capable of two meanings and two different pronunciations, and it is only one of numerous examples that could be given. Like the Mycenaean scribe we may hesitate for a moment before making a choice; it is familiarity and the context that ultimately decide.

If it is generally accepted today that the language of Linear B is Greek, it has to be admitted that the written material so far available is limited in quantity and content. The content consists of inventories for the most part and catalogues: inventories of stores, livestock, and agricultural produce; catalogues of men, women, and children. And of the latter category a great part of the text is taken up with proper names

18 Linear B tablet dealing with tripods and vases.

18

and the occupations of the individuals concerned. At least 65 per cent of the sign groups are proper names, of which a number can be equated with those known in Classical antiquity. About 200 or so are almost certainly place-names, although quite a number of these cannot be identified geographically. Some 3,500 tablets have been studied and these have yielded a total vocabulary of 630 words, of which about 40 per cent can be read with a fair degree of certainty. The number of texts that contain sentences of any length is limited and consequently our knowledge of grammar and syntax is equally so. These are the 'chariot', 'land tenure', and 'furniture' tablets. Although some details are still disputed, the general lines on which the Mycenaean economy was organized are now clear (see Chapter 7).

Before the decipherment of Linear B our only other written sources of enlightenment on the Mycenaean Age were the Homeric epics of the *Iliad* and *Odyssey*, and various legendary tales recounted by Classical and later authors. Many of these latter accounts were derived at second or third hand and recorded in some cases more than a millennium after the period to which they referred. But if the Homeric poems were composed in the eighth century BC, as is generally believed, and certainly not earlier than the ninth, there is a gap of some 400 years or more between one of the principal events of the Mycenaean era, the Trojan War, and the record of it as given by Homer in the *Iliad*; that is, if we assume that our present version of the epic is substantially as it was conceived in the eighth century BC. Even so, there is evidence of at least some later additions and interpolations in Archaic and Classical times, though the extent of them is still a matter of argument. If therefore a received text has been tampered with, of what historical value is the original version – if we could be sure of it – composed many centuries after the events to which it refers? It was such considerations as these that led nineteenth-century critics to doubt not only the historicity of the epic but the very existence of Troy. Schliemann proved to them by the practical testimony of the spade that Troy had existed and had been destroyed – though he misinterpreted the evidence – and that Mycenae was 'rich in gold' (as Homer had said), although he mistook the burials within the Grave Circle for those of Agamemnon and his followers.

But Mycenaean archaeology was not yet born when Schliemann started his memorable campaigns. Later excavations and research were to establish a closer relation between the epics and the findings of archaeology. A tradition that Homer was born in Chios accords well with the predominantly Ionic language of the epics and it would be natural if his descriptions of warfare and society were drawn from the familiar life of his own day. Yet he does preserve features that are true to the period of his tale: the use of bronze weapons, the boar's tusk helmet that Meriones lent to Odysseus, the tower shield of Ajax. All of these are vouched for archaeologically, while the last two can be shown to have had a very ancient history stretching back to beyond the beginning of the Mycenaean era.

Literary research supplemented the findings of archaeology. In structure the Homeric poems show obvious resemblances with the great medieval epics such as the *Nibelungenlied*, *Beowulf*, and in more

recent times the Yugoslav epics, which were orally composed and handed down from generation to generation by word of mouth, or song, and only later committed to writing. A similar oral tradition can be recognized in the Homeric epics. Whether Homer was conversant with writing is a moot point. There is no evidence of Linear B after the twelfth century and an entirely new form of script, Phoenician-inspired and totally unrelated to Linear B, did not come into use till the eighth century BC. But the genius of the epic is not dependent on writing. It draws its inspiration and strength from a different mode, the vast reservoir of heroic epithets and formulaic descriptions augmented, maintained, and hallowed by centuries of oral usage. Some of these can be shown to be very old on linguistic evidence. Many of the formulas, constantly recurring and composed in hexameters that are ill-adapted to the Ionic dialect in which the poems have come down to us, proclaim their antiquity. And those who created and perpetuated them were bards who wove them into the sagas that they sang or recited at the courts of kings, extolling the deeds of their royal patrons and those of their forefathers. Of the formulas used the traditional heroic name and epithet was among the most important. Such an epithet as 'swift of foot' applied to Achilles applies to him alone. The two are inseparable. Other examples can be quoted: Odysseus 'of many counsels', Agamemnon 'ruling far and wide', Ajax 'son of Telamon'. And when we find Ajax exclusively associated with the shield 'like a tower', a shield that had gone out of use by the time of the Trojan War, we recognize in him the hero of a saga that is extraneous to, and antedates, the story of the *Iliad*. The same can be claimed for Achilles who, though a minor king, yet dominates the poem and with impunity flouts his overlord, Agamemnon.

Of a different category is the Catalogue of Ships (Book II of the *Iliad*), which at whatever date it was incorporated in the *Iliad* describes a political hegemony of states that was no longer valid after the Trojan War. The Catalogue is an Order of Battle of those who took part in the famous expedition. Mycenae was pre-eminent as leader of the hosts and contributed 100 ships. No other Mycenaean kingdom supplied so many, though Pylos was not far behind with 90 ships. Yet Mycenae had dwindled to an insignificant township in Homer's time and the site of Mycenaean Pylos was no longer known in the Classical period. Athens, of some importance in the eighth century BC, is of small account in the epic. Many cities mentioned in the Catalogue could not in antiquity – and cannot now – be identified. It is also of some significance that Ionia, the home of the two great epics and main source of the local background to the poems, does not figure in the *Iliad* or *Odyssey*; the Catalogue refers to a period before the Greeks settled in Ionia.

Support for an ancient stratum in the Homeric epics is given in indirect ways by Linear B. Some archaic forms of speech in the poems are matched in the Linear B script, but had fallen into disuse in Classical times. Two examples are: the genitive singular in *-oio* and *-ao*, and the termination *-phi*. And *Potni' Athenaie* (Lady Athene) recalls *Athana potnia* of the tablets. There are two terms for 'king' in Homer: *wanax* and *basileus*. Both words are found in Linear B but only *wanax* stands for 'king'. In the Classical period *wanax* was already obsolete and had

been supplanted by the lesser title of *basileus*. Many Homeric personal names, but by no means all, occur in the script. Homeric words for weapons incline towards the Linear B rather than to the Classical nomenclature. The relation between epic and tablets is palpable, if superficial.

Although the great antiquity of the epics can be demonstrated, it is not easy to disentangle the different periods of composition that are contained in them. The oldest sagas may go back to the beginning of Mycenaean times. Basically the *Iliad* recalls events contemporary with the Trojan War, and the *Odyssey* those of the period immediately following, but centred round the fortunes, or rather misfortunes, of one particular hero. Both poems, however, in the course of their evolution have absorbed other heroic tales and reflect many aspects of the life and customs of later periods. The use of iron (but not for weapons) is mentioned and the rite of burial is cremation, a custom almost unknown in the Mycenaean era but adopted for a time during the Dark Ages that succeeded the fall of Mycenae about 1100 BC. The references to temples seem more at home in the period after the Ionian Migration (tenth century BC) and later. Instances of the foregoing are rarely recorded in Mycenaean archaeology. On the other hand many Mycenaean features, such as the great vaulted tombs and the wall-paintings of the palaces, find no mention in the epics. Lastly, there are alleged interpolations and amendments in the poems some of which might be as late as the sixth century BC. But when allowance has been made for all these factors an undoubted historical basis remains.

3
Religion and cult centres

If one were to reconstruct the Christian religion from the archaeological record, that is, from bare surviving ruins consisting often only of foundations, scraps of frescoes, fragments of mosaics, an occasional inscription, broken objects used in the cult, how valid would be the picture so obtained? Even should a varied but incomplete selection of writings, texts, rubrics, and the like survive to supplement the material side, how much agreement would there be in the interpretation of such documents? To some students of comparative religion there seems to be an obvious connection between the Mother of God and the Mother Goddess of the Eastern Mediterranean; between the death and resurrection of the God-man, Jesus Christ, and the perennial sacrifice of the 'divine son' of the Mother at winter and his rebirth at the spring equinox. A superficial resemblance there indeed is – and this did not go unnoticed in ancient times – but any deep and serious study of the Christian literature will reveal the fundamental difference in concepts between Christianity and other 'similar' religions. With what diffidence must one therefore approach the Mycenaean religion, of which we have but negligible written records and ones that throw no light on the beliefs held! Our main source of information is purely external: shrines, figurines, objects of stone or bronze used in worship, seal-stones and signet rings engraved with religious symbols or depicting some scene of ritual, fragments of frescoes and sometimes pictures on vases, a stele or painted slab telling a similar story. All these are not only difficult to interpret; they are but outward representations and their inner meaning can never be known with certainty.

The frequently used term 'Minoan-Mycenaean' religion might seem to imply that there is a close identity between the two but recent studies have shown this to be misleading. It is true that there are many outward similarities; Minoan and Mycenaean representations of religious scenes are almost identical, the cult objects the same. Divinity in human form is usually portrayed as a goddess; a god plays an inferior role. Some scenes suggest a mystic union between deity and worshipper, others depict fertility rites. Tree and Pillar cults, religious concepts of almost universal validity, are frequently shown. But how different by contrast is the picture presented by the Homeric epics. There Zeus is Father of all and supreme ruler. Gods and goddesses are but mortals writ large and differ from humans only by reason of their immortality. Little mystery is attached to them. As exalted beings they stand apart. Yet in the later, Classical period, both facets, or what have been termed the Dionysian and Apollonian aspects, of religion can be discerned: the one basically a chthonic religion with Mother Earth as its primeval source 19

19 Seal impression from Knossos. The Mother of the Mountains and Mistress of Animals.

and inspiration – a form of worship natural to a settled, agricultural community; the other, a religion inspired by the sky and its elements, Olympian and aloof, the natural encompassment of a nomadic tribe. It is generally supposed that the Minoan religion with its chthonic and mystic overtones was the shared patrimony of the Aegean before the advent of the Greeks, and the newcomers adopted the old established forms while preserving their own heritage of Indo-European beliefs. The Greeks by temperament were not averse to foreign ideas. Their genius was to absorb them and to give them new life and character. But in the beginning it would seem that, outwardly at least, the 'established' religion held sway.

Relations between Crete and the lands bordering the Eastern Mediterranean were close from an early time, and the Mycenaeans had many trade contacts with those countries in the days of their hegemony. It is only natural therefore to suppose that Minoans and Mycenaeans alike shared the conception of a Mother Goddess and her divine son, and sometimes consort, who is fated to die or be sacrificed at the death of the old year, which he symbolizes, and to be reborn in the spring. The rebirth was celebrated with great solemnity accompanied by fertility rites that were often of an orgiastic nature. Closely connected with this belief is the *Hieros Gamos*, the divine union of the goddess and her consort, enacted by human agents, to give sacramental effect to the regeneration of Nature. There is enough evidence to show that such practices and beliefs formed part of the content of the Minoan religion, but that it was its central core is doubtful. In Crete the Mother Goddess is a composite character. She incorporates within herself all aspects of Nature from the cradle to the grave. She presides over the birth of a child as Eileithyia and also under many other names. She is worshipped on the mountain peaks as Mother of the Mountains and a well-known seal from Knossos portrays her standing on a peak accompanied by two lions, one on either side of her, reminding us that she is also Mistress of Animals, the wild ungovernable forces of Nature. Another facet of Nature is vegetation and it is probable that she became fused (or confused) with the goddess of the Tree cult. In another aspect she was the patroness of marriage and as the Snake-goddess she presided over the home. Again, as Mistress of Animals she had power over life and death. If the general evolution in religion is from the many into one, she

45

19

represents that process, but some scholars suggest the reverse development; certainly in Greece by Classical times one finds a multitude of gods and goddesses, each with their well-defined spheres, ruled over by all-powerful Zeus, who in Crete, in his Minoan form, was nevertheless subject to the all-powerful Mother.

This dual aspect of Zeus gives us perhaps some insight into the different concepts behind the two religions and their interaction upon one another. Ancient religious systems are not as a rule intolerant or exclusive; more often than not a syncretism is sought. It would be natural therefore for the Mycenaeans to identify their supreme deity with the principal god of the Minoan pantheon even if this involved diminished status and new and incongruous attributes. In like manner other Greek gods and goddesses came to be indentified with Minoan deities or in some cases were derived from them. The Linear B texts afford some help here. Zeus appears once in the Pylos, and several times in the Knossos tablets. Hera, Athene, Artemis, perhaps Apollo (under the name *Paiawon*), Poseidon, Dionysus, Ares (under the form *Enualios*) are all mentioned. Unfortunately the information about them is mostly concerned with their dues in kind and other taxes, there is little to throw light on their attributes; but it is indeed important to know that their names were already household words in Mycenaean times.

There are three aspects of the Cretan Mother Goddess that stand out more clearly than any of the others; these are her roles as goddess of vegetation, Mistress of Animals, and household goddess. In terms of the Greek pantheon these aspects could be identified as Demeter, Artemis, and Athene. The association of the corn-goddess Demeter with Eleusis, where she presided as principal divinity, is well known and the Mysteries associated with this sacred place almost certainly derive from the indigenous religion. Hera, spouse of Zeus and chief goddess of the Argolid, is another form of the Mother Goddess, but by Classical times her august role had declined and she became subject to the Father figure. Artemis is called Mistress of Animals by Homer. In the Geometrical and Classical periods she is frequently represented as standing between two wild beasts that are chained, and therefore in submission to her. This is a familiar scene on Minoan gems. The same goddess appears under many other aspects and it is significant that as Mistress of Nature the Greek Artemis was identified in west Anatolia with the Great Goddess of the Ephesians, in other words, with a form of the Mother Goddess. In origin, then, Artemis was an all-important divinity who suffered an eclipse with the passage of time, a fact that could not be inferred from our knowledge of Greek myth alone. In later times she appears only as the virgin huntress, though retaining her character as goddess of childbirth, and twin sister to Apollo, a relationship that did not exist in the beginning. The household goddess is associated with the snake and the bird (although the latter could also be the epiphany of other deities). She has plausibly been identified with the shield goddess on a limestone tablet found at Mycenae, and in that capacity her protection would be extended to the citadel. One is immediately reminded of Athene who in the house of Erechtheus on the Athenian acropolis was associated with snake, bird, shield, and tree,

20

20 Painted limestone tablet, Mycenae. L 19.0 cm. LH III. The central figure is a goddess armed with a figure-of-eight shield. To the right of her is an altar.

and in the Homeric epics acted as protectress of her favourite heroes on the Greek side. The Mother Goddess seems to be represented on both the Pylos and the Knossos tablets as Potnia, 'The Lady'. She is frequently associated on both lots of tablets with the names of places and as such could be interpreted as the patron goddess of the place. Parallels in Christian tradition would be Our Lady of Walsingham, Our Lady of Lourdes, etc. Later, Potnia became identified with various Olympian deities.

From the tablets Poseidon, brother of Zeus, would appear to be an important deity in Pylos and this finds its echo in Homer where it is related that Nestor sacrificed nine times nine bulls to the Earth-shaker. Poseidon was also worshipped in the form of a horse, a recognized aspect of the fertility-spirit, and it may be that this form was retained from the original nomadic life and home of the Greeks. His association with the sea would seem to be a later accretion. The ecstatic cult of Dionysus flourished in the Archaic period but there was already some evidence that this was but a revival of an ancient worship, a supposition that is reinforced by the finding of his name on the tablets. As the Divine Child he was associated with the Great Mother of Asia Minor. The snake is closely connected with the Divine Child and, when one recalls that Dionysus was said to have been buried at Delphi and that Apollo slew the python before he became the lord of the Delphic sanctuary, there is a strong presumption that Dionysus preceded him there. And there is the legend that Dionysus came to Delphi from Crete, the home of mystical religion. But Greek tradition also relates that the Earth goddess, Ge, was worshipped at Delphi before Apollo.

In contrast to later times the gods were not venerated in great temples during the Mycenaean period. Very often the place of worship was no larger than a shrine. Many shrines and sanctuaries are known in Crete but they are rare on the Greek mainland. The best known one until recently was at Asine, one of the southern ports of the Mycenaean capital. A shrine was situated in a corner of a long two-columned room that was undoubtedly intended for secular as well as religious use. Five small female idols, various clay vessels and a stone axe of primitive form were found on a roughly constructed stone bench and on the floor in

front of it. But of greater interest was a fair-sized terracotta head found with them. Its sex has been disputed but one is inclined to regard it as a female on account of the 'pigtail' attached to the back of the head, which now finds parallels with the female idols discovered at Mycenae during the excavations of 1968 and 1969. It is not contemporary with the idols of Mycenae but belongs to the last period of Mycenaean civilization or, in chronological terms, Late Helladic IIIC.

Traces of what are believed to be shrines have been noted at Berbati near Mycenae and at Malthi in Messenia, but there is also evidence that they existed in the great Mycenaean palaces. At Pylos a small chamber has been interpreted as a shrine. In front of it in a small courtyard was an altar built of rubble and mud brick, covered with stucco and painted on all surfaces with linear and geometric patterns. But some form of cult may well have been concentrated in the private part of the palace itself, the megaron. The focus of the Mycenaean palace was the great circular hearth in the centre of the throne-room. Because of its great 76 size (diameter 4.02 m) and careful decoration it has been thought that it probably had a religious as well as a functional purpose. The hearth played an important part in later Greek religion and was associated with the cult of Hestia. In Crete there was no fixed hearth. In the palace at Pylos miniature votive cups were found on a table of offering in the throne-room and to the right of the emplacement for the throne runs a channel, cut into the floor, that ends in a shallow saucer-like basin. It at 75A once suggests the ritual of libations in which the king would play a principal part. But the role of priest–king with its overtones of divinization as understood in Egypt and Babylonia was foreign to the Greek temperament. At Mycenae, it is generally supposed, the Archaic temple that the Greeks raised to Athene on the crown of the acropolis in 21 the sixth century BC occupied the site of a shrine.

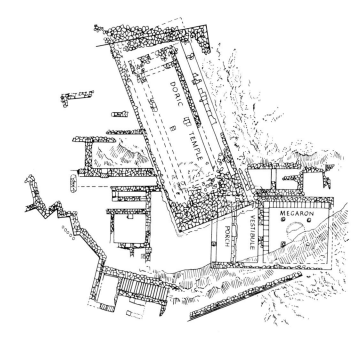

21 Plan of the acropolis summit, Mycenae. The Archaic temple of the sixth century BC was built over the ruins of the Mycenaean palace.

The sanctuaries that have been discussed above were associated either with palaces or private dwellings. Public places of worship, such as temples, were once thought not to have existed in Mycenaean times, but recent excavations have changed the picture very considerably. On Keos, an island of the Cyclades near Attica, Professor J.L. Caskey has excavated a large Bronze Age settlement. In a narrow rectangular building that was constructed towards the end of the Middle Helladic period fragments of near life-sized terracotta statues were discovered that made up into at least fifteen if not more figures. Among the fragments was a complete head. Its surface is much worn but it is possible that it was covered with white stucco and painted, as in the case of a slightly smaller head found at Mycenae which resembles it. The figures have been interpreted as votaries of the goddess and the head perhaps belonged to a cult statue. There is no doubt that this is a temple. It continued in use till the end of the Bronze Age. At the other end of the time scale and far removed from the mainland important excavations by Dr Vassos Karageorghis have uncovered a complex of large temples in ashlar masonry in Cyprus. Two of these date from the early thirteenth century and are of Near Eastern derivation but, in the early twelfth century, on the arrival of Greek refugees from the mainland (Chapter 8), further temples were built in a grandiose but similar style. A great number of Late Helladic IIIC sherds were found on the floors of these temples and it is obvious that they were adapted to

22

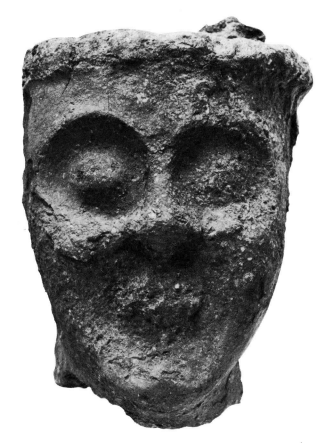

22 Terracotta head of a goddess from Keos. Ht 19.7 cm. Last phase of MH III and showing that cult statues of human size existed in Mycenaean times.

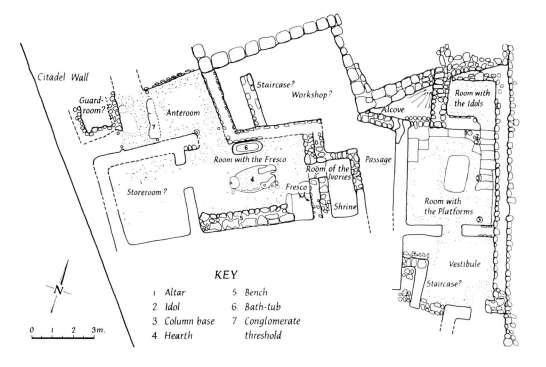

KEY

1 Altar
2 Idol
3 Column base
4 Hearth
5 Bench
6 Bath-tub
7 Conglomerate
 threshold

Citadel Wall

Guard-room?

Anteroom

Staircase?

Workshop?

Alcove

Room with the Idols

Room with the Fresco

Room of the Ivories

Passage

Storeroom?

Fresco

Shrine

Room with the Platforms

Vestibule

Staircase?

N

0 1 2 3m.

the use of the newcomers. These temples in origin, however, show in the one case Minoan and, in the other, Near Eastern influence.

At Mycenae a very different tradition prevailed as the latest excavations have revealed. As far back as 1950 Wace uncovered a shrine in a house which was partly excavated by Tsountas and known by his name. It is much larger than any of the shrines referred to above. It measures 6.45 by 4.5 m, and is preceded by an open court to the north in which there is a square altar with a fine plaster veneer that had been many times renewed. Within the shrine at its south end, and facing the altar, was another one of unique form. In plan it has the rounded outline of a horse-shoe with a raised surround and to the west of it two appendages, one of which is roughly circular in plan with a large hole in the centre that seems to have been used for libations. All of this complex is covered in plaster. This shrine was recently investigated by G.E. Mylonas and areas to the east and west of it excavated (where this had not been done before) with important results which are described below.

A surprising and unexpected discovery made in 1968 and 1969 was that of two sacred areas at the foot of the acropolis and just within the Cyclopean walls. These sacred areas are contiguous but there was no direct communication between them and both the conception of the buildings and the nature of the cult practised in each were entirely different. The more important of the two appears to have been a temple (designated 'Room with the Platforms' on the plan). It is approached by a vestibule from the south that leads into a room, 5.1 × 4.3 m with many unusual architectural features. In the centre is a low, rectangular

23 Plan of two cult areas south of Grave Circle A in the Citadel of Mycenae.

23

24 View of the temple from the south. Platforms at the far end. Steps lead up to the Room with the Idols.

25 The female idol found on a platform near the staircase. Ht *c.* 60 cm.

dais, covered as were all parts of the room with a white plaster. This shallow platform is slightly concave. There were no signs of burning on it, so it is unlikely to have been a hearth; it may have been used for libations. Across the far end of the room is a line of narrow platforms that differ in height and dimensions. They adjoin one another but without recognizable symmetry of plan. One platform in the northwest corner is higher than the others and on a different axis. Behind it in the northwest corner of the room is a kind of window, opening on to steep rock. The visible part of the rock is almost sheer and is in its natural state. It had never been cut. It could only be seen from within the temple, for a view of it from the outside was obscured by an oblique wall that may have been built specially for that purpose. It would seem that the rock played some part in the cult.

On the highest platform to the east stood a large female idol, modelled in clay, about 60 cm high. She faced the west towards the highest platform in the opposite corner of the room. In front of her was a low, round table generally referred to as a 'table of offerings'. Anyone standing in the entrance would not see her as she was obscured from view by a tall, wooden column, one of three in line that supported the roof. These columns were not placed, as one would expect, on the long axis of the room but over to the east side of it. Immediately to the east of them are steps that lead up to a little room, no more than 1.8 m square,

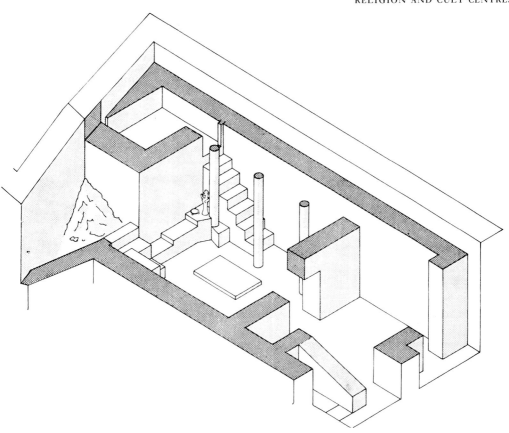

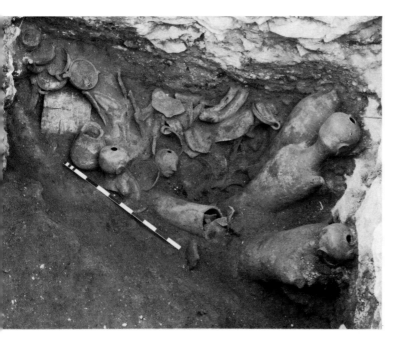

26 Isometric drawing of the temple viewed from the southwest.

27 Room with the Idols, as uncovered during excavation. Viewed from the south.

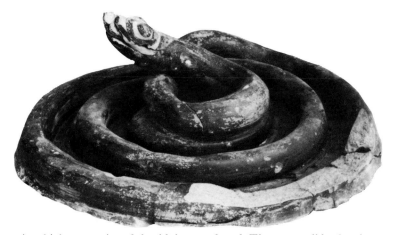

28 A snake, modelled in clay, found in the Room with the Idols. Cf. ill. 150.

in which a quantity of clay idols were found. They were all broken but many of them could be restored. Three 'tables of offering' were found with them and a number of plain vases, mostly bowls and kylikes. One bowl contained an assortment of ornaments: beads of glass and semi-precious stones, miniature carved ivories, etc. that were no doubt used in the cult. Other idols, but in a more fragmentary state, were discovered close by in the alcove created by the oblique wall that hid the rock from public view. Altogether there were 19 of the larger idols with an average height of 60 cm, 4 smaller ones about 30 cm high and a few figurines of a well-known type. This catalogue is incomplete without mention of another extraordinary, unexpected find, namely 17 snakes, most of them in fragments but two of them complete, modelled to the life in clay.

28, 150

The tall idols have never before been found on the Greek mainland. None of them are later than the thirteenth century and a few are earlier. Similar figures, even larger, are known from Crete but they appear to be of the twelfth century. Those found on Keos (see above) are earlier, but show strong Minoan influence and several features that are not consonant with the Mycenae figures. Apart from their greater size they are all very much of one general type.

The Mycenae idols are the work of a potter and they are made like pots; they are hollow. The arms were stuck into the cylindrical body of the vase (as are the handles of an amphora); the features were moulded on to the head. The arms are either raised aloft or held outstretched in front of the body as if they held some cult symbol. One figure appears to

29 hold such an object but the top of it is broken. Unlike the smaller figures most of the large idols have an awesome, forbidding expression. Each one has a striking individuality of its own. In this they differ from the earlier terracotta figures of Keos and the later ones in Crete. A further distinction, according to Professor Hodges is that the Mycenae idols can be categorized as male and female. The chest of the female is

30 flattened and she has locks of hair. The male is barrel-chested and bald. By these criteria there are 10 female figures, 7 male and 2 indeterminate. The large terracotta head found at Asine (see above) appears to be another of these idols. She is female because she has tresses of hair.

What a very different picture is presented to us by these new archaeological finds to what was hitherto known about the Mycenaean religion! It was generally accepted that the goddess played a predominant role. This impression seemed to be supported by the numerous female figurines (see below) found in excavations and the cult scenes engraved on gems. But from the Linear B tablets we learnt that most of the Homeric gods and goddesses were already known and worshipped in the thirteenth century. Now at Mycenae male and female idols have been discovered that may perhaps represent these deities. The idols with their fearsome but very individual expressions are quite unlike the poetic descriptions of them in Homer and no identification is possible, but one idol stands out above the rest. He is the tallest of them all and in his right, upraised hand he holds a hammer-axe.

31

It has been noted that the platforms in the temple are of varying heights. Did these perhaps indicate the status of the deities in the hierarchy? Undoubtedly some of the idols were placed on these platforms but only one was found in position. Not all the figures found in this room belonged to the temple. Some of them are earlier than the building, which was not constructed before the beginning of the thirteenth century. Two of the idols, including the one with the hammer-axe, can be dated on stylistic grounds to the early fourteenth century. They must have been brought there from other sacred areas in the vicinity, perhaps at a time when an enemy attack was expected. What is difficult to explain is the part played in the cult by the snakes. Like the idols they all have a character of their own. We have seen that snakes are associated with Athena, Apollo and Dionysus, but in many religions they have a chthonic significance and were believed to be connected with the powers of the underworld. This aspect of the cult

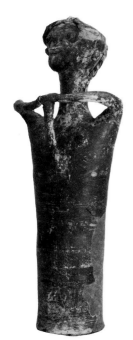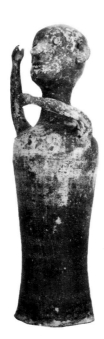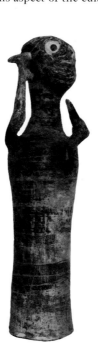

29 (*Far left*) Idol carrying some cult object. Only the shaft of it remains. Ht 60 cm.

30 (*Centre left*) Male idol, barrel-chested and bald. He probably held some cult object diagonally across the body. Ht *c.* 57 cm.

31 (*Left*) Idol holding hammer-axe. Ht *c.*70 cm.

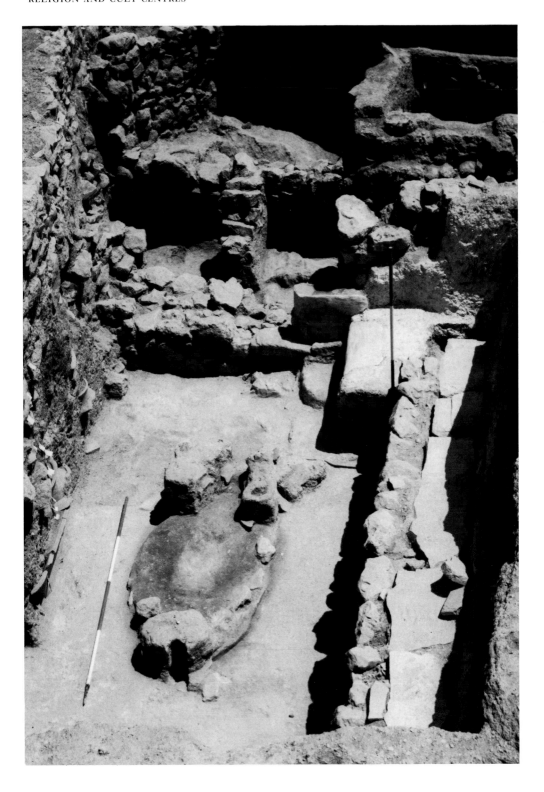

would be more in accord with the older, indigenous religion. One is tempted to ask whether the snakes were not in some way associated with the unhewn, natural rock in the temple, as representing this underworld.

The other cult area to the west bears little resemblance to the temple. It could only be approached from the north. After passing through an anteroom one came into a long room, 5.33 × 3.50 m, in which there is a central hearth of elliptical form. To the left of the entrance stood an undecorated larnax, or bath-tub, of terracotta. A water-jug, kylix and jug, all broken, were found at one end of it; these were no doubt used in the bath ritual. A long bench made of earth and about 91 cm high occupied the south side of the room. It was covered for its full length with a row of large slabs. The bench terminated at a white-plastered platform that was at a slightly lower level. This was an altar. Backing on to it was a wall, the east end of the room, on which was painted a fresco. About half of the fresco was still in position when found and its bright colours were well preserved. The north face of the altar was also painted. Only part of the design survives but it is important. It shows three pairs of 'horns of consecration' over a row of discs painted alternately red and black. The latter stand for the joist ends of a building. Such a combination is usually taken to represent a shrine or altar. The fresco itself extends for a distance of 1.83 m and portrays three goddesses, two standing and one seated. Directly over the platform is the central and principal figure. Unfortunately, the upper half of the lady is missing. Her dress is unusual. It is like that worn by 'La Parisienne' of the well-known Knossos fresco (now thought to be a goddess). She appears to have held in front of her a large sword, the point resting on the floor. Facing her is another goddess, dressed in a Minoan flounced skirt and a red bodice exposing the breast. The head is now indistinct. In her right hand she holds aloft a perpendicular object, which is very probably a spear, and with this she salutes the principal figure. Low down, to the left of the platform, is the best-preserved figure of all. She is on a smaller scale than the other two and is

33 The fresco as preserved in the Nauplia Museum.

34 Altar with fresco on its north face.

33

34

32 (*Opposite*) Room with the Fresco, viewed from the west. The bench covered with large slabs is on the right. An elliptical hearth occupies the centre of the room.

35 probably a minor goddess. She is seated. In each hand she holds a flame-like object – the colour is brilliant red – but almost certainly the object represented is some kind of cereal. The same subject is portrayed on an ivory pyxis lid from Ras Shamra in the Levant, but the coiffure is different; in the fresco the lady is wearing a headdress of Minoan style. She is, it would appear, offering the fruits of the earth to the central goddess, whom she faces. Here then is a religious scene evincing an entirely different ethos from that of the temple. It seems to be Minoan-inspired.

It would appear that, before the devastating cataclysm that destroyed the site towards the end of the thirteenth century, the room suffered some serious damage by fire, which perhaps was thought to be a desecration. In any event the room was then filled in with earth to the level of the bench mentioned above. It is difficult to explain the significance of the two rows of slabs that were placed along the south side of the room, but in the earth underneath them were found several vases, some of them complete, a Minoan stone vase and the ivory pommel of a sword, as well as other objects of less value. Two other finds, however, from this same area are totally exceptional for their
36 artistic merit and beauty: an ivory lion and the ivory head of a young
37 man (?). Both are carved in the round and the head is not only unique but of exquisite workmanship. It is a matter of speculation whether these valuable objects were abandoned after the misadventure suffered or whether they were purposely buried; they were both damaged.

35 Fresco of the smallest of the three goddesses.

36 Ivory lion found to the south of the altar. Ht 7.5 cm.

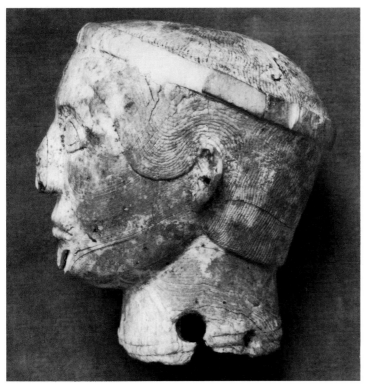

37 Ivory head of a young man (?). Ht 8.2 cm.

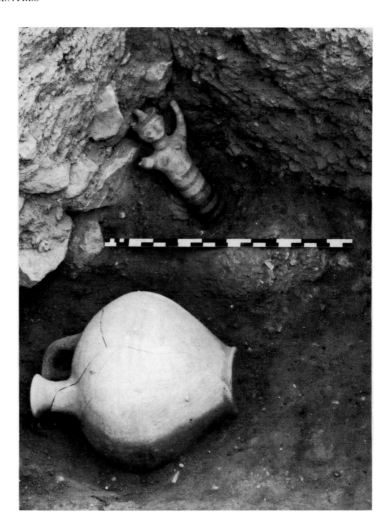

38 Goddess on a dais in the southwest corner of the Shrine. The large stirrup-jar in the foreground is one of the many complete vases found in the Shrine.

23

38, 39

Beyond the Room with the Fresco and to the east of it is another little room that was added at a later date but before the great destruction referred to above. Several pieces of unworked ivory were found in the north part of the room including an ivory core. But the other end of it had been adapted to a shrine. In the southwest corner of this room was a low dais of rather crude construction and standing on it a little goddess with arms upraised. She was the sole occupant of the shrine and no other deity was worshipped in it. Forty-four conical glass ornaments were uncovered at the foot of the platform. They were probably sewn on to some belt or stole, a dedicatory gift to the goddess. There was a large stirrup-jar close to the dais and some smaller stirrup-jars, kylikes and cups scattered about the room. These were evidently used in the cult, the nature of which seems to have been of a different order to that practised in the temple or in the neighbouring Room with the Fresco. Certainly the little goddess is Mycenaean and there is no trace of Minoan influence here. She is 29 cm high. Her expression is benign and

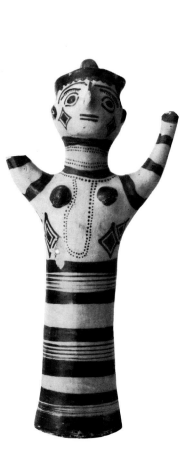

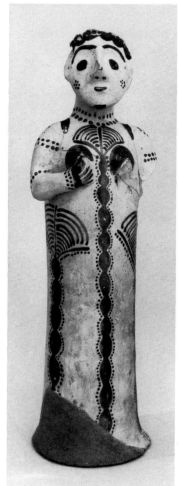

39 The little goddess from the Shrine. LH IIIB. Ht 29 cm.

40 Goddess holding her breasts. Found in the temple. LH IIIA. Ht 33 cm.

she would appear to belong to the same group of small figures found in the temple area, of which the most enchanting example is the goddess holding her breasts. All these small idols, of which there are only four, are entirely different in kind from the large, rather forbidding figures associated with the temple. The latter are painted monochrome except for some reserved areas about the face, which have the effect of accentuating certain features. The former are painted with designs used in pottery and for this reason can be more closely dated. The goddess from the shrine is decorated with motives prevalent in the second half of the thirteenth century. The lady clasping her breasts is earlier; the style of the decoration on her dress belongs to the end of the fourteenth century.

40

Immediately to the east of the temple and at a much higher level is a great hall, a megaron. It is a long building of two rooms, the larger one of which has a square hearth. On it was found thick ash and thin broken slabs that had fallen from above. A good deal of the fine plaster floor of

41

59

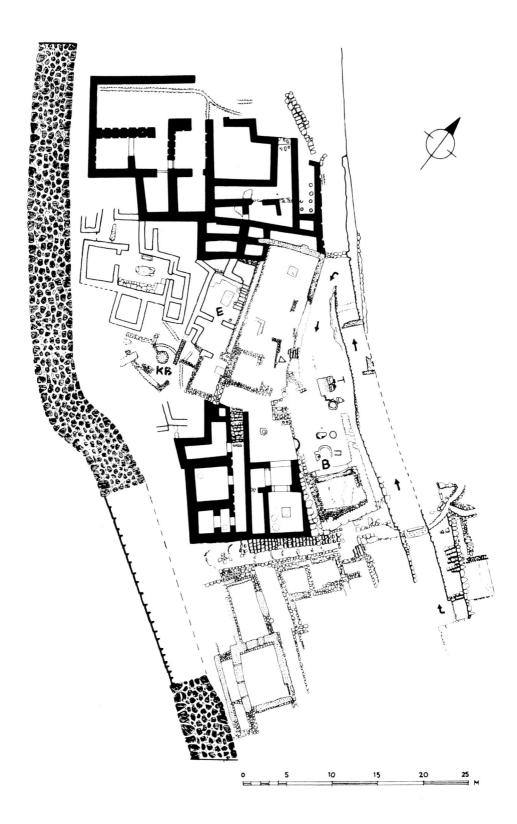

E

KB

B

0 5 10 15 20 25
 M

the room is preserved. Unfortunately, nothing was found in it except destruction debris but it undoubtedly was yet another cult room. It adjoins the broad plastered ramp that leads down from the north to the shrine in the Tsountas House. This was a processional way, or rather one of two processional ways, that converged on what Mylonas has rightly called the Cult Centre of Mycenae. The one from the north, starting from the Ramp House, passes up an impressive ramp edged with poros blocks and continuing through a long, well-proportioned corridor furnished with wide doors at either end emerges at the plaster ramp referred to above. At this point it meets another equally broad ramp and of the same good quality surface descending from the south and skirting the Tsountas House shrine on the east. The upper stretches of this road would take a zigzag course up the steep slope of the acropolis and undoubtedly finish up at the palace. Mylonas's excavations have recently uncovered the last section of this road on a higher terrace. It consists of a monumental staircase, partly preserved, which at its south end makes a sharp turn to the north and proceeds through a small vestibule to a gateway, the entrance to the Cult Centre and the start of the processional way descending from the south. The gateway being of wood has not survived, but its position is marked by a great conglomerate threshold and part of a fresco with a chariot scene is preserved on the east wall of the vestibule to the south.

The excavations that Mylonas executed to the west of the Tsountas shrine have revealed other new aspects of the Cult Centre. To the southwest of the temple a round altar, 1.40 m in diameter, has been brought to light with a quantity of ashes around it. It fronts on to the southwest entrance of the temple. Some kind of stone structure encloses it on the west side. Mylonas has also cleared an area to the south of the lower terraces of the Tsountas House and uncovered a room that he believes could have been for the use of the high-priest. Part of a magnificent fresco of a lady was found on the topmost layer of the LH IIIC fill of the room. The whole Cult Centre was destroyed at the end of LH IIIB.

If the discovery of this group of idols was the first to have been made on the Greek mainland, other similar finds were to follow. In nearby Tiryns the German excavations in the lower fortress have uncovered a small shrine of the Late Mycenaean period, in which were found very similar but smaller terracotta figures. More recently excavations led by Professor Colin Renfrew at Phylakopi on the island of Melos have revealed two sanctuaries. One is of considerable size (6.6 × 6.0 m). It is the older of the two and was built in the middle of the fourteenth century but both were in use in the thirteenth century and continued in existence till the end of the Mycenaean period (1100 BC) when they were destroyed. A unique feature, previously only known from representations on seals, is a rounded *baetyl* stone in front of the entrance to the large sanctuary. Within this building there was an altar in each corner except in the southeast. With the southwest one were associated five male figures; there is no doubt about their sex as the male genital organ is prominent. Like the female figures at Tiryns they appear to belong to LH IIIC. But a more important and outstanding find was made in a narrow room attached to the west side of the large

41 The Cult Centre of Mycenae. On the right is the processional way descending from the summit of the acropolis. B=The Tsountas House shrine. E=Temple. To the east of it is the Megaron, to the west the Room with the Fresco. KB=Round altar discovered by Mylonas.

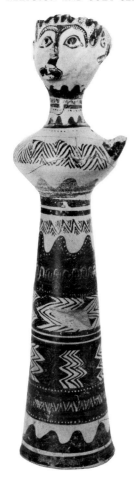

sanctuary. Here was found an idol 45 cm tall of the same category as those found at Mycenae. She is finely and elaborately decorated in a style that can be dated to the fourteenth century. There were many other important finds from this excavation, among which should be mentioned terracotta bulls that had some cultic significance. One example was also found in the Tiryns shrine.

We now turn to a different and much smaller class of figure. These are the little clay figurines that are found in thousands all over Greece and even in areas further afield where Mycenaean influence penetrated. The most frequent subject is a standing woman. Although they undoubtedly have a religious significance there is no agreement as to the interpretation to be placed on them. They are often found with child burials and so some scholars regard them as divine nurses for the protection of the child on its last journey. Others see them as toys, and perhaps the animal figurines (mostly bovine) and stylized chariot groups could be interpreted in that way. But great quantities, and perhaps the larger number, of these figurines occur in settlements. When they are found in sanctuaries one must suppose that they had a deeper religious meaning, particularly those with a more individualistic character such as a seated figure (sometimes represented by an empty throne), a woman carrying a child; and the larger figurines found at Delphi and Epidaurus may have been cult statuettes. The earliest examples known, not many, belong to the first phase of LH IIIA. They are abundant in the thirteenth century. They start quite suddenly without any apparent progenitors (Crete being a possible source. Figurines are common there in Middle Minoan, but seem to be rarer in Late Minoan). At first the modelling of them is almost naturalistic. After that there is a progressive development in stylization; the arms that were once modelled free are brought close to the body. In a further stage the upper part of the body becomes a disc, the head an appendage, and the lower part a column, so that the shape resembles the Greek

42 'The Lady of Phylakopi' from a newly excavated sanctuary on Melos. Ht 45.1 cm.

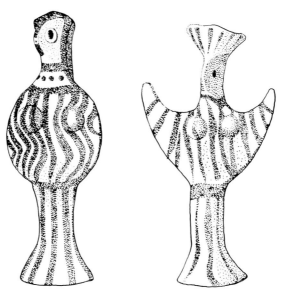

43 Phi and psi figurines.

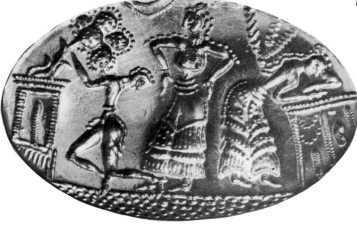

44 (*Above left*) Gold-plated silver ring from Mycenae showing women worshipping before a rustic sanctuary.

45 (*Left*) Gold signet ring from Mycenae. The tree cult features prominently in this orgiastic scene. Diam. 2.9 cm.

46 (*Above*) Gold ornament representing a shrine, from Grave Circle A.

letter φ. In the last stage the arms are extended to form a stylized crescent and the shape calls to mind the letter ψ. These figurines show obvious points of similarity with the large figures discussed above.

Besides the palace and domestic shrines there were also rustic sanctuaries. These are only known from representations on gem-stones and signet rings. The Tree cult figures prominently among them and the scenes associated with it can generally be interpreted as vegetation rites. A tree or a sacred bough is often shown within a precinct attended by worshippers, sometimes in calm adoration, sometimes in ecstatic dance. Or a tree may stand beside a shrine and so represent a sacred grove, the seat perhaps of an oracle as at Dodona. The worship of a deity in the form of a column, pillar, or *baetyl* also takes place in rustic shrines, sometimes in association with the Tree cult, but on the Greek mainland the column is more often portrayed as a structural part of a shrine; and in the well-known models from the Shaft Graves of a palace sanctuary three columns are shown in a building crowned by horns of consecration. In such cases the column may stand for the sanctity of the building rather than a divinity; so also when it is heraldically supported, as in the famous Lion Gate relief.

44

45

46

96

47

48

This dual function, religious and secular, applies to other objects used. Certain vases, notably a particular kind of libation jug shown in cult scenes, may have been intended for ritual use only, but the funnel-shaped rhyton, or filler, certainly had a practical as well as religious purpose; so also the table of offering. Definite cult objects, or rather symbols, are the horns of consecration and the double axe. The former seem to have been a sanctifying symbol. They appear frequently in cult scenes. Placed on altars and on the entablatures of shrines, they enclose within their arms cult objects such as the sacred bough, the libation jug, and the double axe. Many conflicting interpretations are put forward concerning the double axe and none of them is altogether satisfactory. In Mycenaean religion it appears to have had no significance. On vases it was probably decorative, and carved on stone blocks it could be a mason's mark.

The survival of the Mycenaean religion into Classical times is borne out in many ways, but of particular interest is the continuity of habitation at the great sanctuaries, and there is some evidence of cult continuity also. Traces of animal sacrifices, figurines, and part of a rhyton in the shape of a lioness's head were found beneath the great temple of Apollo at Delphi. No Mycenaean pottery has yet been discovered within the sacred precincts of Olympia but Mycenaean tombs have been excavated in the vicinity. Beneath the most sacred area at Eleusis, the telesterion, there was a building of some importance which may have had religious significance. And at Amyklaion near Sparta the throne of Apollo stood on a base which contained the tomb of Hyakinthos, a pre-Greek god who from the votive offerings of figurines appears to have been venerated in Mycenaean times.

47 Gold signet ring from Tiryns showing 'demons' bearing libation jugs.

48 LH IIIA rhyton or filler.

4

Tombs of kings and commoners

The earliest graves of the Mycenaean age show little change from the types already developed in the Middle Helladic period. There are two varieties: a shallow pit dug in the soft rock and just large enough to hold the contracted body of an individual laid on his side; and an oblong grave lined with stone slabs, known as a cist grave. (Sometimes stones and the rock are substituted for the walls of the tomb and the grave itself may have a covering of slabs.) Usually only one vase is placed with the dead and very often none at all. 49

It is thought by many scholars that the much larger 'shaft grave' type which succeeds the cist grave is simply a development from it. Its most complete form occurs in the two Grave Circles at Mycenae. The shaft could reach a depth of 3 or 4 m. A layer of pebbles was laid on the floor to receive the body and the long sides of the tomb were lined with low rubble walls that provided ledges for the support of the wooden roof. After the roof had been placed in position, the deep pit was filled in with earth. Sometimes a carved stela or slab was set up to mark the spot. Certain of these graves were intended for a single individual but others are much larger (the largest is 6.4×4.5 m) and contained several burials, all presumably belonging to one family. Because of their rich contents they have merited the name of 'royal' graves. In Schliemann's Grave Circle (now known as A) there were six such graves containing from two to five skeletons each. Only Grave II had a single burial. There were also other smaller pit-graves within the circle. In Grave Circle B there were 24 tombs of which 14 could qualify as Shaft Graves. The contents of these, though spectacular, are not as rich as those from Grave Circle A; on the other hand B is a little earlier than A and dates from the beginning of the sixteenth century. In both Grave Circles there are instances of extended burial, a practice that seems to have started at the very end of, or shortly after the Middle Helladic period concurrently with the increase in size of the tomb. An unusual feature, not found before or after, are the gold masks that covered the faces of some of the dead. Five of these were uncovered in Grave Circle A and one in B. Certain aspects of these royal tombs – the unusual size of the graves, the wealth and quantity of the funerary goods, the gold masks, and one instance of alleged mummification – suggest that the parvenu Mycenaeans were trying to keep up with the Egyptians, who had set a fashion for grandeur in the Near East for centuries.

51, 52

116

50

frontispiece

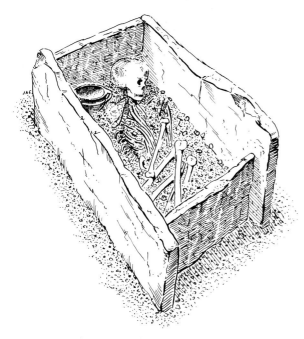

49 Middle Helladic cist grave.

50 Grave Circle A, viewed from the southeast. The enclosure wall is a later addition of the thirteenth century. The six Shaft Graves are in the west part of the Circle.

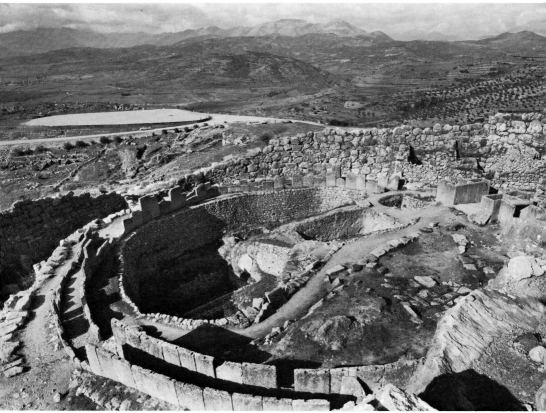

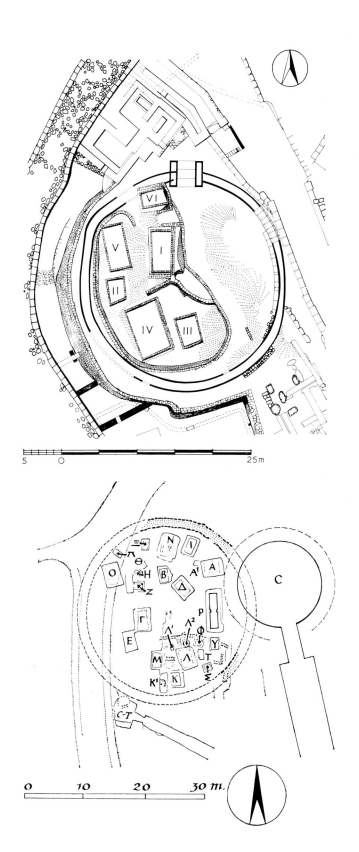

51 Plan of Grave Circle A showing the location of the six Shaft Graves.

52 Plan of Grave Circle B, partly destroyed by the later so-called Tomb of Clytemnestra.

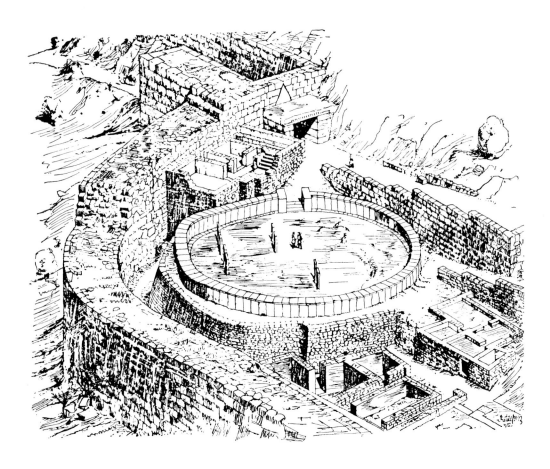

53 Reconstruction of Grave Circle A as it was in the thirteenth century.

Both Grave Circles were part of one great cemetery that reached right up to the foot of the acropolis. Later on in the thirteenth century, when the defences of the citadel were enlarged, Grave Circle A was still held in such veneration that it was separated off from the rest of the cemetery and incorporated within the extended Cyclopean walls at no little inconvenience to the defence. At the same time a new and more imposing enclosure wall was built at a higher level, which endures to this day.

53

Nothing comparable to these rich burials is known from other parts of Greece, though in the island of Levkas (northwest Greece) a tightly packed group of grave circles produced many rich finds. These are much earlier (Early Helladic), but one grave circle with a diameter of 12.10 m in the north part of the island belongs to the Middle Helladic period. Related to this form of burial and to the grave circles is the tumulus, of which quite a number have been discovered in recent years. No less than four in close proximity to one another were excavated by Professor Marinatos at Marathon. The diameter of the two largest is about 17 m. One of them contained eight tombs. The oldest tumulus is MH, the youngest LH IIIB. Tumuli are known from other parts of

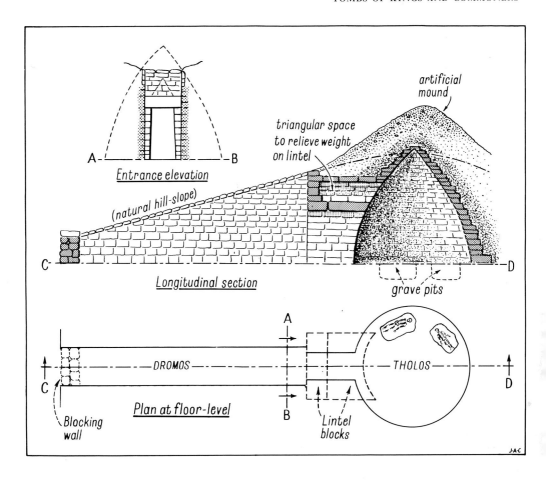

Entrance elevation

triangular space
to relieve weight
on lintel

artificial
mound

(natural hill-slope)

Longitudinal section

grave pits

DROMOS

THOLOS

Plan at floor-level

Blocking
wall

Lintel
blocks

Greece but the greatest number are found in Messenia and date from MH to LH I. The tombs are often stone chambers within the mass of earth and rubble making up the mound which is of no great height and normally has a surround of slabs.

54 Tholos tomb, section and plan.

The last interment in Grave Circle A is dated to about 1500 BC, but the custom of burial in shaft graves continued to about the end of LH II (*c.* 1400 BC). Shaft graves of LH I are also known from Eleusis and Lerna. Meanwhile an entirely different type of royal tomb succeeded to the royal Shaft Graves at Mycenae. This was the much larger tholos tomb. Round in plan and shaped like a pointed dome, it is usually built into the side of a hill (always, at Mycenae). The tholos was approached by a *dromos*, or long corridor, cut horizontally into the slope of the hill. (For a more detailed description see below.) The builders of these tombs at Mycenae are generally referred to as the tholos dynasty. Nine of these tombs have been discovered at Mycenae. They range in date from about 1500 to 1250 BC and show a steady advance in the technique of their construction until the culmination is reached in the magnificent monuments known as 'The Treasury of Atreus' and 'The Tomb of Clytemnestra'.

54

55–8

Recent research has shown that the tholos type of tomb is much older than was originally supposed. At one time it was thought to be later than the royal Shaft Graves, but only at Mycenae does this appear to be the case. The earliest example known is near modern Koryphasion in Messenia. The greater part of the pottery found in it belonged to the last phase of MH; it can therefore be dated to the early part of the sixteenth century. Tholoi are found all over Greece and to a lesser extent in distant parts of the Mycenaean realm. Well over a hundred have been excavated and the existence of many more is suspected. There is a special concentration of them in Messenia.

Concerning the origin of the tholos tomb there is as yet no general agreement. Circular tombs of one form or another are found over most of the Mediterranean and even further afield, but it is not always possible to date them closely. Some of those in south Spain are apparently very old, going back into the third millennium (according to recent carbon dating), but they are very much smaller than the Greek tholoi and poorly preserved. Others in the same area approach more nearly to the Mycenaean form, but are apparently later in date and therefore possibly influenced by the Greek model. Much nearer home, the island of Crete had a long tradition of circular tombs, the earliest of which can also be placed in the third millennium. Some of these tombs continued in use for a long time, even as late as MM III, a period that corresponds roughly to the last phase of the Middle Helladic and it is at that time that relations between Crete and Messenia were particularly close. It is quite possible therefore that the inspiration came from that quarter and a contributory influence could be the tumulus, which is found more frequently in the southwest Peloponnese than in any other part of Greece. Furthermore several tholos tombs in Messenia are built above ground, as in Crete, with a mound of earth raised over them. With the exception of certain tholos tombs in Euboea this practice was not adopted elsewhere as apparently it was realized that the mound provided insufficient pressure on the upper part of the tomb to counteract the outward thrust of the vault which consequently collapsed in most cases. Greater pressure was provided by the sides of the hill in which they were built.

In the construction of the earlier tholos tombs very small, undressed stones were used; they were selected for their flatness. The thickness of the wall in the smaller tombs may not be more than 91 cm. The lower part of the wall was normally built vertically, like a drum, up to about one quarter of the height planned for the tomb. Thereafter a vault was added on the corbelling system. This method had long been familiar in the Near East and in Crete. To create the curve of the vault each course of masonry is made to project beyond, or overhang, the one below. The topmost course of the vault is a single capping-stone. The space between the outer vault and the circular shaft in which the tomb was built was then tightly packed with earth and a mound raised over the point of the dome. With advances in building technique ever larger stones were used, and these were carefully shaped on the under surface to produce the curve of the vault. In the final development enormous blocks were used, and perfection was attained in the dome of the Treasury of Atreus. (Exceptionally, this tomb and the tholos at

55 'Treasury of Atreus'. View from inside the tomb. The entrance is on the right. The doorway on the left leads into a side-chamber. The diameter of the tholos is 14.9 m and its height 13.7 m.

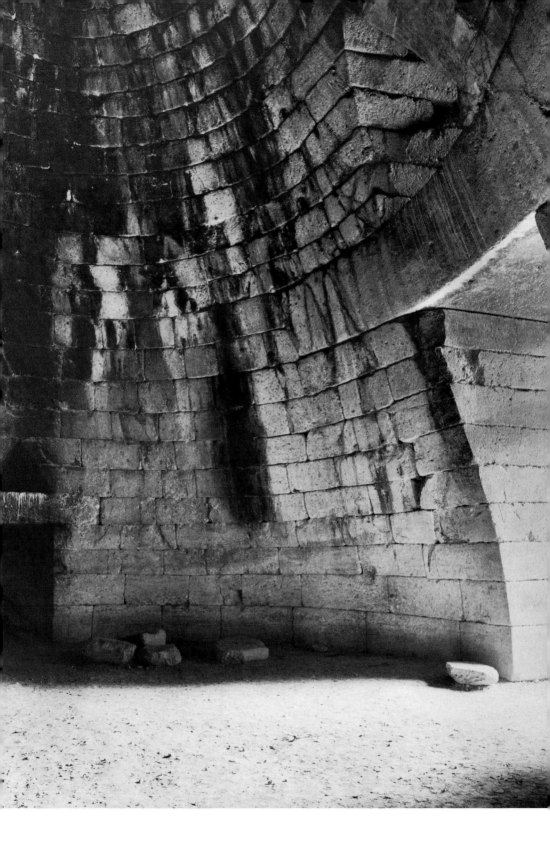

EPANO PHOURNOS KATO PHOURNOS

56 Evolution of the
doorway and dromos of
tholoi at Mycenae.

57 'Treasury of Atreus'.
Plan and section of
threshold.

CLYTEMNESTRA

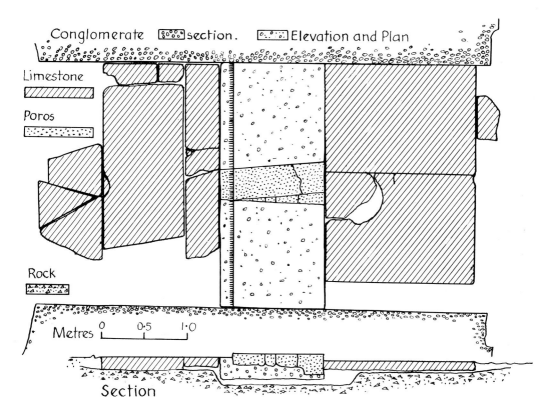

Conglomerate [∘∘∘] section. [∘∘∘] Elevation and Plan

Limestone

Poros

Rock

Metres 0 0.5 1.0

Section

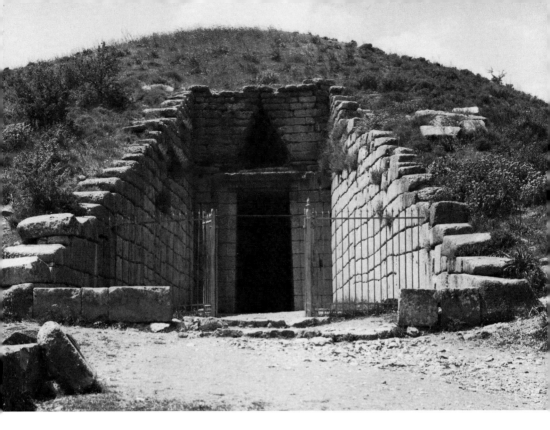

Orchomenos, described by Pausanias as the 'treasury of Minyas', have a side-chamber which was not vaulted.)

Two other components enter into the construction of a tholos tomb: the doorway and the dromos. Each shows development over the centuries and this is best demonstrated by the evolution traceable in the nine tholoi of Mycenae, although it does not follow that this evolution is valid for other parts of Greece. The lintels of the doorway associated with the earliest tombs, those built with very small slabs, are short and have no relieving triangles. This was a later development, the purpose being to deflect the stress from the superstructure on to the stronger piers of the doorway. (Nearly all the lintels in the early tholoi have crashed.) Stone thresholds are not found in the early period. In later tholoi structural improvements can be noted. The lintel is longer and often survives through the relief of pressure afforded by the empty triangular space above it, and the door jambs are built of solid ashlar masonry. Thresholds of sawn conglomerate are introduced. The one in the Treasury of Atreus is a model of exact fitting. As it was impossible to obtain a close-fitting of the threshold if made in one block, two pieces were used. Wedges of poros limestone were then inserted between the two conglomerate blocks and driven home to press them securely against the door jambs. The evolution of the dromos or passageway leading up to the tomb can be briefly described. At first, the corridor is cut in the rock and unlined by masonry. When it was found that the sides of the dromos often collapsed, later examples were lined with rubble. The final stage is to be seen in the magnificent approaches to the later tholos tombs, when ashlar conglomerate was used.

58 Dromos and doorway of the 'Treasury of Atreus'. The doorway is 5.5 m high and 2.75 m wide at the base.

57

56

66

58

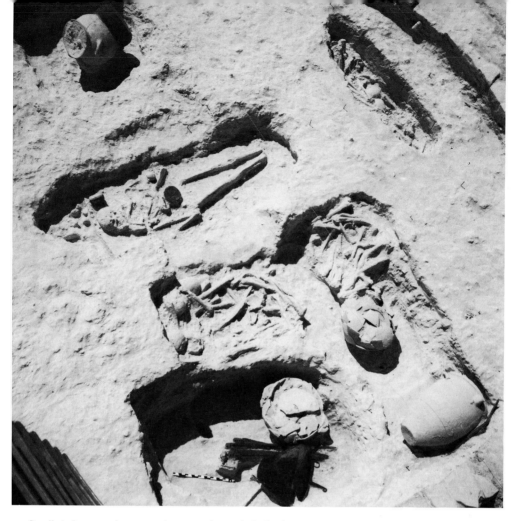

59 Small tholos near the Palace of Nestor. Only the foundations of the dome remain. The collapsed Palace Style jar is in the foreground.

At an early period the importance of keeping moisture out of the tomb was realized, for the seepage of water into the joints very quickly undermined the structure. To counteract this danger at Mycenae, layers of *plesia*, a waterproof clay extant in the district, were alternated with earth in covering the dome. Three such layers were used for the protection of the vault of the so-called 'Tomb of Aegisthus' (fifteenth century); even so the vault collapsed. The latest tholos at Mycenae is the 'Tomb of Clytemnestra' of the thirteenth century. Many centuries of architectural knowledge are incorporated in this monument. And in 1952/3 a new feature was revealed. At that time Professor Wace uncovered a curving wall of very handsome appearance that formed an arc to the east of the 'Tomb of Clytemnestra'. This was the retaining wall, built of poros, which served to support the mound over the tholos.

64

(Traces of a similar retaining wall have been found for the Treasury of Atreus.) Furthermore, there is evidence that a white coating of plaster had been used for the top layer of this mound, an unusual and striking form of embellishment. This tomb, therefore, may have been the one that Pausanias describes as the tomb of Atreus, head of the house of Atreidae and father of Agamemnon. (He was already familiar with the earlier tomb which, because it was open, he described as a treasury.)

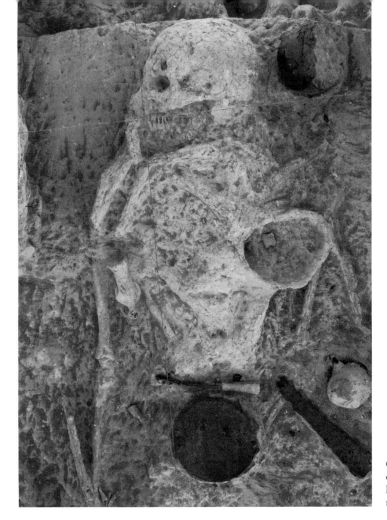

60 Extended burial in the centre of the tholos, the last to be laid out in the tomb.

Alternately, as only relative and not absolute dates can be given for these tholoi, the 'Tomb of Clytemnestra' could be that of Agamemnon and the earlier tholos that of Atreus, with whose name it is traditionally associated.

Our knowledge of the burial customs in tholoi is limited, as nearly all of them had been plundered in ancient times. A welcome exception to the rule was a small tholos in the vicinity of Nestor's palace at Pylos. Its 59 miraculous escape from the tomb robbers may have been due to an early collapse of the structure (probably in the fourteenth century) and its subsequent loss of identity in later, unsettled times. The tomb, 5.5 m in diameter, contained a large number of interments (about 23). Four of the burials, the earliest, were placed in pithoi or storage jars; this is a custom that occurs sporadically in Greece in the late Middle Helladic period and usually in tumuli, but was quite common in Crete at that time. One of the burials was in a spouted jar of Cretan form. The bones of another interment were placed in a Palace Style jar (see p. 23). This 5 same custom may have been used in a tholos at Kakovatos, some 40 miles farther north up the coast. There fragments of several Palace Style jars were found and, scattered about the tomb, a quantity of bones.

60

61 LH II/III figurine
found upside down on
the chest of the skeleton
shown in ill. 60. Ht 11.1
cm.

62

63

The other burials in the Pylos tomb, with the exception of the last one, were crammed into pits dug for the purpose. This is a common Mycenaean practice, for where space is limited, there is no alternative if there is to be adequate room for the solemn obsequies of the last deceased. In the present instance the final burial was laid out at full length in the middle of the tomb and with him were placed those objects dear to him in life: a dagger by his left side, an arrow shaft between his legs, a small bronze bowl at his head, a bronze mirror on the lower abdomen (for mirrors were equally popular with men), and a small vase, perhaps containing ointment, by his side. On his chest there was a bronze awl with an ivory handle, and a female figurine. As none of the pottery from this tomb is recognizably later than the transition period LH II/III (*c* 1400 BC), this is one of the earliest Mycenaean figurines known.

The grave goods of the pithos burials are interesting. With one of the older jars, painted in a MH tradition, there was a shallow cauldron, a rapier, a dagger, all of bronze; a fragment of a gold leaf circlet was found at the bottom of the jar. With another jar, also painted in MH style, there were four rapiers, two flint arrowheads, and a deep cauldron containing a number of bronze implements. Within the jar and mixed up with the bones were several long bronze pins, perhaps used for pinning the shroud, and a fragment of a silver vessel with a repoussé design. The spouted jar of Cretan design only contained a terracotta cup of Vapheio style, but close by were three rapiers and two daggers. The fourth jar of Palace Style, and therefore latest in date (fifteenth century), contained nothing but the skeleton. Two of the pits for the rejected skeletons were devoid of grave goods, but one of them contained six daggers and three fragments of gold foil which made up into a handsome diadem. It is a very much smaller version of the magnificent examples uncovered in the Shaft Graves of Mycenae. Many of the weapons, in fact, found in this tholos find their counterparts in the Shaft Graves. The tomb seems to have been used for about 150 years.

The contents of this tholos have been described at some length because it is one of the few that has escaped comparatively intact. It was not a rich tomb but must have been representative of the status of the princely family living in that district. Two other tholoi that partly escaped the attention of the plunderers give some indication of the great wealth that was deposited in these tombs. One of these at Routsi, not many miles distant from the Pylos tholos, was excavated by Professor Marinatos; as well as a great number of finely carved gems it produced several beautifully inlaid daggers that bear comparison with those found in the royal Shaft Graves. The other tomb, at Dendra (ancient Midea), not far from Mycenae, was excavated by the Swedish School. Two pits that had been overlooked by the tomb robbers contained treasures remarkable for their splendour. This tomb also illustrates an apparent distinction in burial custom between the southwest and northeast Peloponnese. Although the tholoi around Mycenae have all been robbed and have only the grandeur of their monuments to convey the riches that they once held, they appear to have contained but few burials; in other words, each tomb in the

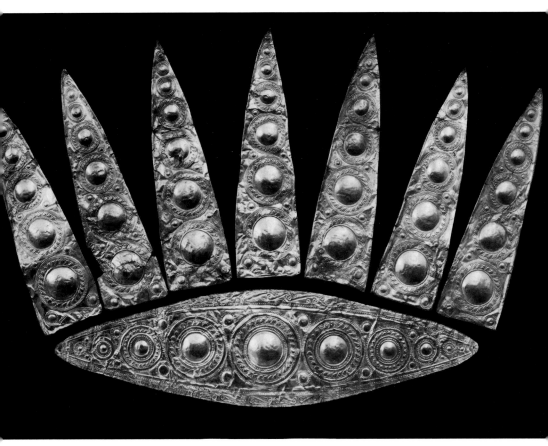

62 Gold diadem from Shaft Grave III, Mycenae. Width 66 cm. Its large size would have made it awkward for a living person to wear.

63 Inlaid dagger blade from a tholos at Routsi, Messenia. Length of blade 25.4 cm. It bears comparison with the famous dagger blades from Grave Circle A at Mycenae (ill. 111).

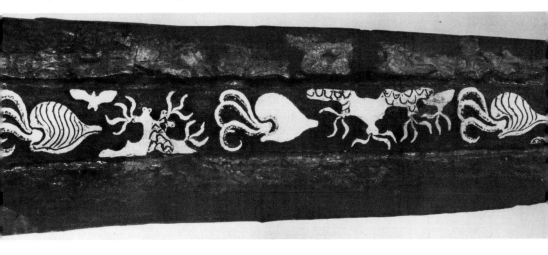

northeast Peloponnese seems to have been prepared as the last resting place for a single king, his consort, and perhaps a favourite child. An exception to the rule may be the so-called Lion Tomb at Mycenae, where a semicircular pit along the wall of the vault could have contained the discarded remains of earlier burials. In Messenia, on the other hand, the tholoi were family vaults built to receive many generations. At Mycenae no tholoi appear to have been built after the mid-thirteenth century, but elsewhere in Greece they continued in use to the end of the Mycenaean Age, and in Thessaly and Messenia tholoi, though much smaller in size, were being raised as late as the Protogeometric period (tenth century BC).

Only an abbreviated and largely hypothetical account can be given of the funerary rites in a tholos at the death of a royal personage. The great vaulted tomb was probably to be seen in all its splendour when it was opened to receive the first royal funeral. If it was held in the Treasury of Atreus, the procession of mourners would move slowly up the long dromos, the walls rising higher on either side of them as they penetrated into the heart of the hill. Before them towered the tremendous doorway with its intricately carved entablature and the tall half-columns flanking the entrance to the tomb. The great bronze doors with their gilded bosses would be swung back to receive the cortège and in the dim light the vault with horizontal bands of bronze would gleam with a thousand gold rosettes. Spread out on the earthen floor was a carpet of gold to receive the body of the king, arrayed in his robes of state, crowned with his diadem, his seals of office attached to his wrist, and his favourite dagger at his side. Around him would be laid

64
58

65

64 'Treasury of Atreus'. Isometric view.

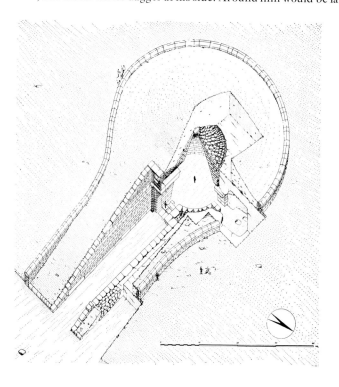

the vessels of food, the flagons of wine, jars of oil and unguent, and all the necessities for the sustenance and care of the body on his last journey. Weapons of war would be added too: swords, rapiers, daggers, and spears, the mighty figure-of-eight shield, the well-stocked quiver, and the bow. One rapier has a special task to perform. It is taken from the pile and to the words of a solemn incantation the blade is bent so that its spirit may be released and be swift to do battle for its master, should threatening demons bar his way. Then the signal is given for the

65 'Treasury of Atreus'. Reconstruction of the façade of the doorway.

79

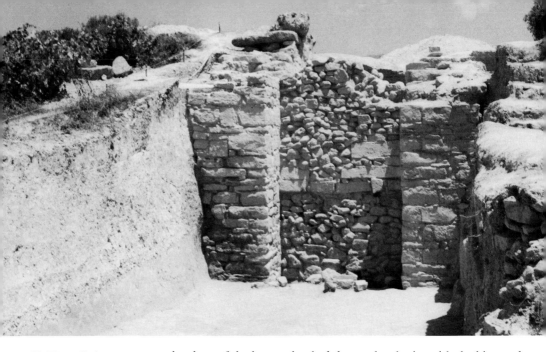

66 The walled-up
doorway of a tholos tomb.
The entrance was sealed
after each burial but the
wall was only partly
dismantled for later
burials (as far as the
horizontal layers of great
ashlar blocks).

slaughter of the horses that had drawn the chariot with the bier, and
that have been fidgeting nervously in the dromos, apprehensive of the
doom that awaits them. There follows the slaying of the rams and other
sacrificial beasts within the vaulted tomb itself. The fires are lit, the
sacrifices roasted, and all partake of the funeral banquet. In the still
glowing embers the mourners cast their last tributes to the dead, and
then withdraw. After the great doors have been closed the masons can
begin their work of sealing up the entrance. The mourners would have
to tread with care around the slaughtered horses, now carefully laid out
to face one another in death; only with difficulty can they make their
way through the serried ranks of slaves that line the dromos, and as they
come out into the unwonted light they see other slaves silhouetted on
the dromos walls and behind them banks of soil. A few large blocks of
stone have already been placed in position at the entrance to the long
corridor, for the filling in of the dromos is about to begin.

66

The above is naturally a composite picture embroidered with
fantasy, and it embodies customs that were not carried out at every
funeral. For instance, we have only one record of the slaughter of horses
in the dromos. That was only recently brought to light in the re-
exacavation of the dromos of a tholos tomb near Marathon. The
episode of the bent rapier was taken from the unplundered tomb at
Pylos – though it must be admitted that there is no real evidence for this
custom as practised in other cultures – and the gold carpet from the
large pillaged tholos near the palace.

66

Second and subsequent burials in the same tomb would have been
far less impressive. If the death was sudden and in the height of
summer, even a host of slaves working feverishly could not clear the
dromos and dismantle the stone blocking wall in time. Instead, the
dromos was partly cleared to form a ramp and only the upper part of the
blocking was dismantled. The cortège would have to walk up the ramp
and descend by ladders into the tomb. The atmosphere in the vault
after a long passage of time cannot have been pleasant. Hastily fires

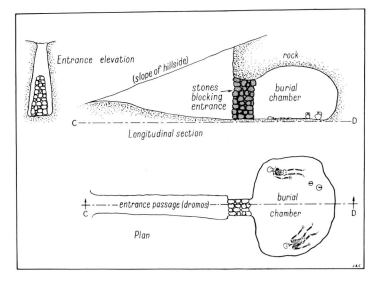

67 Chamber tomb. Section and plan.

would have been lit and aromatic perfumes burnt to sweeten the air in preparation for the next solemnity. All must be made ready to receive the new burial, and so the remains of the former tenant are gathered together and placed in a hurriedly dug grave near the wall of the vault. A lot of petty pilfering must have taken place during these preparations in which so many people would be busily engaged; and nobody would protest if some members of the family removed different precious articles, which they might claim were once their own. This is to record but human foibles. At an earlier period the sanctity and awe in which the kings of the Shaft Graves were held was no doubt sufficient to avert such spoliations.

If the second sepulture lacked the dignity of the first, later ones must have been even more macabre. Apart from having to scramble in and out of the tomb, there was an increasing lack of space as each new burial was deposited and former interments thrown aside. Extra pits would be dug or existing pits crammed with the latest skeleton. That is the unpleasant picture left by the little tholos at Pylos. Time has softened the outlines, but the crude reality remains.

The burial customs described above were not confined to royal tombs alone. They were general in all classes of society and throughout the whole Mycenaean age. Only the style of sepulture varied. The poorest section of the community could but afford the simple grave of their Middle Helladic forefathers, whereas for the nobility and wealthier classes burial in a chamber tomb was almost universal.

The use of chamber tombs starts in LH I but in Messenia a little earlier. According to some authorities they are copied from the rock-cut graves of the Middle Kingdom in Egypt. Others would derive them, more convincingly, from Crete. In Messenia some of the earlier examples of chamber tombs are not unlike a small version of a tholos, reproducing the circular form and even the pointed dome. But 67 normally the plan is roughly square or oblong with rounded corners. Like the tholos, it is excavated in the side of a hill and approached by an

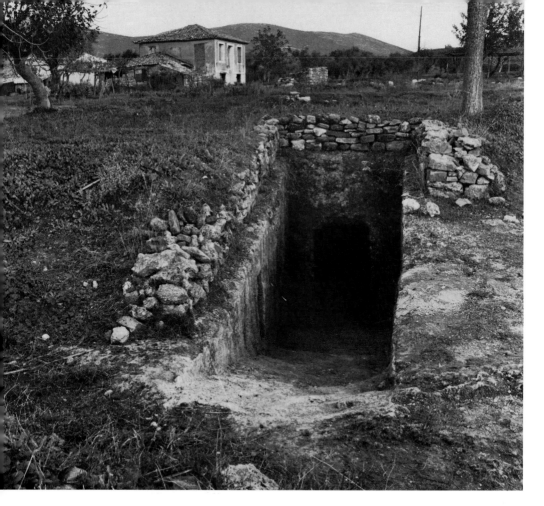

68 The dromos of an LH
I/II chamber tomb.

open corridor or dromos which was filled in after the burial; but the
important difference, apart from size, is that no masonry is used except
for walling-up the door to the chamber or for reinforcing weaknesses in
the rock structure. To avoid the danger of collapse the roof is normally
slightly hipped, but this precaution was often unavailing. The walls of
the dromos usually were inclined inwards, the width of the passage
being narrower at the top than at the bottom. This same feature was
sometimes reproduced in the doorway which therefore resembled the
entrance to an Egyptian tomb. The floor of the dromos sloped down
68 towards the chamber. In LH I and II the dromos is usually short and
wide, its incline steep, and sometimes it is stepped. In LH III the slope
is gentle and the corridor could be more than 30 m in length.

Chamber tombs were family burial vaults and, as with the royal
tholoi, they were reopened for each successive burial. The deceased
was laid in the centre of the tomb, usually on his back, his head
sometimes supported by a stone pillow. He was buried fully clothed
apparently, as buttons are sometimes found on the skeleton. Apart
from personal belongings, the grave furniture usually included a
number of vessels, mostly of clay. At the next interment he would be
69 laid to one side, if there was room, but as the tomb filled up, the earlier
occupants would be disposed of in pits. Sometimes a side chamber, if it

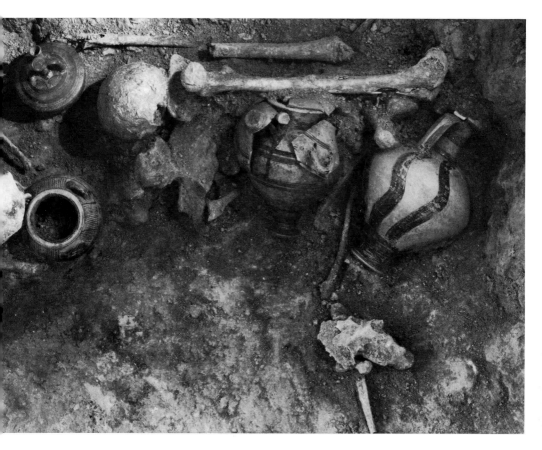

existed, would be used as a charnel house. Occasionally former burials were relegated to a niche cut in the walls or a pit dug in the dromos. The most desperate measure was to clear out the whole of the chamber, throw the bones into the dromos, and start afresh. This may have happened in cases where the tomb was taken over by a collateral branch of the family or by an entirely new family. But often nature would lend a hand. In many cases disintegration of the roof laid a pall of débris over the floor and, instead of clearing this away, some families would choose to place the burials on top of this layer. Over a long period of time the level of the 'floor' would almost reach the roof! Such cases provide admirable stratification for the archaeologist and sound dating evidence. The restrictions of space would not allow an elaborate ritual within the tomb, even when it was new. Some sort of ceremony took place in the dromos, for almost invariably a large number of kylikes (drinking cups), purposely broken, are found in the corridor. This suggests that libations were poured to the dead. There is also evidence of a funerary feast. After the last rite had been performed, the door of the tomb was walled up and the dromos filled in. As it would have to be cleared again for a new interment and the wall taken down, it is presumed that a stone marker was placed above the tomb for identification. None have been found, but in one case at least a small

69 An unplundered chamber tomb near the Palace of Nestor. Skeletal remains of an earlier burial laid aside with its grave goods. LH IIIA/B I.

70

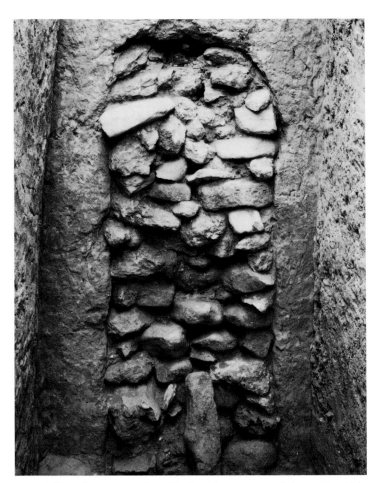

70 The blocked-up doorway of the tomb shown in ill. 69 with a small rough pillar at the base of the wall, possibly a 'marker'.

rough pillar of stone was placed before the entrance of the tomb within the dromos itself. It may have signified that no further burials were to be laid there, for the tomb was found intact and it contained but three burials.

The last solemn rites that were performed at a burial are in strong contrast to the callous disrespect shown to earlier interments. Professor Mylonas has advanced a plausible theory to account for this. In his opinion the soul of the deceased only remained attached to the grave so long as flesh and bone stayed together. Once the flesh dissolved the spirit was released from this world never to return to it again. The funerary gifts were partly intended to placate the dead person during the period of waiting. They were also needed for the journey to his final abode; but once he had reached his destination, an event that was signified by the disintegration of the body, both bones and gifts could be treated with impunity. These beliefs are perhaps not so far removed from the later Classical conception of Hades, the melancholy land of shades that knew neither joy nor sorrow, a belief so ingrained in the Greek temperament that traces of it survive even into Byzantine Christianity.

5
Citadels, palaces and houses

The plan of the nucleus of a Mycenaean palace derives from a Middle Helladic model of uncomplicated design: a long room, preceded by a vestibule on its short side. In front of the vestibule of this early model there was no doubt a porch of primitive construction, such as is found with many village houses in Greece today; that is, a trellis framework supported on two posts, with a vine or some creeper for shade. In the Mycenaean palace these features took the form of a columned porch, leading into a vestibule and thence into the main room or megaron. Frequently the Middle Helladic house had another room at the back, which was used as a storeroom and had its own separate entrance, a feature reproduced in Nestor's palace at Pylos. A fixed hearth, sometimes round, is usually found in the living rooms of MH and LH houses. In the Mycenaean palace it was of great size and occupied the central part of the megaron. Arranged symmetrically around the circular hearth were four round column bases, often of a hard blue limestone. The size of these indicates that they supported tall wooden columns of great height and strength, sufficient to raise the central part of the roof above the rest of the room and thereby create a clerestory. At Pylos the remains of two pipes of a great terracotta chimney were found above the hearth, but in humble dwellings there would probably be a smoke-hole.

71

75H

76

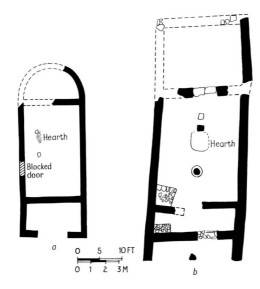

71 House plans at Korakou. *a* Middle Helladic; *b* Late Helladic.

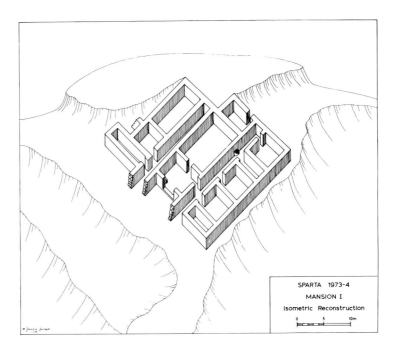

72 Mansion I. The Menelaion, Sparta. Isometric reconstruction.

No palace of the LH I/II period survives. The nearest approach to one is a partly excavated building of LH I date at Peristeria in Messenia which has a more sophisticated plan than the standard MH megaron and includes a courtyard. The remains of earlier walls were found under the palace of Mycenae but no plan can be reconstructed from them. Associated with them were fresco fragments of the earlier period. Other fragments of the same date were found under the LH III palace at Tiryns. At Iolkos a lateral excavation near the base of the acropolis uncovered projections of walls that are thought to have been part of an LH I/II palace. The earliest palatial-style building that we know, however, was discovered in the last few years in Laconia close by the Menelaion, a shrine dedicated to Menelaos and Helen. This is on a hill 1.9 miles east-south-east of Sparta. The site had previously been partially excavated by the British School in 1910 and the remains of a LH IIIB house uncovered which had been destroyed by fire. The latest excavations revealed some MH walls that were so badly eroded that no plan of them could be restored. There were no remains of the LH I and IIA constructions, but these appear to have been monumental to judge by the poros blocks re-used in the subsequent building which from the pottery could be dated to LH IIB/IIIA I (c. 1400 BC). Its plan recalls that of the Palace of Nestor: a megaron with a room at the back and rooms on either side separated by a corridor. It probably had a second storey – one room may have been the well for a wooden staircase – but it had no hearth or column bases, though one was found out of context a short distance away. This mansion, if not a palace, appears to have been destroyed by an earthquake; one end of it collapsed over the side of the scarp. Its successor had a similar plan but was built on a different axis and away from the edge of the scarp. It is dated by an Ephyraean krater

75
72

and LH IIIA1 pottery found in its foundations. It was abandoned for no known reason for 100 years and was not reoccupied until LH IIIB2.

73 View of the island of Sphaktria from the Palace of Nestor, Pylos.

The palace of Mycenae, as chief city of all the principalities of Greece, would have been the most resplendent of all the royal residences. But it has suffered not only from the hand of the despoiler; its superb, commanding position on the crown of the acropolis has exposed it to the merciless elements and they have not spared it either. The foundations of the megaron, vestibule, porch, and courtyard indeed survive in part, but of important buildings higher up there is scarcely a trace and later builders have stripped every stone to the bare rock to construct an Archaic temple or a Hellenistic house. Tiryns was one of the lesser Mycenaean kingdoms, and yet the grandeur of the palace plan is more to be discerned there than at Mycenae. But for the fullest exposition of residential plan and administrative office one must turn to the palace of Nestor at Pylos.

Unlike the citadels of Mycenae, Tiryns, and Athens, the capital city of Nestor is not confined within the rocky bulwarks of an acropolis. Its defences compared to theirs are minimal. From the sea and a narrow fertile plain the ground rises gradually and not too precipitously to a flat-topped eminence that unobtrusively asserts its superiority over the neighbouring hills. Set back from the sea to avoid surprise attack, the city commanded an extensive view; a great part of the coast to the west came under its eye as well as the hinterland rising to the mountain barrier of Aegalion to the east. The modern approach to the site may not impress the visitor as do the menacing and towering walls of Mycenae and Tiryns, for it is tucked away from the road in an olive grove, now sadly decimated by the excavations. Only the lower courses

82

21

80

73

74

87

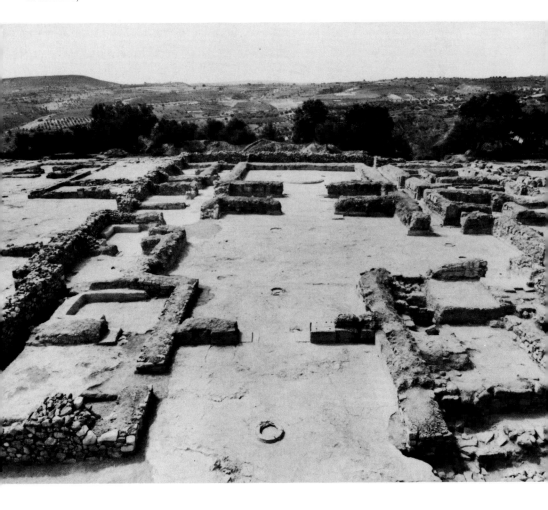

74 The Palace of Nestor from the southeast. In the foreground the propylon with the archives room on the left. The royal apartments are beyond the court. The queen's apartments are on the right.

96

97

are to be seen today, but in ancient times the lofty walls of the palace would be visible from afar. The approach was through a building not unlike the Classical propylon in plan, a gateway with an outer and inner porch, each supported by a single column. As in all Mycenaean palaces and buildings, private or public, the columns were usually of wood and consequently do not survive, but the form of them is known. At Mycenae there was considerable variety. The stone half-columns from the tholoi are either fluted ('Tomb of Clytemnestra') or have a zigzag pattern (Treasury of Atreus). In the Lion Gate relief the shaft is plain and tapers towards the base (in contradistinction to the column of the Classical orders). This is usually the type that is reproduced in the miniature ivory columns found in the House of Sphinxes. These same ivories show capitals that vary from the simple prototype of the Doric echinus to the elaborate and sophisticated form of the sixth-century Archaic capital from a Treasury at Delphi, which indeed is fore-shadowed in the Mycenaean ivory models. Whatever the form of the capital at Pylos, the column–shaft is almost invariably fluted; the

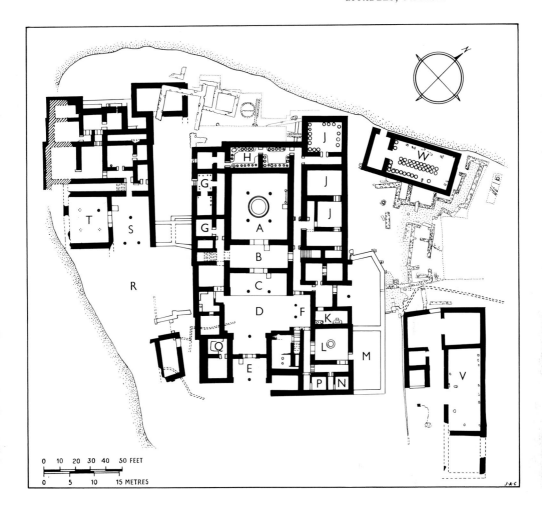

number of flutes varies from 32 to 64. This evidence arises from the continual replastering in ancient times of the collar at the base of the shaft; the perished column has left its impression in the plaster surround.

On the right, as one entered the gateway, was a room that seems to have been for the use of the guard; a low platform immediately to the left of the door indicates the position of the sentry's stand. The rooms to the left of the gateway were for the archives. Here were kept records of daily transactions: the share of produce due in taxes to the royal household, or to the gods: the allotment of materials, manpower, and so on for the many tasks of government. The entrance to the palace was a convenient control point for the execution of daily business. So at Mycenae the Granary by the Lion Gate may have served the same administrative purpose.

If one was an honoured guest at Pylos, one would be taken across the court to a waiting room that was immediately to the left of the porticoed entrance to the royal apartments. Here there was a white stuccoed

75 Plan of the palace, Pylos. A=megaron; B=vestibule; C=porch; D, M, R=courts; E=propylon; F=columned porch; G=pantries; H, J, W=storerooms; K=bathroom; L=queen's megaron; N=boudoir; P=lavatory; Q=archives room.

bench filling one corner of the room, the vertical face of which was painted with some pattern, now mostly effaced. There were also two large pithoi, both of which may have contained wine, for next door there was a pantry well-supplied with drinking cups (kylikes). There must have been a lot of woodwork in this pantry, probably cupboards and shelves, since here the fire that finally destroyed the palace was so intense that it melted some of the pottery to a mass of green glaze! The waiting room, whether wine was served or no, must have been a place of ritual preparation for any guest about to enter the presence. Ablutions and libations would probably form part of the ceremony.

The layout of the state rooms shows that they were well adapted both for solemn occasions and for the practical management of everyday affairs. The porch and vestibule were richly adorned with frescoes, and here a favoured guest might be offered rest for the night. 'Nestor of Gerenia bade Telemachus, the dear son of godlike Odysseus, to sleep there on a corded bedstead under the echoing portico.' The contrast on moving from the wide but shallow vestibule into the well-proportioned columned hall of the megaron must have made a deep impression. One's gaze was immediately drawn to the four tall, fluted columns
76 upholding the lantern or clerestory over the great circular hearth with its painted border. The fire, burning low, would add motion to the many coloured spirals that followed one another round the verge in an unbroken ring. We do not know what decoration, if any, was applied to the ceilings above the aisles, but special care was devoted to the embellishment of the floor. The plaster surface was methodically, but not too accurately, divided off into squares of which the outline was incised; and the squares were painted with various designs. These were usually geometric but one particular square in front of the throne was
74 decorated with a stylized octopus, which was perhaps a royal emblem. The walls of the throne-room now stand but 91 cm high, but when first built their stuccoed surfaces recounted many a saga in brilliant colour of feats of valour and heroic legend, such tales as the king fain would hear at royal feasts from the lips of the bard; and indeed one fragment of
77 a fresco survives to show perhaps the bard himself, lyre in hand, or maybe it is Orpheus charming beast and bird by his music. Behind the throne a different theme is protrayed upon the walls. It is a device of royal heraldry. Two couchant griffins face each other across the throne,
110 proud heads aloft, their wings outspread. Each wears a jewelled tufted crest, peacock feathers adorn the powerful shoulders, and the tails are upraised and curled as if in royal salute. Behind each griffin and in attendance, as it were, is a couchant lion. Might the lions, by some rule of Mycenaean heraldry, represent the arms of a house allied by marriage? Are these the royal lions of Mycenae? And, one might go on to ask, was the house of Nestor related to the buccaneer prince who conquered Knossos and whose royal griffins usurped the throne of Minos? But this is to impose medieval heraldic custom on Mycenaean.

During the day the vestibule, or antechamber to the throne-room, was a place of great activity. It was the corridor through which direct communication might be had with all parts of the palace. Apart from the two great central portals in the long sides of the room there were the doors at either of the short ends. The one on the left, as you faced the

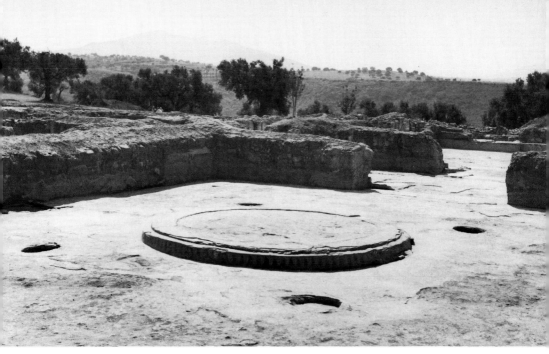

76 The great hearth. Diam. *c.* 4 m. The surround in stucco was many times renewed. Its vertical edge is decorated with tongues of flame. Palace of Nestor, Pylos.

77 The so-called Orpheus fresco from the throne-room. Palace of Nestor, Pylos.

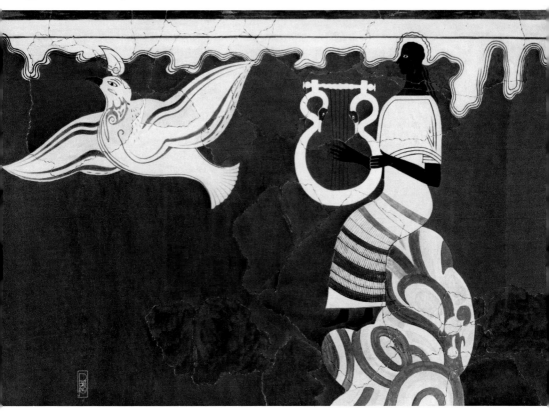

75G megaron, gave direct access to the pantries and crockery-stores, and a staircase opposite the door led up to the second storey. The pantries were an important part of the palace establishment. In one of them the stems of no less than 2,853 kylikes – all originally stacked on shelves – were counted. The consumption of wine in the palace appears to have been high. The poet tells us of Nestor's golden cup that, when filled, none but he could raise. On the other hand, so large a stock of kylikes may also have been intended for distribution to other centres in the kingdom.

The door at the opposite end of the vestibule brought one into a corridor and face to face with another staircase, of which the lower flight of eight stone steps is well preserved. Turning to the left in this corridor one had access to various storerooms and to a double room at
75H the back of the megaron, which contained vast supplies of olive oil. The system of oil storage differed from that in the House of the Oil Merchant at Mycenae (see below). At Pylos the pithoi are partly sunk into the ground: the upper half is above floor level and this is encased in clay covered in stucco, which prevented seepage of spilt oil and could be easily cleaned. The pithoi are arranged around the sides of the room, so that in their plaster casings they look as if they were enclosed within a long and broad bench. The containers were very deep and long ladles had to be used to empty the jars when the level of oil was getting low.

Returning once more to the vestibule along the above-mentioned corridor, but this time keeping straight ahead and passing through a columned porch that gave on to the main courtyard, one would reach
75L the queen's apartments. These comprised a smaller megaron with central, painted hearth but without columns, and two small rooms separated by a corridor, one of which from its decoration could be described as a boudoir. Next door to, and to the north-west of, the queen's megaron but not immediately accessible to it was a large
78 bathroom. The bath itself is of terracotta and enclosed in a surround in true modern fashion, except that it consists of clay covered over with white plaster. A refinement, not found with many modern baths, is a broad step, also plastered, for assistance into the bath; once one was comfortably ensconced therein a ledge at the waisted centre provided a convenient resting-place for the equivalent of a sponge-rack! In the corner of the room are two great wide-mouthed jars, also encased in a plaster-coated surround. At the bottom of the jars there were broken 'champagne glasses' (kylikes), and two similar vessels were also found in the bath. One should avoid jumping to modern conclusions. In some Turkish baths today (in their home of origin) water is poured over the body from shallow vessels not unlike, and certainly no greater in capacity than, a Mycenaean kylix. In ancient times oil, as well as water, would be used for the cleansing of the body. In the *Odyssey* it is related that the fair Polycaste, youngest daughter of Nestor, bathed Telemachus, 'And when she had bathed him and anointed him with olive oil . . . forth from the bath he came in form like unto the immortals.'

The position of the bathroom in relation to the plan of the palace suggests that it was for general rather than private use. It is much more easily reached from the central court and its rooms than from the queen's megaron, which it immediately adjoins. It would therefore be

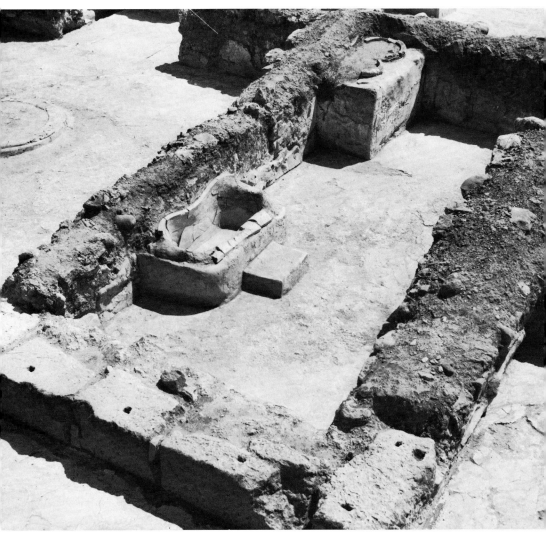

quite natural and convenient for Telemachus to be conducted there from the vestibule for his ceremonial bath. No comparable bath or bathroom has yet been found on any other Mycenaean site. At Tiryns there only remains the floor which is a great monolithic slab with drilled dowel holes along the edge for the fixing of wooden walls; these, of course, would have been plastered. The floor is gently tilted to allow the waste water to flow towards the drain. At Pylos the bath itself has no 'plug' and the water would have to be baled out and poured away into a drainage conduit passing through the wall.

The central court of a Mycenaean palace must always have presented an animated scene. At Pylos it is smaller than at either Mycenae or Tiryns, but its diversity of porticoes and loggias gave it a more varied and unconventional appearance. The largest of the palace courts, that at Tiryns, was much more formal, but its long colonnades with

78 The bathroom adjoining the queen's megaron. Palace of Nestor, Pylos.

80

93

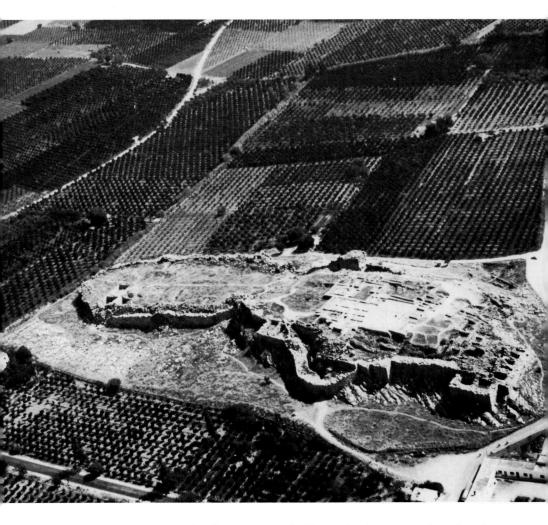

79 Tiryns. View from the
air.

81

occasional alternation of pillar and column must have lent it great
dignity. The Great Court at Mycenae was paved with stucco and
divided off into squares painted with geometric patterns, but the courts
at Pylos had plain cement surfaces interrupted inconspicuously by an
occasional drain outlet for rain water. This consisted usually of a stone
slab pierced with three holes. Underneath the palace there is a maze of
drains not yet fully explored. The smaller ones, built of stone with
upright slabs and cover stone, were big enough to allow a slender man
to wriggle through. They emptied into much larger drains of like
construction in which a man could almost stand up. A similar system
can be seen at Mycenae but there the roof consists of two stones
juxtaposed to make a pointed arch, the corbel technique. Mycenaean
drains were primarily used to dispose of rainfall and any rubbish that
was swept along with it. Anything approaching a civilized lavatory
must have been of rare occurrence.

Around the great palace complex were clustered the houses as in a

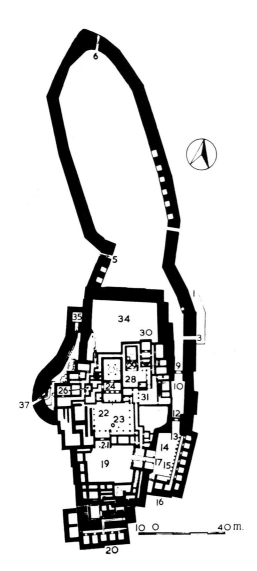

80 Plan of the citadel of
Tiryns. **22**=the court;
24=the megaron;
20=south gallery.

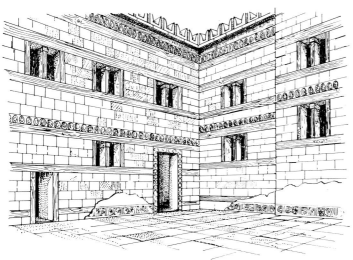

81 The Great Court at
Mycenae. Reconstruction.

82 Mycenae, viewed from the west.

medieval fortress town. Those around Pylos have not been investigated to any great extent, and at Mycenae only the basements have for the most part been preserved. Because of the often precipitous nature of the terrain, terraced buildings were quite usual and the most direct communication between one level and another was the stepped street, but the indirect approach by means of a ramp, winding backwards and forwards up the side of the hill, was also used. Sometimes such a road would assume monumental proportions as in the case of the Great
86C Ramp at Mycenae, which is supported by a terrace wall of Cyclopean construction (see below). We may picture Agamemnon driving in his

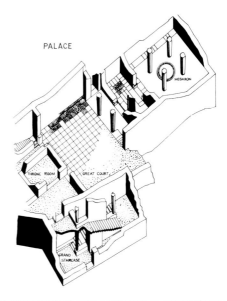

chariot through the Lion Gate and up the acropolis to the entrance of his palace which was approached by a great staircase. The first flight of twenty-two steps of this monumental stairway is still preserved today. The treads of ashen-grey sandstone are built on a stone fill. The second flight, parallel to it and leading up in the reverse direction, no longer survives but it is believed to have been of wood.

The ramp or Processional Way that skirts the east side of the Tsountas shrine probably finished in a landing opposite the base of this staircase. The view from this point is superb. From here one could gaze on the smiling plain of Argos, on the grey bluffs of the Arcadian

83 (*Top*) The Palace, Mycenae. Isometric reconstruction.

84 (*Above*) The Grand Staircase, Mycenae. Only the first flight is preserved. (Cf. ill. 83.)

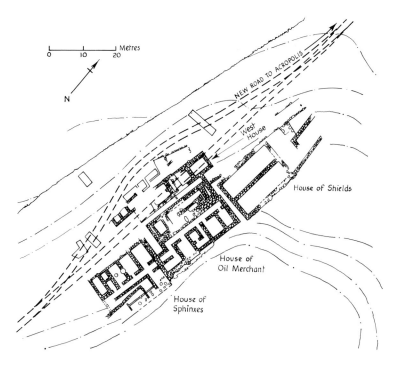

85 Houses outside the citadel, Mycenae.

hills beyond, and on the peaceful little villages at the foot of the acropolis, which made up the capital city of Mycenae.

For the city of Agamemnon, like all the other royal Mycenaean townships, was a miscellany of tribal villages, each settled on one of the many hills grouped round the citadel; or so it is assumed from the plural form of the names of the principal cities (Mykenai, Thebai, Athenai). Each village appears to have been a separate unit with its own burial ground near by. In the neighbourhood of the citadel were imposing buildings thought to be royal workshops or, as some claim, the houses of the great merchants. Three of these houses lie in a row just by the modern road and distant about 150 m from the acropolis. According to their principal finds they have been named (from north to south) the House of Shields, The House of the Oil Merchant, and the House of Sphinxes. The northernmost house is much ruined and only the plan of two great rooms side by side with entrances apparently at the north can be made out. The second house is built on an artificial terrace held up by a massive retaining wall. The western half is at a higher level and represents the main storey of the building, but only the plan of the basement to the east is well preserved. It has a long corridor running almost the whole length of the house, off which open various storerooms. One of these contained large pithoi, or storage jars, that were almost certainly used for olive oil. Because of their great size they had to be supported on two sides by low walls of crude brick. Furthermore, the floor was raised near the entrance to prevent the escape of spilt oil. The third house, that of the Sphinxes, also consists of a basement only and the arrangement of store-rooms off a long corridor is very similar. From the ruins of this house (and others in the citadel) it

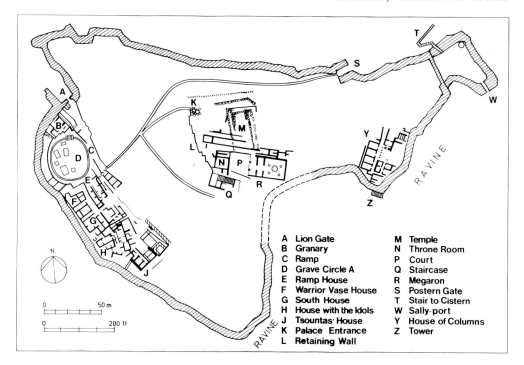

A	Lion Gate	M	Temple
B	Granary	N	Throne Room
C	Ramp	P	Court
D	Grave Circle A	Q	Staircase
E	Ramp House	R	Megaron
F	Warrior Vase House	S	Postern Gate
G	South House	T	Stair to Cistern
H	House with the Idols	W	Sally-port
J	Tsountas' House	Y	House of Columns
K	Palace Entrance	Z	Tower
L	Retaining Wall		

is possible to calculate the height of the basement at about 1.50 m. The West House, recently revealed when the modern road was shifted further to the west, immediately adjoins the above-mentioned houses but does not appear to be connected with them. Owing to its ruined state its plan cannot be made out with certainty, but it seems to have included a building with megaron, vestibule, and porch.

86 Plan of the citadel, Mycenae.

The plan of a house, other than that of the basement area, has in fact seldom been preserved, but where this has happened it is often found to be of the megaron form. A house at Korakou, near Corinth, has such a plan. It has a built porch preceding the vestibule, and the living room (megaron) had a column on either side of a central hearth, which was made up of coarse potsherds set in clay. A very large house consisting of twelve rooms was excavated by Mylonas on the ridge that enclosed the Treasury of Atreus. The main room, as at Korakou, contained a square hearth between two column bases. In a three-roomed house nearby fragments of a clay chimney were found above a round hearth. Unlike the other house, its destruction was not caused by fire but by an earthquake; a woman's skeleton was found in the doorway among fallen masonry.

71

Within the citadel of Mycenae several houses have been excavated of which the best known are the Granary by the Lion Gate and the so-called House of the Warrior Vase near the Grave Circle; but they have been so thoroughly looted that it is no longer possible to determine their purpose, with the possible exception of the Granary. The South House, which is immediately south of the House of the Warrior Vase, was partly dug by Wace in the 1920s. The area between it and the Tsountas House was later excavated in seven seasons from 1959 to 1969

86B, F

86G

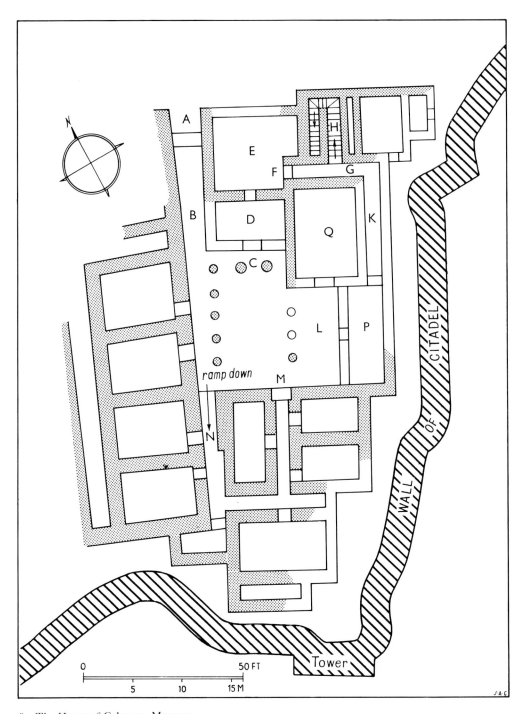

87 The House of Columns, Mycenae.

▬▬▬ Grooves in masonry showing position of wooden tie-beams
▦▦▦ Outer coat of plaster
▩▩▩ Clay and pebble backing for plaster

0 1 metre

by myself in conjunction with the Greek Archaeological Society. Further rooms to the south and east of the South House were uncovered. Those to the east appear to be an annex of the main building. They were remarkable for the state of preservation of their mud-brick walls which had been solidified by the heat of a great destructive fire. One room contained the emplacements for eight storage jars. To the east of it was a fine corridor leading to the Processional Way. Nothing was found in the other rooms to give a clue as to their real purpose but in view of their close proximity to the two important cult rooms that were later revealed to the south, it is presumed that they were intended for the accommodation of the priesthood engaged in carrying out the religious ceremonies. Several rooms to the south of the annex are associated with the cult buildings and include storerooms for ivories and other valuable objects. The whole complex is referred to as the House with the Idols. It is separated from the South House Annex by a gully that was later made into a corridor in which a quantity of discarded pottery of an early LH IIIB phase was found. Another house at the east end of the citadel, called the House of Columns by Wace, appears to be the East Wing of the Palace. Though it is much ruined and the plan is difficult to reconstruct, it is clear that it had a colonnaded court, which gave access to a megaron-type of building and at a lower level to storerooms.

The basement walls of houses were solidly built of dressed stone or rubble, the thickness varying with the size and weight of the superstructure that had to be supported. The wall was often built with a framework of wood, a form of reinforcement, or so it is believed, against earthquakes. This consisted of upright posts placed at equal intervals on both faces of the wall and tied to one another by crosspieces passing through the thickness of the wall. There were also horizontal beams let into the faces of the wall at various levels. The half-timbering

88 Plastered and timbered walls, South House, Mycenae.

87

88

89 Warrior falling from roof. Fresco fragment, Mycenae.

was seldom, if ever, visible. In basement rooms it was concealed by a coating of mud-plaster, in living or public rooms by decoration of superior quality. In the latter case the surface was usually made of a fine stucco that was frequently painted with frescoes. The storey above the basement is almost invariably of mud-brick construction. Three different kinds of superstructure on stone foundations have been recognized at Mycenae: (a) sun-dried bricks; the dimensions of these vary. The largest size is about 60 × 40 × 10 cm; the length as a rule (60 cm) corresponds to the thickness of the wall; (b) hard-packed clay or pisé; this was probably produced in the same way as concrete, i.e. within a wooden mould; (c) facings of mud-brick with a core of clay and rubble. A combination of any one of the above-mentioned techniques was possible. The walls were built in sections and very often a mud-brick section would be continued by one of pisé. A modified version of half-timbering was also used in combination with mud-brick walls.

There is much discussion concerning the form of the roof. That of the later Greek temple was gabled, but few roof tiles belonging to Mycenaean buildings have ever been found, and so it is likely that the roof was flat as are those of so many Greek houses today. This statement finds some support from a fresco fragment portraying a warrior falling from a flat-roofed building. Fragments of burnt roofing, with impressions in clay of brushwood and beam, show that the same technique was used as in modern village houses, namely, brushwood or wattle laid across joists and covered with a coating of mud-plaster and hard-packed earth. Such a construction could serve as the floor of an upper storey if this existed. The floors in the poorer houses, as today in Greece, were of stamped earth, but in the more well-to-do dwellings they had a covering of white plaster.

The doorway was often treated with special care, at least in palaces and larger residences. The door-jamb was built in many cases of rubble and mud-brick, sheathed with wood. The threshold was either of wood or of stone. In the great reception rooms of the palace at Mycenae and in the so-called House of Columns near by, the thresholds are enormous blocks of conglomerate. A lot of work has gone into the finish

of this very tough stone. The upper surface has been smoothed by careful dressing to a fine polish except for shallow emplacements for the door-jambs that are sharply cut out at either side. The grooves left by the bronze saw which was used to cut these emplacements and the ledge that acted as the doorstop are often visible. In one corner of the threshold – or in two, if there were double doors – a hemispherical socket was hollowed out in which the doorpost could revolve. Sometimes traces of bronze have been found in these sockets. It is possible that in the palaces the threshold and the wood-work of the doors were sheathed in bronze. In gateways such as the Lion Gate at Mycenae and the Great Gate at Tiryns the sockets for the timbers that barred the doors are still to be seen.

Staircases in houses were normally constructed of wood which has naturally perished. In some buildings, such as the Granary and the House of Columns at Mycenae, their existence can be inferred with a 87 fair degree of certainty from the remains of rubble piers in the centre of the presumed stair well. The basements of some houses had no doors and could only be entered from above by a ladder. Such houses would very often, it is presumed, have an outside wooden staircase, as in Greek villages today.

The problem of the water supply was a serious one in summer, just as it is today. It was of particular importance during a siege. Several ingenious systems were devised to overcome the difficulty. At Mycenae a secret cistern (sometimes wrongly referred to as the Perseia Fountain) was constructed at the end of the thirteenth century, which is a marvel of engineering. Three flights of steps lead down to the reservoir. The

90 Plan of secret cistern, Mycenae.

Cyclopean wall

N

0 5 m.

first flight is built within the fortification walls. The other two are constructed underground and outside the walls. The cistern was fed from the spring called Perseia (after the hero Perseus), which flows to this day and is situated about 200 m from the citadel on higher ground. It is presumed that the water was brought by an underground channel but no evidence for this has ever been found except for some terracotta pipes leading into the opening in the roof above the cistern. The cistern itself is not of great size, but the capacity was enormously increased when the water was allowed to flood the whole of the lower flight of steps where the rock vault rises to a height of over 3.6 m; and to prevent seepage this part of the staircase was covered with waterproof cement, which is still preserved. Neither the location nor even the existence of this reservoir could be known to the enemy except through treachery. Once known, the citadel was doomed.

At Tiryns excavation has uncovered two adjoining underground springs just outside the walls of the lower fortress. These are approached by two descending passages passing under the wall and are built in Cyclopean masonry with corbelled roofs. Pottery sherds show that they were still being used in the LH IIIC period.

At Athens the system was more secure, as an artificial well sunk on the north slopes of the acropolis was within the defences. A shaft of great depth was excavated in a natural cleft of the rock, which allowed sufficient room for a stairway of seven flights to give access to the well. The first two flights were of wood, the remaining five of stone, which was partly supported by rubble masonry and partly anchored to the sheer face of the rock by means of wooden cross ties.

It has always been a mystery how Pylos was able to cope with the water problem in time of siege, and indeed with defence in general. Although the sides of the hill on which the palace buildings are situated are, or had been made, precipitous, the advantages of the site as a natural fortress cannot compare with those of other Mycenaean sites, nor were its deficiencies in this respect made good by powerful fortification walls. It is true that in an earlier period (LH I/II) quite substantial perimeter walls were built, but of Cyclopean walls there is no trace. However, where there is no security of water supply, of what use are the strongest walls? Pylos must have depended on her strong right arm to defend herself.

Pylos was not the only Mycenaean city with limited natural means of defence. Little is known about Thebes as so much of the ancient city lies beneath the modern town and cannot therefore be excavated, but it does not appear to have had any impressive fortification walls, nor is the site naturally a very strong one. Ancient Iolkos, renowned in legend as the city from which the Argonauts set sail, overshadowed by Mount Pelion from whose forests the timber for the Argo was hewn, is now enveloped in the modern town of Volos. Its site has only recently been recognized and very little excavation has taken place. But this illustrious city, though set on a hill, does not appear to have had formidable means of defence.

The best known Mycenaean fortresses whose majestic walls can still be seen are Mycenae, Tiryns, Midea, Asine in the Argolid, Gla in Boeotia, and Phylakopi on the island of Melos. Not much is yet known

91 Entrance passage leading to the secret (Perseia) cistern, Mycenae.

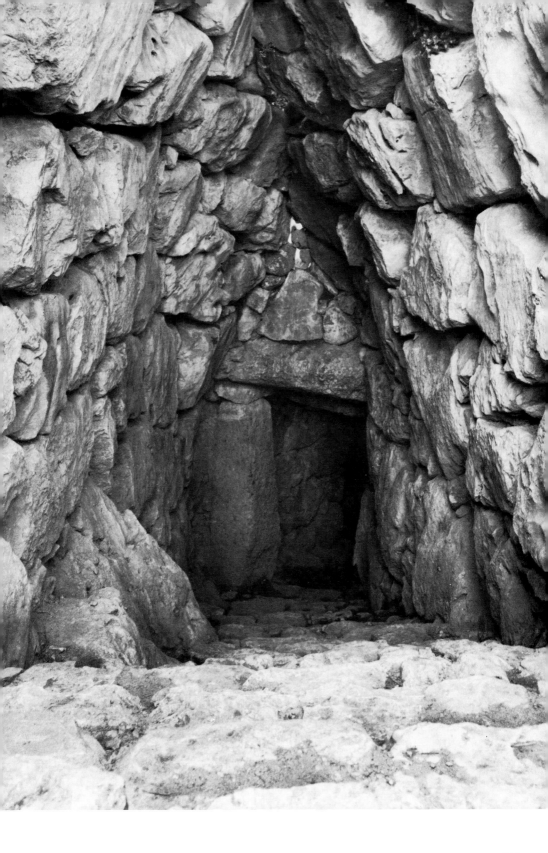

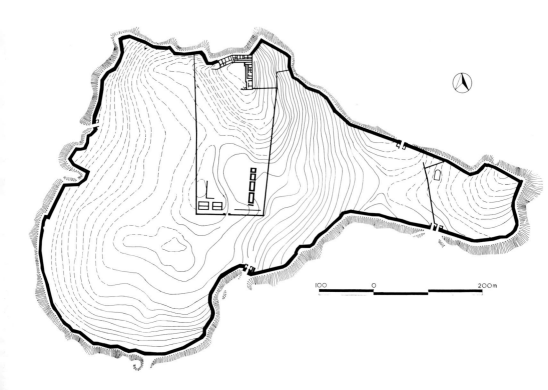

92 Plan of the citadel of Gla.

concerning Gla; it is at present being re-excavated. In Classical times it was an island in a great lake, the former Lake Copais. It now stands as a low, rocky hummock in a sea of rice and cotton fields, for the lake has been drained in modern times. However, a great dyke, believed to be Mycenaean, suggests that the lake was also drained in the Mycenaean period. All that remains today of Gla are the foundation courses of the palace, of enigmatic constructions to the south of it, and the magnificent fortification walls, 4.6 m thick, that follow the contours of the 'island'. (The plan of the palace is completely individual. There is no central court dominated by the megaron and its antechambers. Instead, the buildings, with no room of any great size, are laid out in the shape of an L.) The circuit of the walls is very much larger than those of either Mycenae or Tiryns. Even so, a Cyclopean-built fortress at Petra in Thessaly has a yet greater perimeter (5 miles). Unfortunately, very little is known about it except that the pottery scattered around is LH III. Of the same period is the fortress of Krisa, a 'Homeric' site near Delphi. It is much ruined but the best preserved part of the walls is over 3 m in height. Another impressive Cyclopean stronghold is that of ancient Dymaia in the northwest Peloponnese. The walls of Midea, not far distant from Mycenae, are still extant and they are comparatively

well preserved. But it is at Tiryns and Mycenae that these awe-inspiring walls, now largely restored but imposing formerly even in their ruin, can be seen as once they appeared to would-be invaders who must surely have gazed on them with amazement not unmixed with fear.

To the later Greeks the building of these walls appeared to be beyond the powers of man. Only a race of giants, the one-eyed Cyclopes, could have raised such stones, and Cyclopean is the name that has been used for these walls and all like constructions ever since. In Egypt there was a long tradition of handling blocks of even greater size. One system used there was the construction of a great ramp of earth up which the large blocks were hauled to the required height and then placed in position. As the building rose, so the ramp was raised and lengthened, so that the gradient might not become too steep. It is difficult to believe that such a system could have been used for the building of Cyclopean walls but it would have been possible for the raising and placing in position of the enormous lintels over the doorways of the tholos tombs (the inner lintel of the Treasury of Atreus is estimated to weigh 120 tons). In such cases the side of the hill would correspond to a ramp.

93 North Gate of the fortress of Gla, the largest of all the Mycenaean fortresses. The plain beyond is the former Lake Copaïs.

94 (*Overleaf*) The west bastion (foreground) guarding the Lion Gate, Mycenae. The grandeur of Cyclopean masonry is well illustrated here.

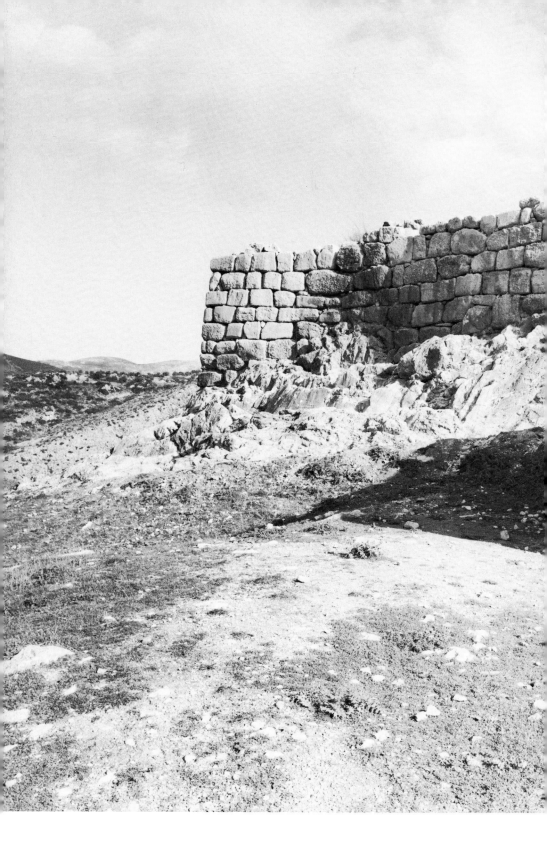

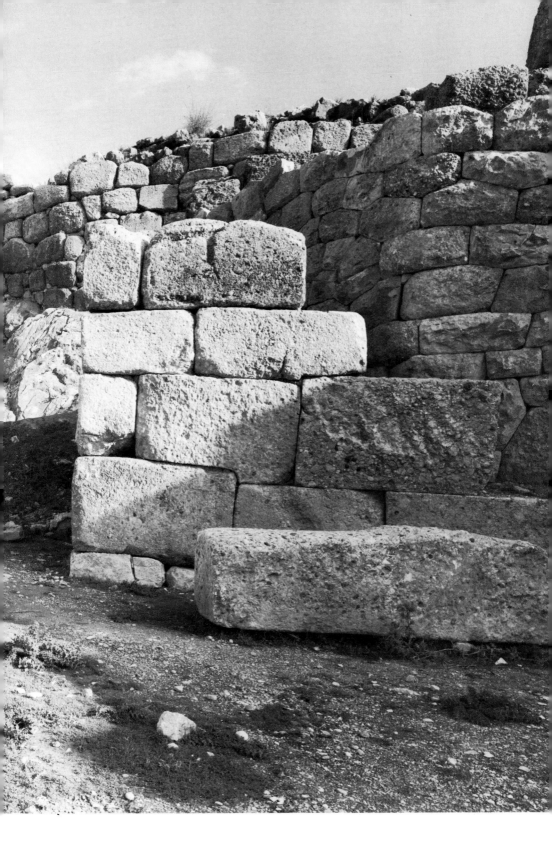

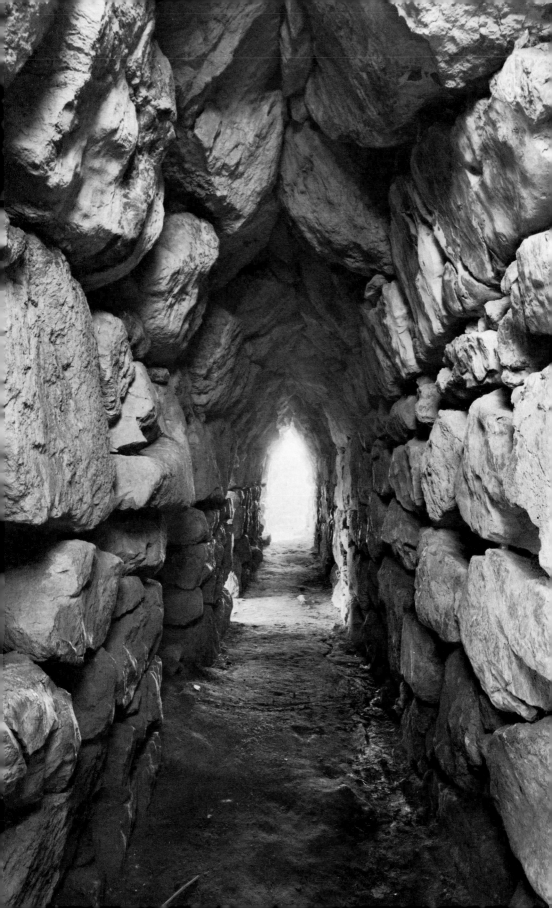

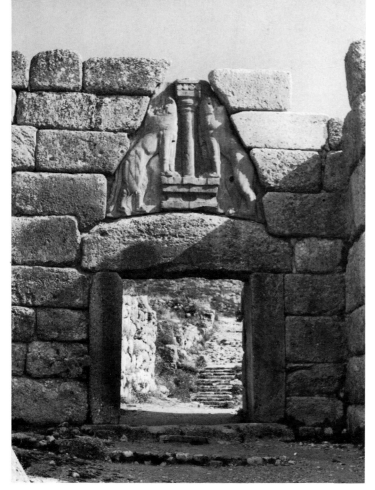

96 The Lion Gate, Mycenae, with its two lionesses, now headless, standing guard over the entrance to the Citadel. Between them is a column which supports on an abacus a row of four roundels, representing the ends of un-squared timbers used as joists for an upper floor.

The large boulders used in Cyclopean walls were only partly hammer-dressed and many not at all. The foundation layer was set on a packing of small stones. Other courses were laid on dry and any gaps were filled with clay and small stones. In fortification walls the thickness averaged about 4.6 m; at Mycenae this is sometimes as much as 6.7 m. Cyclopean blocks, however, are only used for the faces of the wall; the core is rubble and earth. Another style in building, conspicuous at Mycenae and Pylos, was ashlar masonry. Large symmetrical blocks were dressed by hammer and cut by saw. The courses are more regular and evenly laid than in Cyclopean building. This style can be seen in the walls and bastion on either side of the Lion Gate; it adds great dignity to the approach. It was also used in some of the tholoi, particularly the late ones at Mycenae. The most impressive examples are the Treasury of Atreus and the 'Tomb of Clytemnestra'.

94, 96

58

Used in conjunction with both Cyclopean and ashlar masonry is corbelling. In Mycenaean architecture a pointed arch was the rule, and this might involve the use of but two courses and sometimes only one, particularly if Cyclopean blocks were being used. This style of architecture is well exemplified by the roofs of the famous galleries at Tiryns and of their adjacent storage chambers, all Cyclopean-built. Such constructions by being incorporated in the thickness of the walls

95 (*Opposite*) The south gallery, Tiryns, a fine example of Cyclopean masonry. (Cf. ill. 91.)

saved valuable space, or rather created it for much needed purposes. At the same time the 'Gothic windows' in the storage chambers provided embrasures from which an attacking force could be harassed. Corbel construction is often found in the Mycenae acropolis. The roof of the stairway to the secret cistern is built in that fashion; and near by there is the Sally Port, a tunnel with a pointed roof passing right through the walls that are 6.7 m thick at that point. The main drains in the citadel, which debouch through the walls, are built in the same manner. But the examples that are most familiar to the visitor are the relieving triangle above the Lion Gate and those above the great portals of the late tholos tombs. However, the triangular space as now seen in the Treasury of Atreus would not have been visible in the finished monument. It would have been concealed by a decorated panel. The only surviving instance of this form of embellishment is the magnificent tympanum relief over the Lion Gate.

91

86W

6
Daily life, the arts and society

In discussing the dwellings of the mighty and the less exalted, descriptions have largely been confined to the buildings, and little has been said about those who lived in them. It is very seldom that articles directly concerned with the more personal side of daily life are found in context. Such objects as survive *in situ* are crockery, storage vessels, and so on, which had little interest for the despoilers; for the majority of the palaces and houses that have been under review were destroyed by fire and this, it seems, followed on the systematic looting of everything of worth on the premises. Naturally some articles of value were overlooked and others cast aside because they were damaged. It is only by these that the archaeologist is provided with some clue concerning the use of the building, though seldom of the room. For almost invariably the more personal objects have fallen from an upper storey and do not belong to the rooms in which they have been found. In houses it is usually only the basement that survives, and in palaces the public rooms. Our knowledge of the daily life of the Mycenaeans has therefore to be gleaned from very indirect sources: frescoes, scenes depicted on vases, metalwork, ivories, and more recently, the tablets.

Furniture
We know next to nothing of the movable furniture of the houses from archaeological finds. One type of 'fixture' that has survived on the spot, however, is the plastered bench. This is quite a prominent feature in the palaces and to a lesser extent in the richer houses. Such benches are often found in what may be interpreted as waiting-rooms; certainly where bureaucracies are concerned, they would be an essential piece of furniture. It is quite a common scene today to see Greeks seated on a bench, patiently waiting their turn at a bank or government office. But benches seem also to have been used as shelves, as appears to have been the case in the archives room at Pylos. The existence of beds and chairs had been presumed from the knowledge that such furniture was in use in Minoan Crete, but the decisive evidence for these was recently supplied by the tablets. An extract from one of the furniture tablets reads as follows: 'One ebony (?) footstool inlaid with figures of men and lions in ivory . . . One footstool inlaid with a man and a horse and an octopus and a palm-tree (?) in ivory.' Two striking facts emerge from these inventories: that the footstool was a frequent piece of furniture in 47

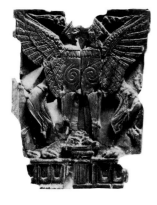

97 (*Above*) Ivory plaque of confronted sphinxes, from the House of Sphinxes, Mycenae. Width 7.6 cm. LH IIIB.

98 (*Middle*) Ivory inlays: rosette, ivy leaf, lily, murex shell, dolphin.

99 (*Below*) Ivory group from Mycenae. Ht 6.3 cm. Found at the foot of the archaic temple.

the palace, and that it was expensively embellished. The description in the inventory of the inlay decoration may require us to revise our ideas about the many fragments of burnt ivories found in excavations (the fact of their burning has preserved them for posterity). It is usually assumed that they formed part of the inlay of caskets, and no doubt they often did. There is a wooden box from Shaft Grave V which is decorated with ivory animal figures; another example is the casket borne by the lady in the Tiryns fresco. But many of the ivories found in the House of Shields and in the House of Sphinxes in Mycenae could as well have decorated furniture as caskets. The various elements such as rosette, ivy leaf, lily, murex shell, dolphin – all motives incidentally that occur on the pottery – would be well suited to either purpose, but the miniature columns, of which such a great diversity was found in the House of Sphinxes would perhaps be more in place in a larger frame, such as a footstool. Tables, according to the tablets, could be of stone, ivory, or ebony, and they are described as being inlaid with *kuanos* (paste), gold, and ivory.

The quality, variety and comparative abundance of the furniture described in the tablets could not have been inferred from the results of excavation hitherto. The wealth of the Shaft Graves and other occasional rich finds have been considered as isolated examples. Our ideas have now to be revised. Sufficient allowance has not been made for the enormous gaps in our knowledge created by the plunderer. Other furnishings that are not mentioned in the tablets can only be surmised. The Mycenaeans were well versed in the arts of weaving.

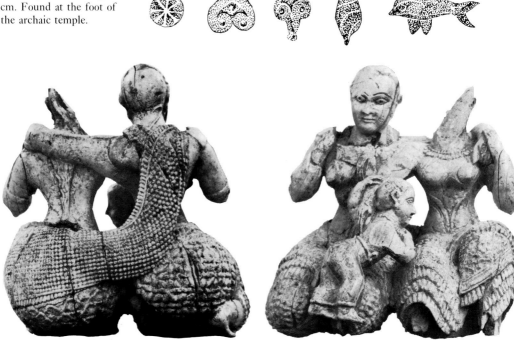

Upholstery of some kind would not be beyond their powers, and rugs and skins are found in both primitive and civilized communities.

Dress

The fashions of dress, at least, for women, were originally dictated by Minoan society and it is surprising to find that there should have been no noticeable change throughout the whole of the Mycenaean age. The dress worn by the goddess from Shaft Grave III (sixteenth century) is not recognizably different from that of the woman portrayed on the ivory handle from the 'Tomb of Clytemnestra' (thirteenth century), or from any other representation of the same period such as the ivory group from Mycenae. The latter is perhaps the best example as it shows the dress in great detail, the bare bosoms, the tight bodice with short sleeves, and the flounced and pleated skirt of many complications. The shawl, shared by both ladies, was of particularly fine workmanship and was bordered with a fringe of tassels. One of the ladies wears her hair down her back, carefully waved and ending in a point. Her companion has a different coiffure; the hair is tightly fitted to the shape of the head, but one tress has been carried across the top to make a kind of bandeau. If, as has been suggested, mother and daughter are to be recognized in this group, the simpler hair style may represent the younger generation.

99

Costumes of women of the ruling class were frequently adorned with gold sequins or rosettes, and the hems of the jackets bordered with thin gold plate; so it appears from the frescoes. Pieces of gold foil of these

100

100 Fresco fragment from the palace at Tiryns. Partly restored. Although only very small fragments of the great fresco representing a procession of women survive, they give a good idea of the costume worn at the time (LH III).

101 Gold jewellery from Prosymna in the Argolid. Rosettes and papyrus. LH III. Diam. of rosette 2.2 cm.

102 Gold jewellery from Prosymna in the Argolid. Rosette and lilies. The rosette was also worn as an earring.

103 One of a pair of gold earrings from Shaft Grave III. Diam. 7.6 cm.

shapes have been found in tombs and are usually perforated with one or more holes for sewing on to the dress. The jewellery worn by the women in the ivory group described above can be matched by examples found in chamber tombs. At that period the beads were usually of gold or of coloured opaque glass, but in an earlier age they could be of amethyst, carnelian, amber and gold. Ropes of beads were often worn, the number of ropes being controlled by spacer-beads, which would allow from two to four 'garlands'. Heavy and elaborate gold earrings were the fashion during the Shaft Grave period, but in the fourteenth/thirteenth centuries a gold rosette or a simple penannular ring was preferred. Very gorgeous trappings were found in the Shaft Graves, huge – and it must be admitted vulgar – gold 'tiaras' adorning the women, gold pectorals and armlets the men; but it is doubtful whether these were worn in real life. They must have been intended for burial only, in accord with the rich and sumptuous examples of Egyptian custom.

The work-a-day dress for men, at least in warm weather, was a loin cloth or short kilt; there are many such representations in Mycenaean art. The formal dress as pictured in frescoes was a simple tunic with short sleeves, a narrow waist, a rather full but short 'skirt'. Very often

105
89

104 Gold funeral pectoral from Shaft Grave V. Ht 36.8 cm. This was laid over the body that wore the gold mask reproduced as the Frontispiece to this book.

105 Fresco with warriors and horses, from Mycenae. Restored drawing. The fragments of this fresco that are preserved do not provide complete evidence for the everyday dress of the men.

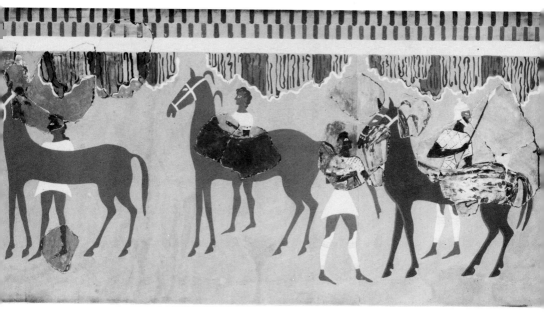

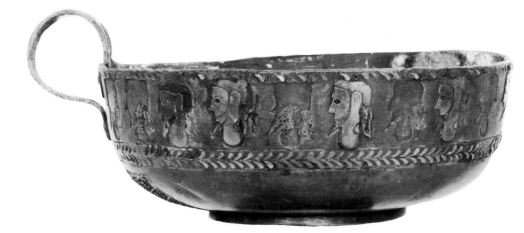

106 Silver cup with inlaid male heads, from a chamber tomb, Mycenae. Diam. 16.5 cm. LH III.

106

107 'Buttons' or whorls.

leggings were worn. Anyone who has had to make his way through the thick and thorny scrub of Greece would appreciate the advantages of this protection. The bard in the fresco from the throne-room at Pylos wears a close-fitting costume that reaches down to the ankles. The lower part of it is pleated and perhaps flounced, as different colours are shown in bands. The upper part of the dress is doubled in some fashion to form a kind of short cape. The man's hair is long and one curl falls in front of the ear in the Minoan fashion. The dress and hairstyle are altogether unusual and uncharacteristic; they suggest priestly attire. Men often wore beards, but the upper lip was usually shaven. The hair was not allowed, as a rule, to fall below the shoulders. A frequent find in tombs is a truncated cone, pierced axially, made of terracotta in LH I and II and of steatite in LH III. It is like a spindle-whorl in shape, but such large number of them were found associated with single burials, that they have been generally interpreted as buttons. However, Professor Iakovidis has recently suggested that they were dress-weights attached to the bottom fringe of a garment as worn, for instance, by the principal goddess in the Room with the Fresco. The gilded bone plaques incised with intricate designs from the Shaft Graves are thought to be buttons. They are unique and must be regarded as part of the paraphernalia of burial.

Ornaments and gems

Signet rings were worn by both men and women in high position. They were either of gold or silver, rarely of bronze. Gold can weather time, but silver oxidizes. Consequently few examples of the latter survive. The oval-shaped bezel, normally at right angles to the hoop and therefore in line with the finger, was engraved with skill and with a fine

108 feeling for composition. The craft was learnt from the Minoans. Closely related to the signet ring and its precursor in time is the engraved seal-stone or gem, which had a long history in Crete. The earliest Mycenaean gems, those of the Shaft Grave period, are very

109 likely of Minoan workmanship. The seals were made in a variety of shapes, circular and lentoid, oval, oblong, and amygdaloid (almond-shaped). In the early Mycenaean period they were of hard stones, such as amethyst, carnelian, sard, haematite, etc. In LH III the softer

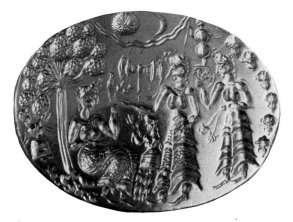

steatite (or soapstone) was generally preferred. The instruments used were a fine drill and graver. The themes were both secular and religious. Oriental influence is to be discerned in the antithetical composition of some of the subjects. Apart from their talismanic properties, the principal use of gem and signet rings known to us is for the sealing of stores. A lump of clay was affixed with string to the mouth of a storage jar or any other object that had to be sealed. While the clay was still soft it was impressed with the seal and usually a Linear B inscription was added. Thus the object was labelled as well as receiving a proprietary mark. Clay sealings have been found at Mycenae, Pylos, and at the Menelaion near Sparta. They are usually prism-shaped and often show the impression of string marks and finger-prints. Seal-stones are found with burials, sometimes in great numbers. From their position in relation to the skeleton they appear to have been worn on a string round the wrist. There are many fine examples of the engraver's art, but quite outstanding is the Griffin seal found in a tholos tomb near the palace at Pylos. The griffins standing guard over the throne of Nestor have already been described, but the oblong gold seal, on which the royal griffin is portrayed with such finesse and majesty, belongs to an earlier period, LH II (or late fifteenth century).

108 Gold signet ring from Mycenae. Diam. 3.3 cm. A religious scene variously interpreted. The goddess under the tree holds three poppies.

109 Seal impressions from the House of the Oil Merchant, Mycenae.

110

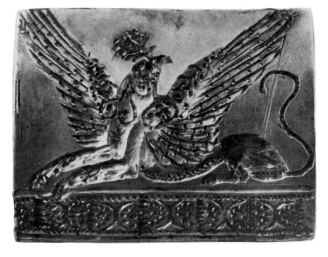

110 The Royal Griffin seal which escaped the plunderers of the tholos near Pylos.

Food

111 The 'Lion Hunt' dagger from Shaft Grave IV. Length 24 cm. A superb example of gold, silver and niello inlay technique in bronze.

The normal diet cannot have been very different from what it is today. The basic ingredients remain the same. For meat there was principally mutton or lamb, goat, pork, and beef. The tablets at Knossos record great quantities of sheep, and the Grecian countryside is equally well suited for the grazing of sheep and goats. Cattle, then as now, were more rare. Pig bones have been identified and, apart from the meat of domesticated animals, there were the rewards of the chase: venison, wild boar, hares, duck, geese and partridge. Hunting wild game was a favourite activity of the Mycenaeans and is frequently portrayed in their art. Among the more dangerous pursuits was the lion hunt. The stela from Shaft Grave V shows a huntsman in a chariot in full gallop after the prey. At other times the combat was on foot, as is vividly

111 pictured on one of the inlaid daggers from Shaft Grave IV. There several men attack a pride of lions with bow and spear. In other scenes engraved on gems the battle is more even; a warrior takes on a lion single-handed and does not always come out best from the fray. The tablets record that hounds were used in the chase and a krater fragment from Messenia shows one of them in pursuit of a stag. A scene (admittedly Egyptian-inspired) on a dagger blade from Shaft Grave V suggests that cats were trained to stalk wild duck, as in a later age hawks would be used in falconry. Though Homer rarely mentions the eating of fish, fishbones have been found at Mycenae and Thebes, and a variety of shells occur in abundance. It can be assumed therefore that the protein diet was heavily supplemented from the sea, for few countries can boast of a longer coastline than Greece and the fish of the Mediterranean are renowned for their savour. Shellfish of all kinds were popular. The murex and the octopus are favourite subjects on

11, 48 vases, and the latter was no doubt considered a delicacy as it is today. But the staple diet would have been bread made from wheat or barley. According to the tablets, the flour was ground by the women and baked by the men. From the same source we learn of the production of cheese. It would be derived presumably, as today, from sheep and goats. Vegetables such as peas, beans, vetches, and lentils are known from excavations. Nuts and fruits, with the exception of figs, are less well documented, but the usual Mediterranean varieties such as figs, pears, apples, almonds, walnuts and hazelnuts are to be expected; the plum

tree is native to Greece. The red poppy (shown on gems) was a source of opium. Figs appear prominently on the Pylos tablets. Two important natural products mentioned in the tablets are wine and honey. Olive oil, for which there is both archaeological and written evidence – the latter recording large quantities – must have been one of the most important sources of wealth. It could be used for cooking and lighting and there was perhaps a surplus available for export. But conditions for the cultivation of the olive are not so propitious in northern Greece as in the south, and this may be one reason why the former was backward in development in comparison with the latter.

Cooking utensils

From the above resources an accomplished cook could produce a variety of appetizing meals aided by all manner of spices, such as those recorded on the tablets from the House of Sphinxes. For the preparation of meals and the manner of their serving we have to rely on Homeric descriptions, but as the art of cooking is conservative by nature, his account no doubt holds true for Mycenaean times. Fragments of cooking pots are one of the commonest finds on Mycenaean settlements. Bronze cauldrons figure in the tablets and several specimens have been found, mostly in tombs. Other varieties of bronze vessels used in the kitchen or at table were jugs and amphorae for wine and water, but these would only be found in the houses of the well-to-do. The poorer classes would have to rely upon clay substitutes. For that reason many clay vessels show the influence of metallic models and are often copied from them. This is very noticeable in the case of the so-called Vapheio cup (see below), of which there are many fine examples in gold and silver from the Shaft Graves.

59

139

Gold and silver articles

The wealth of the Shaft Graves in precious vessels – and it is noticeable that they far exceed in number those made of clay from the same tombs – gives some idea of the display of 'gold and silver plate' that could be laid out at a royal feast. Even the richest families could not hope to vie with such affluence, but in fourteenth-century Midea (Dendra) about 150 years later (LH IIIA), the sovereign of that principality was laid to rest in his vaulted tomb with no mean treasure, not comparable, it is true, in quantity with that of the Shaft Graves, but certainly in quality and artistic merit.

112 Gold cup from a tholos at Midea in the Argolid, decorated in repoussé and incised technique with marine motifs (octopus and dolphin). Diam. 17.8 cm.

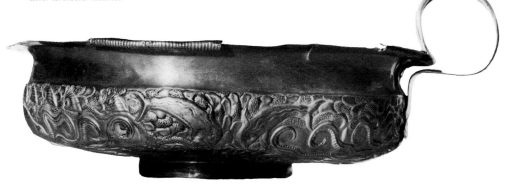

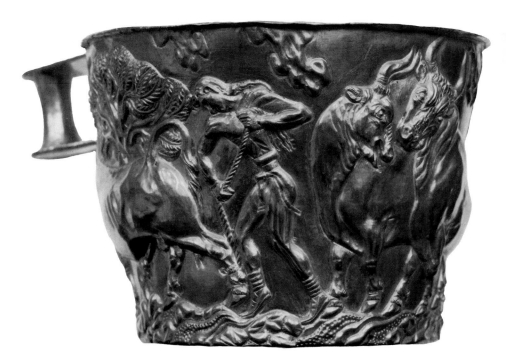

113 (*Above and above right*) Two gold cups from the Vapheio tholos tomb near Sparta. Diam. of smaller cup 11.4 cm. Vivid scenes connected with bull-hunting and capture are portrayed in repoussé work on these magnificent cups.

113

114

These instances are from the very few unplundered tombs in Mycenaean Greece. By good fortune a grave pit in the tholos near Vapheio was overlooked by the robbers who stripped the tomb. In it were found the two famous cups, exquisite works of Minoan craftsmanship, but it must also be remembered that the date of the tomb is LH II, a period when the Mycenaeans, having served close upon two centuries of tutorship under Minoan artists, were producing work of high quality in their own right. On these cups are portrayed with great delicacy and feeling various scenes connected with the cycle of bull-leaping, a dangerous sport that may have had a religious significance. The tale is told in consecutive scenes that follow one another round the two cups. In the first scene the bull is attracted by a decoy cow. His attention thus engaged, he is caught unawares by the trainer and tethered by the foot. On the second cup the bull is seen struggling in a net; he is in captivity. But later on he is seen venting his rage on two athletes, both of whom are in dire peril, if not doomed. This same sport was vividly illustrated in a thirteenth-century fresco from the palace of Tiryns. The game or ritual had had a long tradition in Crete, where it may have formed the foundation for the legend of Theseus and the Minotaur.

Silver figures quite prominently in the Shaft Grave treasures. Outstanding is a silver funnel-shaped rhyton, or filler, from Tomb IV. It is decorated in repoussé with scenes of battle and of a city undergoing siege. Unfortunately, but few fragments of this unique vessel have survived. Two other magnificent rhytons from this same tomb are in the form of an animal's head. The liquid issued from the mouth and it is likely that these vessels were used ritually for libations. One, shaped as

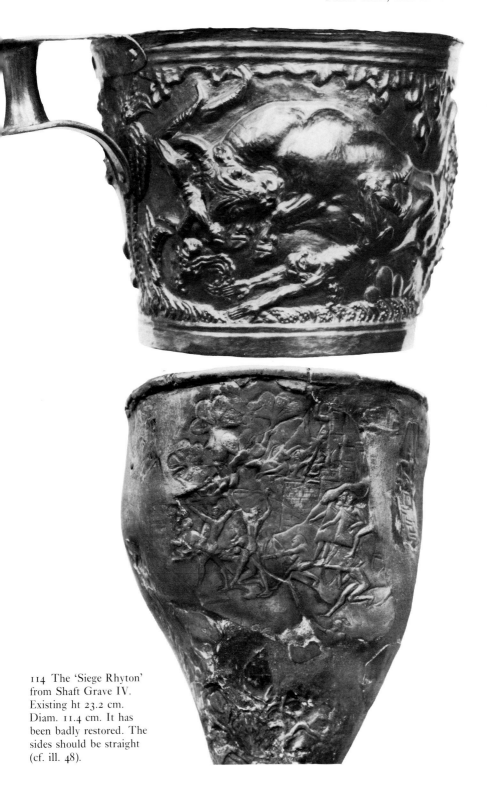

114 The 'Siege Rhyton'
from Shaft Grave IV.
Existing ht 23.2 cm.
Diam. 11.4 cm. It has
been badly restored. The
sides should be straight
(cf. ill. 48).

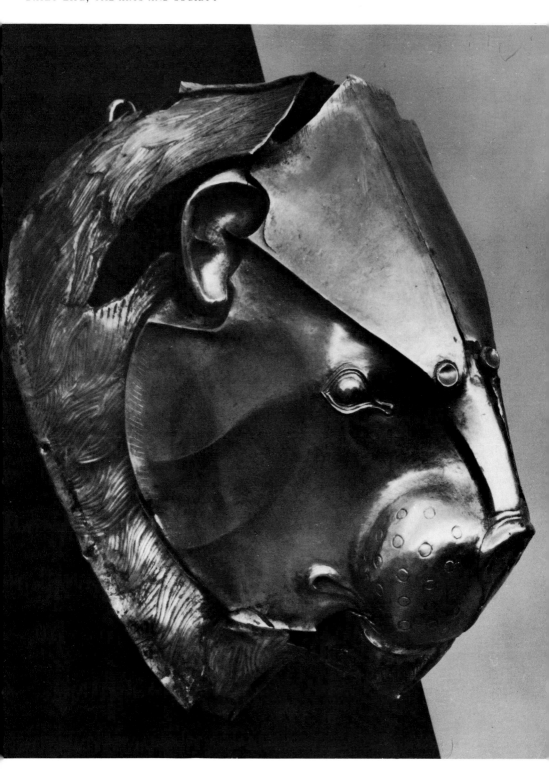

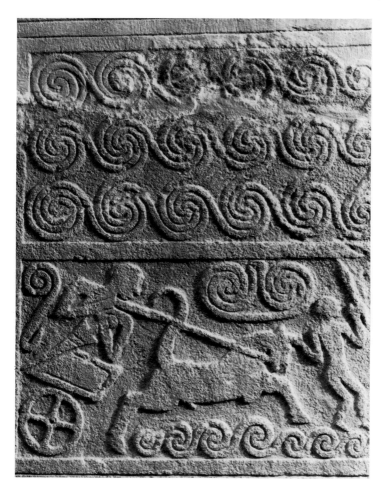

116 Grave stela associated with Shaft Grave V. Ht 1.35 m. Width 1.06 m. Seventeen stelae were found in Grave Circle A, of which six were undecorated. A lesser number were found in Grave Circle B.

a lion's head is of gold; the other, in the form of a bull's head, is of gold and silver. These two metals were also used, with niello (a black amalgam) for the very critical and delicate inlay work on metal. Superb examples of this technique are to be seen in the inlaid daggers from the Shaft Graves, and from the tholos of Routsi (LH II). A silver cup from Dendra (LH IIIA) is decorated with bulls' heads in a similar technique.

115

Stone carving

Not many examples of craftsmanship in stone survive and the sculpture of figures in the round does not appear to have been attempted on a large scale. The Shaft Grave stelae (see above) exhibit the earliest efforts at stone carving. The work is crude and the artist was not fully master of his material. He is most successful in the execution of the spiral borders, but when it comes to representing the figures they are treated in a similar manner, that is, they are merely blocked out and no attempt is made at modelling. A strong sense of movement, however, is introduced. After this early period no major works in stone carving are

115 (*Opposite*) Gold rhyton in the form of a lion's head from Shaft Grave IV. Ht 20.5 cm. LH I. Animal-shaped rhytons were almost certainly used for cult purposes.

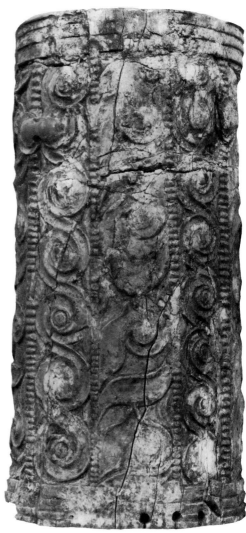

117 Steatite rhyton from the House of Shields, Mycenae. Ht 19 cm. LH IIIB. It was originally embellished with inlay.

118 Ivory pyxis from a tholos tomb at Routsi, Messenia. Ht *c.* 15 cm. LH II. The style of running spiral and sacred ivy is Minoan inspired.

found until the thirteenth century. The outstanding example is, of course, the relief of lions (or rather lionesses) over the Lion Gate. The heads are missing, but it is clear that they were sculptured separately as there is a dowel hole in the neck of each beast to secure them. They were probably made in some other stone, perhaps steatite which is a lighter material. There are differing interpretations as to the symbolism of this famous relief, some emphasizing the religious aspects, others the secular; but all are agreed in recognizing in this early example of Greek sculpture a great monument, noble and majestic in conception, and a worthy precursor of later Greek genius.

There must have been several such sculptured reliefs, the purpose of which would have been to conceal the triangular relieving-space above the lintel (see p. 112). Parts of the sculptured façade of the Treasury of Atreus have been preserved and several reconstructions of its original form have been attempted. Most of the elements are sculptured spirals,

but there are two tantalizing fragments in low relief, found near the tomb, that formed part of a bull-leaping scene. Their style strongly recalls that of the Vapheio gold cups. Among the sculptured fragments from this same tomb are architectural elements with a 'triglyph' pattern, so called from its resemblance to the similar decoration on the entablature of Doric temples. In the Mycenaean version there are three vertical fillets (the 'triglyph') flanked on either side by half-rosettes, 47, 65
which are carved in fairly high relief. This pattern repeated was a popular 110
form of architectural decoration and frequently used in the adornment of the palaces, though indeed very few pieces have survived. When found *in situ* it is at the base of a wall or bench, and it is in that position 81
that it is usually portrayed in frescoes.

The implements employed in stone carving were the tubular drill, the saw, and the chisel. A fast-revolving reed, supplemented by sand and water, was probably used for drilling the holes. Sand and water also would be necessary to assist the work of the bronze saw which was slightly toothed or plain. The chisel, also of bronze, was used for the finishing touches and some kind of polishing process with abrasives would follow. The mark of the drill is clearly to be seen in the fashioning of stone vases. The inside of the vessel, particularly if it had a rather narrow mouth, could only be hollowed out in this manner; and as the external appearance of the vase was alone important, the inside is often left unfinished with the stumps of broken-off cylindrical cores showing. Several of such cores were found at Ayios Stephanos, a Bronze Age site about 26 miles south of Sparta. A large number of stone vases were found in the House of Shields at Mycenae. They were of 117
serpentine, limestone, pudding-stone and *lapis Lacedaemonius*, a dark green mottled stone, the principal source of which is found in the neighbourbood of Ayios Stephanos. An admirable example of fine workmanship in this hard stone is the fluted rhyton, unfortunately incomplete, found on the acropolis of Myceane. The surface of stone vases was sometimes carved to receive ornamental inlays of paste (called *kuanos* on the tablets) or semi-precious stones.

Sculpture in the round

Although it is difficult to generalize because of the scanty surviving material, it seems that sculpture in the round was largely confined to small figures, and these are mainly of terracotta. Of exceptional size in terracotta are the cult statues from Keos and the stuccoed head from 22
Mycenae, and more recently the idols from Mycenae, Phylakopi and Tiryns – though these are a good deal smaller. Then there is the remarkable ivory group from Mycenae. To these must now be added 99
the inspired renderings of the ivory head and of the lion from the Room 36, 37
with the Fresco. These are masterpieces and represent a field in which the Mycenaean artist excelled.

Ivory reliefs

Ivory figures in the round are rare, however. The greater part of the work that has survived is in relief, such as the carving on ivory combs, on the handles of mirrors, on pyxides (boxes), and the ivory panels 118, 119, 127
made for the adornment of caskets, as well as the inlays for furniture

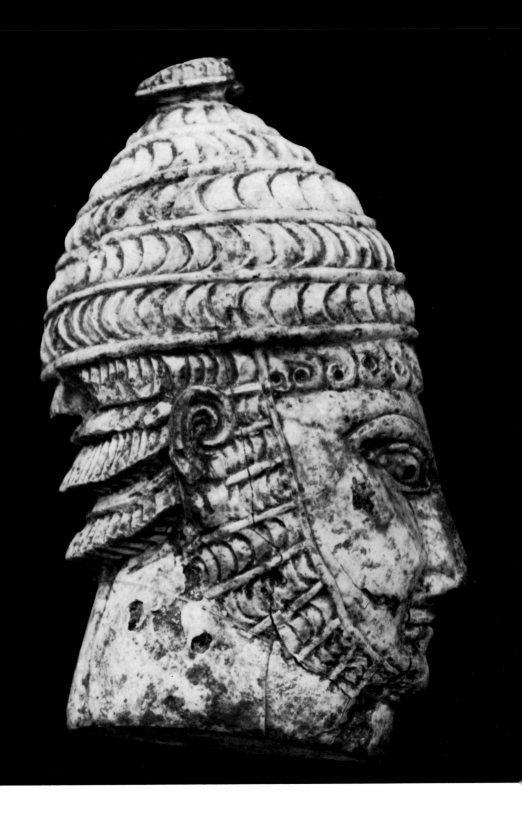

120 Ivory pyxis lid from Ras Shamra. Ht 13.6 cm.

and even for chariots – according to the tablets. The early period (LH I and II) is not so well documented; examples are chiefly from the Shaft Graves and from tholos tombs in Messenia. However, at that time, when the influence, if not the hand, of the Minoan artist is so apparent, the work cannot be taken as truly representative of Mycenaean achievement. As in other domains of art, LH III was the great period in which the Mycenaean genius fulfilled itself. By that time it had absorbed what Crete had to offer and felt sure enough of itself to welcome and adapt ideas from other quarters. Syria was probably the main source of the raw material – elephants only became extinct there in the ninth century BC – and from Syria came impulses that had their sure effect on the evolution of Mycenaean ivory carving. Concepts that are obviously of Oriental provenance are the sphinx and griffin, and at 97
least one theme was adopted by Mycenaean iconography – together perhaps with the religious concept – and that is the divinity holding out the life-giving plant to animal creation. In return the Oriental 120
craftsmen adopted Mycenaean decorative patterns, portrayed subjects popular in Mycenaean art such as animal combats and bull scenes, and even received back their own original concepts as re-interpreted by Mycenaean artists. Sometimes we can distinguish Mycenaean ivory carvings actually imported by these eastern Mediterranean lands.

Fresco painting

The art of painting is represented by the frescoes and the pottery. Fresco material – predominantly LH III – is abundant but so much of it is fragmentary and worn that only incomplete reconstruction is possible in most cases and the significance of the total scene can rarely be captured. The discovery of the greater part of a fresco in its original position at Mycenae is a unique occurrence on the Greek mainland. It survived because it was in a room on the ground floor, which did not suffer the vehemence of destruction that reduced the upper storeys to rubble. Frescoes often decorated the upper rooms of a building and, when the building collapsed, they were shattered. The floors and hearths of palaces were also painted but the decoration is almost effaced.

119 (*Opposite*) Ivory relief of man wearing boar's tusk helmet, from Mycenae. Ht 7.3 cm. LH III. This was probably used as an inlay for a casket.

The art of fresco painting was inherited from the Minoans and underwent little change or development after being transplanted to the Greek mainland. Except for the Mycenaean outline technique and the addition of green to the colour range, there is little to distinguish the style of the latest Mycenaean frescoes from the painting in Crete of an earlier period. However, the subjects dictated by Greek taste were in the main different and reflected the energetic and warlike side of their character. Scenes of combat and of the chase were preferred but these were by no means the only themes represented. Apart from the heraldic *tableau* behind the throne, the varied activities of everyday life, both secular and religious, were depicted. We see ladies gossiping in windows, horses being groomed, a palace vista (all from Mycenae), and the sport of bull-leaping (Tiryns). Some of the subjects are perhaps mythological. One of these at Tiryns may represent Pandora's box, and the lyre-player at Pylos is possibly Orpheus. Till recently religious subjects have been few: a fragmentary fresco of a shrine at Pylos and the procession of genii with asses' heads from Tsountas's House, Mycenae come to mind. But now in the neighbourhood of the last-mentioned area, the Cult Centre of Mycenae, several fragments of religious scenes have been found, of which the most complete example is that of the three goddesses in the Room with the Fresco referred to above.

All these varied scenes were usually confined by an intricate border of geometric patterns arranged in narrow horizontal bands. Sometimes this border decoration was dictated by architectural considerations. Thus the 'triglyph' motive provides a skirting for the walls of the Great Court of the palace at Mycenae. Parts of this fresco are, or were, still preserved *in situ*. Geometric designs filled the squares of the palace floors. Those used in the Great Court at Mycenae imitated the graining of wood and the patterning of stone. Marine motives are more prominent at Tiryns.

Much of the fresco-painting is executed in a hieratic style; the figures of men and women are formalized and rather stiff, animals are more natural except when used heraldically. The skin of the men is usually rendered in red and that of the women in white, a convention derived from Egypt via Crete. The stylized symbols for rock, sky, and cloud were taken over from the Minoans unchanged; so was the technique. The basic foundation was a mud plaster applied to the wall of crude brick. To this were added coats of plaster of finer texture. The paint was then applied in true *fresco* technique, i.e. whilst the final coat of stucco was still wet. Colours show little variation in shade. The principal ones used were red, brown, orange, yellow, green, blue, grey and black. At Pylos it appears that the whole picture was first sketched in orange and that details in other colours were added later. Hence the penetration of the orange into the plaster is much deeper and the other colours are inclined to flake off.

Painting on pottery

The influence of fresco-painting was an important factor in the decoration of Mycenaean pottery in LH III. It is then that representations of man, animal, and bird start to appear on the pottery. The chariot scenes and the antithetic animals portrayed on vases un-

doubtedly take their origin from the frescoes. The development in pottery has been described in an earlier chapter. During LH III the style attained, and retained, a remarkable uniformity throughout the whole territory wherein the pottery was produced though provincial variations in style can be recognized in many cases during LH IIIB. Few kilns have been discovered – Tiryns and Berbati are two examples – but it is often clear from the quality of the clay that the pottery was produced locally.

Mycenaean society

The wide distribution of its pottery bears witness to the might and fame of Mycenaean Greece in the ancient world, but concerning the form and organization of the society that created this pre-eminent position our knowledge is limited. The tablets, however, provide some pointers towards an elucidation of this problem which will be discussed below. In Homer there are many references to relations between king and vassal and commoner, and between different kings, but these probably reflect the system of government in force at the time he was writing (eighth century) and cannot therefore be taken as evidence for Mycenaean times. From Homer, archaeology, and the tablets together, we may build a picture of a number of lesser kings and on one king having a higher status than the others; and such a position was most assuredly occupied by the lord of Mycenae, a city that archaeology has shown to have been richer and stronger than other cities. But the very geography of Greece makes it difficult for any one ruler to assert absolute and undisputed control over the whole mainland and still less over distant islands and colonies such as Rhodes and Cyprus. The mountains of Greece divide up the country into separate regions. Travel by land was often difficult, making it necessary to rely on communication by sea. Hence command of the sea was an important factor. It must have been the powerful fleet of the high king of Mycenae that ensured his foremost position, and the status of Pylos in that respect, according to the Catalogue of Ships, was not greatly inferior.

The meticulous records kept in the Palace of Nestor, and no doubt in all the other royal seats of power, give evidence of a highly organized bureaucracy, comparable to that of the great kingdoms of Egypt and Babylonia, from whom no doubt the Mycenaeans learnt the business. But it would be a mistake to translate systems of government, with which we are familiar, to Greek foreign waters. The methods would be imported but not the ideas. A certain similarity there must have been, for the very nature of bureaucracy is to superimpose its own character. From the tablets we learn of a hierarchical system, at the head of which was the king, the *wanax*, a title that is also found in Homer. Second to the king was the *Lawagetas*, 'the leader of the people'; it is not certain what this title implies. His estate was one third the size of the king's. A group that stands close to the king is the *hequetai* or 'Followers' who constitute the nobility. They hold estates and own slaves, wear a distinctive form of dress and have their own chariots. They presumably acted as officers for the infantry.

From the Pylos tablets we learn that that kingdom was divided up into sixteen administrative districts. Each district was under a

governor, *ko–re–te*, assisted by a deputy. They appear to have had other titles as well. One of these was *klāwiphoros* or 'key-bearer' which seems to have a religious connotation. This title was also borne by a woman who was probably a priestess. As borne by a *ko–re–te* it would imply that he had religious as well as secular duties. Another important class in the hierarchy is the *telestai* who were wealthy land-holders. They appear to have stood in the same relation to the district governor as the Followers to the king. References in the tablets to land tenure imply that the system was communal as well as private. The community is referred to as the *damos* which in later Greek became *demos*. It has been suggested that the local *damos* would be the equivalent of an English parish. Their interests would be administered by the *telestai*. Some of the land was held in the name of the god. At Pylos, for instance, contributions were levied annually for Poseidon. The word *basileus*, king, occurs frequently in the tablets, but it is clear that it has not the same meaning as in Classical times. The *basileus* seems to occupy a comparatively low grade in the social scale. In Homer, on the other hand, there is apparently no distinction between *anax* (*wanax*) and *basileus*.

Slaves

That slavery was a familiar institution is evident from the tablets. There are lists of women slaves, their occupation, and their origin. Some of them are said to have come from Lemnos, Knidos, Miletus, Halikarnassos and a town that appears to have been in Lydia, all situated on or near the west coast of Asia Minor. Miletus was a Mycenaean colony and the other four places were possibly trading posts. All of these places may have been slave markets. The slaves seem to have been predominantly women, but there are also references to slaves owned by the bronzesmiths who helped them in their work and would therefore more likely be men. The 'slave' of a deity should perhaps be classed rather as 'servant'.

Trades and crafts

The distribution of labour, whether slave or native, is attested in some detail. The bronzesmiths, as befitted such a skilful trade – and one on which the fortunes of the army depended – enjoyed a special status. They were entitled to extra benefits in the form of tax-rebates. Cabinet-making was another specialized handicraft, and included inlay-work. Carding, spinning, and weaving were women's occupations. Other trades mentioned are those of saddler and perfumer. We know that rose, cyperus, and sage, with a base of olive oil, were used as ingredients in the making of perfumes. A physician is recorded once, but no details are given about his profession.

Agriculture and livestock

That part of the economy which employed the greatest number would naturally be agriculture. This appears to have been highly organized, to judge from the numerous entries affecting this occupation: records of deliveries of land produce, taxes in kind due to the palace, a share set aside for some divinity, and so forth. The produce entered included wheat, barley, oil, wool. An elaborate system of assessment was

employed for deliveries of wool. This seems to have been an important industry and a considerable source of wealth. So also was the production of flax. Part of both commodities would be used for local needs, but there must have been a large surplus available for export. Oxen are not recorded in great numbers. They seem mostly to have been used as draught animals and were obviously regarded with affection. In the tablets they are referred to by such pet names as Blondie, Dapple, Darkie, Whitefoot. At an early period an ox or an ox-hide may have been a unit of measure in barter. In LH III copper ingots were cast in the shape of an ox-hide. They vary little in weight and it is quite possible that they were used as a rudimentary form of currency. A great hoard of them was found in the summer palace of Hagia Triadha in Crete and a goodly number were also recovered from the wreck of a Mycenaean ship at Cape Gelidonya, off the southwest coast of Turkey. Three examples are known from Sardinia.

121 Copper ingot from Hagia Triadha.

Roads
The very comprehensive organization revealed by the tablets would be dependent to a great extent on a highly developed road system and speed of communication to which the use of chariots would contribute. Little of this system, naturally, has survived, but it can be traced in part

122

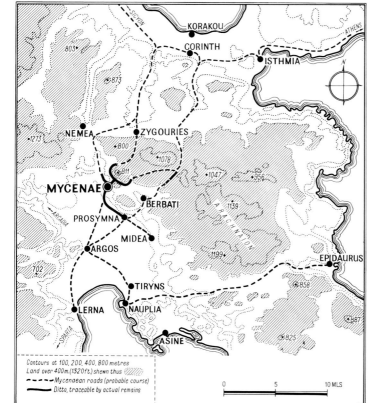

122 Argolis and Corinthia, showing the road system.

from the ruins of prehistoric causeways and culverts that pass over small water-courses. The ruins of a causeway of almost Cyclopean construction can be seen today about a mile to the south of the Mycenae acropolis. It carried the road from Mycenae to the Heraeum (Prosymna) over the Chaos torrent. The road network has been studied principally in the area around Mycenae, but a valuable survey in Messenia has now been completed. Two roads have been traced in part between Mycenae and Corinth, passing on either side of the mountain range that separates the two cities. These roads would have been guarded by forts along the route and perhaps toll was exacted for the use of them. A fort of this kind is situated on the summit of Mount Elias, one of the twin mountains that stand guard over Mycenae. In the *Agamemnon* of Aeschylus it is from the peak of this mountain that the signal fires announcing the fall of Troy were seen and the glad tidings brought to Clytemnestra.

War and trade

War

A strong impression created by the monuments is of the dominant
accent placed upon war by the Mycenaeans. It would almost seem as if
they loved strife for its own sake. This element in their nature is
conspicuous from the very first, as witness the rich and varied warlike
equipment buried in the earliest of the Mycenaean tombs, the Shaft
Graves. On the stelae that at one time marked the position of these
graves chariot scenes are frequently recorded, in which the dead king 116
triumphs over his foes. On fragments of a silver rhyton from Shaft 114
Grave IV the siege and assault of an enemy town are depicted, and from
the many surviving pieces of fresco-painting of a later period one knows
that scenes of combat decorated the walls of the palaces. But the most
impressive monuments of this warrior race are to be seen today in the
great citadels of Mycenae and Tiryns.

The military aspect of the Mycenaean civilization is borne out by the
tablets, particularly in regard to armaments. Of importance in the
military sphere, as already mentioned, are the *hequetai*, the Followers.
One of their functions seems to have been to act as intelligence officers
and to send back vital information by their charioteers to headquarters
(the king). Their activities are implied in the group of Pylos tablets
concerned with 'guarding the coastal regions'. As the capital city had no
real fortifications, early warning of an enemy raid or threatened
invasion was essential.

Chariots

The chariot figures prominently in the records both at Knossos and at
Pylos, although in the case of the latter the reference is indirect, only
chariot wheels being mentioned; these are described as being ser-
viceable and unserviceable. The fact that the wheels are listed
separately shows that they were dismounted from the chassis when the
chariot was being 'garaged'. The reverse operation of mounting them is
described by Homer: 'Swiftly Hebe put on the chariot the curved
wheels of bronze . . .'; as a rule, however, the wheels were of willow or
elm. One series of Knossos tablets gives a full muster roll: chariot,
charioteer, his cuirass, and a pair of horses. The chariot carried two
men, as is clear from frescoes, vase paintings, and seal-stones. The 123
wheels are four-spoked and the axle is placed centrally under the
carriage. A feature peculiar to the Aegean chariot is a stay running from
the top of the carriage to the front end of the pole or shaft. It is joined to
the pole by a series of thongs, and these connections are frequently
reproduced in representations on vases.

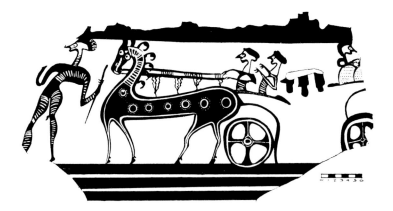

123 Chariot scene from
a krater fragment,
Mycenae.

In the *Iliad* the chariot was merely a means of transport to bring the hero to the battlefield and to convey him swiftly thence, should the combat not end as heroically as anticipated. This is unlikely to have been its role in Mycenaean times, and an older tradition is hinted at in the *Iliad* when the sage Nestor describes the charge of a hundred chariots that took place in his father's time, something more akin to a cavalry charge though there are few parts of Greece that are suitable for such a manoeuvre. It was the use of such tactics and the possession of the chariot that no doubt enabled the otherwise peaceable Egyptians to build up an empire from the sixteenth century BC onwards. In Greece about this very time the earliest representation of a chariot appears on the Shaft Grave stelae and we may suppose that it was this new instrument of warfare (introduced into Egypt by the Hyksos) that assured the rulers of Hellas of dominion over the inhabitants. Similarly the use of the chariot may have been an important contributory factor in their conquest of Crete in the fifteenth century BC; at any rate the chariot first appears there about that time.

116

Weapons and armour

124 The cuirass or coat of mail appears on the Knossos chariot muster roll, but the ideogram for this is not the same as the one depicted on the Pylos tablets, neither is the word used for describing it. At Pylos the

125 Classical word *thorax* is used and the ideogram bears some resemblance

129 to the corslet protrayed on the Warrior Vase belonging to the end of the Mycenaean era. The Knossos cuirass, on the other hand, is remarkably like a bronze coat of mail found in a chamber tomb at Dendra (Midea), which is attributed to the transitional period LH II/III or the end of the fifteenth century, and this is but a little earlier than the presumed date of the Knossos tablets. This unique find reminds us of how much must have perished of which we could have but little conception were it

124 Chariot tablet from
Knossos.

125 Corslet ideogram,
Pylos.

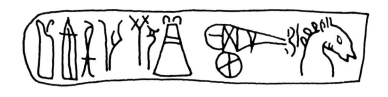

not for the record of the tablets. The later type of corslet as shown on the Warrior Vase appears to be made of leather, but the earlier kind on the Knossos tablets is specifically stated to be of bronze. Bronze has a good chance of withstanding the destruction of time but it is also a valuable metal and it seldom escaped the attention of the tomb-robber.

There are two pieces of armour of which the tablets make no mention, the shield and the greave. These are surprising omissions, which are due no doubt to chance. Although no actual example of a shield has survived, it is fairly well documented from its representation on Mycenaean works of art. The Lion Hunt dagger-blade from Shaft Grave IV shows two different kinds of shield, the figure-of-eight and the 'tower' shield; the latter is also portrayed in a battle scene on a gold signet ring from the same Shaft Grave. The great size of these body-shields precludes them from being made of anything heavier than leather and indeed it is known that the figure-of-eight shield was made from an oxhide; this is apparent from the Fresco of Shields, a recurrent theme in wall decoration which has been found in the palaces of both Knossos and Tiryns, and recently in a room in the neighbourhood of the Cult Centre at Mycenae; the dappled design of the shields reproduces the colouring of the animal hide. Crete seems to have been the home of this particular model and perhaps of the 'tower' shield as well. On the mainland its use seems to have been confined to the sixteenth and fifteenth centuries, but there are echoes of it in the *Iliad*, where vague and ambiguous descriptions of this mighty shield hark back to an old and almost forgotten tradition. In LH III, that is, from the fourteenth century onwards, the whole Mycenaean armoury undergoes a change. Contacts with the East increase and influences from that quarter are reflected in new styles of weapons both of offence and defence. The large body-shield, which figured prominently in single combat and in the chase, is now replaced by the small round shield that was better adapted to collective fighting. But as a sacred symbol and as an ornament the figure-of-eight shield survived for at

126 Bronze coat of mail (right) found in a chamber tomb at Dendra (Midea). LH II/III according to the pottery found in the tomb.

127 Ivory plaque of warrior, from Delos. It illustrates the main equipment used by a Mycenaean warrior: spear, figure-of-eight shield and boar's tusk helmet. Ht 12.7 cm.

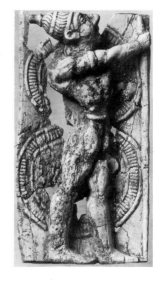

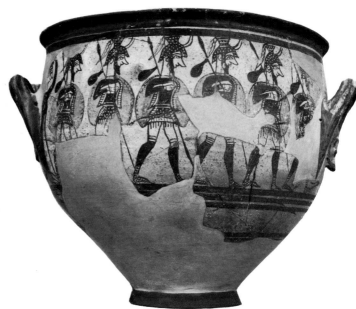

128 Miniature figure-of-eight shield in gold. From the plundered tholos shown in ill. 66. Ht 4.1 cm. The shield has two holes at the 'waist' for suspension. LH II.

129 The Warrior Vase. Ht 42.7 cm. Found by Schliemann in a house on the acropolis at Mycenae. The scene provides information on the battle-dress and armour of the period (LH IIIC).

least another two centuries. Two types of rounded shield are shown on the Warrior Vase (LH IIIC), but there is doubt about their interpretation. A circular shield, reminiscent of the kind used by the Peoples of the Sea (see Chapter 8), is depicted on an LH IIIB sherd. This type appears to have had a hand-grip but no shoulder strap and in this respect it differed from the figure-of-eight shield, which could be worn slung. As is shown on the Warrior Vase, the shield was carried on the left arm. This factor was taken into account in the design of a Mycenaean fortress. At Mycenae the main gate and the postern gate are guarded by bastions so placed as to harass the unprotected (right) side of an attacking force.

The 'well-greaved Achaeans' is a recurring phrase in the *Iliad*. Only four examples of greaves in bronze are known. Three of them are late Mycenaean (one from Athens – previously thought to be Geometric, – one from Cyprus, and one from the north Peloponnese); the fourth belongs to the end of the fifteenth century. It was found in the same tomb as the coat of mail referred to above. Bronze greaves therefore were in use for the early part and the end of the Mycenaean period, and probably for the whole of it but, as has been noted, bronze does not

129

89

often survive. The infantry on the Warrior Vase are clearly wearing a leg protection of some sort and there are several examples in fresco painting of men – soldiers or grooms – who are obviously equipped in similar manner. It is likely that the material was felt or leather.

A purely Greek contribution to armour is the boar's tusk helmet. It is fully described by Homer, yet this type of helmet had gone out of use long before his day; it does not survive the Mycenaean period. There

a b c d

e f g h

130 Late Minoan and
Mycenaean helmets.

are many illustrations of it in Mycenaean art: it is worn by warriors
depicted on gems and seal-stones; it is a popular motive in ivory inlay
work; it is figured on the silver Siege Rhyton, but the most detailed
version of it takes the form of a warrior's head in ivory relief, usually 119
found in an LH III context. Its origin, however, goes back to Middle
Helladic times, its most popular period having apparently been LH I
and II. It was definitely an article of luxury, some thirty to forty pairs of
boar's tusks being required to complete one helmet. Numerous
fragments of these tusks have been found in tombs all over Greece. The
boar's tusks, neatly cut into oblong plates and pierced at the shorter
ends with holes, were sewn on to a frame of conical shape presumably of
leather. The direction of the curve of the tusks was made to alternate in
each successive row, of which there were generally four to five. This
scheme is clearly reproduced in the ivory reliefs. The crown of the 130
helmet was either adorned with a plume or terminated in a knob.
Neckguards and chinstraps are also shown in the ivory reliefs. Besides
this helmet, several other types are known, but what was at one time
thought to be a bronze helmet, found in a chamber tomb at Dendra
many years ago, is now recognized as the shoulder piece of a corslet of
the LH II/III style referred to above. The latest kind of helmet is
portrayed on the Warrior Vase, where two types are shown, one with 129
horns and plume, the other ridged and crested. Both types seem to have 130b, d, e, g
been influenced by forms originating in the Near East. The white dots
that decorate these helmets (and the corslets) on the Warrior Vase are
generally interpreted as metal discs sewn on to the material, which was
probably of leather or felt.

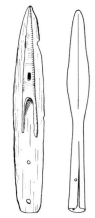

131 Shoe-socket spearhead.

132 Middle Minoan spearhead.

The main weapons of offence in the Mycenaean armoury were the spear, the sword, and the bow. The earliest style of spearhead is of unusual form and but sparsely represented. The bronze blade has a shoe-socket cast on one or both sides of it, into which the split point of the wooden shaft is inserted. Examples have been found at Sesklo, Levkas, Asine, and in Shaft Grave IV at Mycenae; it is of mainland origin. The more normal type of spearhead, in use throughout the whole of the Mycenaean age, was a narrow leaf-shaped blade with a strong mid-rib and a socketed base which was secured to the wooden shaft by a metal collar. The origin of this type seems to be Cretan. Several long, heavy spears of this kind were buried with the Shaft Grave kings and its use with the chariot is depicted on the stelae. It is brandished in single combat in battle scenes portrayed on signet rings of the same period. It also appears as a weapon of the chase in the Lion Hunt dagger. Not many examples of it have survived from the latter part of the Mycenaean period but that it still retained its importance in warfare is confirmed by the fact that it is the only weapon portrayed on the Warrior Vase. There is very inconclusive evidence on the mainland for the light throwing spear, which plays such an important role in the Homeric epic.

At the beginning of the Mycenaean period the most significant weapon of offence was the rapier, of which there are such abundant examples in the Shaft Graves, every warrior being equipped with a far greater number than he would have needed during his turbulent life. All are of fine workmanship and some of them richly and elaborately decorated, such as to suggest trophies rather than practical weapons. They have rounded shoulders, short tangs, and pronounced mid-ribs which are usually semicircular in section. The short tang would make the weapon liable to break away from the hilt. The realization of this weakness would account for some examples having longer tangs. The forbears of this type (A) are certainly Minoan. But alongside these rapiers in the Shaft Graves is found another kind (Type B), less well represented than Type A and of which in the earlier Grave Circle there is only one example. The main difference between the two weapons is that Type B has square or pointed shoulders and a shorter blade. It may possibly have developed from the flanged dagger, of which there were several examples in the earlier Grave Circle, but it can also trace its ancestry to the Near East. A variant of Type B is the horned sword or rapier, the pointed shoulders being extended to form two horns. In the same way, although this is not certain, the cruciform-shouldered rapier appears to be derived from Type A. The dagger is represented at this period by the beautiful examples from the Shaft Graves, justly renowned for their superb artistry. The intricate technique of gold, silver, and niello inlay owes its inspiration apparently to Syrian and not Minoan work. During LH III a new type of sword was favoured, and again we must assume that this was due to broadening contacts with the Near East. The rapier continued in use in LH IIIA, as we know from finds datable to this period; but about this time it was being replaced by the two-edged or slashing sword as opposed to the thrusting style of weapon. One Mycenaean version of this new kind of sword has square shoulders; these, as well as the hilt, are flanged. The blade is broad with

Type A Type B

133 Rapiers. Types A and B.

a widening towards the tip. It has no mid-rib. The earliest examples date from LH IIIA but probably to the latter part of it, that is to say, the second half of the fourteenth century. It is not clear from the tablets which kind of sword is indicated, as the drawings of them are so schematic. One example seems to portray the cruciform type of LH II. All of them are shown with a mid-rib and cannot therefore represent the slashing sword, which would be unable to fulfil its function with such an impediment.

There are but few representations of the use of the bow in the archaeological record on the mainland and those few show exclusively scenes of the chase. The Lion Hunt dagger-blade is an example. From such sources, therefore, it could be assumed that the bow did not play an important part in Mycenaean warfare; but a fragment of a steatite vase from Knossos portrays a bearded archer who from his dress appears to be a Mycenaean, and at Knossos two large deposits of bronze arrowheads (or javelin points?) were found. Bronze arrowheads are coupled with spearheads on the Pylos tablets and there is mention of bow-makers. Only the singlestave bow, or 'self-bow', is portrayed. There is no evidence to support the existence of the composite bow which is used by Odysseus in the slaying of the suitors. In LH I and II the arrowheads are made of flint or obsidian, usually with a hollow base so that their form recalls that of a bishop's mitre. They are beautifully fashioned. In LH III they are made of bronze and are often barbed. Archers as well as stone-slingers are depicted on the Siege Rhyton fragments, but these are not Mycenaeans but the enemy.

Brief mention should be made of the rowers listed on two Pylos tablets. There were more than 500 of them. This is our only reference to a possible navy. Representations of ships are few and mostly very schematic.

Trade

At a very early stage in their history the Mycenaeans turned their attention towards the sea and far-off lands, inspired by a spirit of adventure and a desire to add to the very limited resources with which nature had endowed their homeland. Already in the seventeenth century BC traces of Middle Helladic influence can be seen in the designs on matt-painted pottery produced in Sicily, and one matt-painted cup found in a tomb at Monte Sallia in south-east Sicily appears to be a MH import. But the first evidence of early Mycenaean penetration into this area comes from the Lipari (Aeolian) Islands that lie to the north of Sicily where a great number of potsherds have been found, the majority of them painted in the style of LH I and II; and matt-painted fragments that are transitional between MH and LH I have been discovered on the island of Filicudi. At Lipari itself the quantities of pottery are such as to suggest that it was an important port of call for Mycenaean traders.

134 Cruciform sword.

135 Leaf-shaped dagger or sword.

138

137 Bronze arrowhead.

136 Sword tablet.

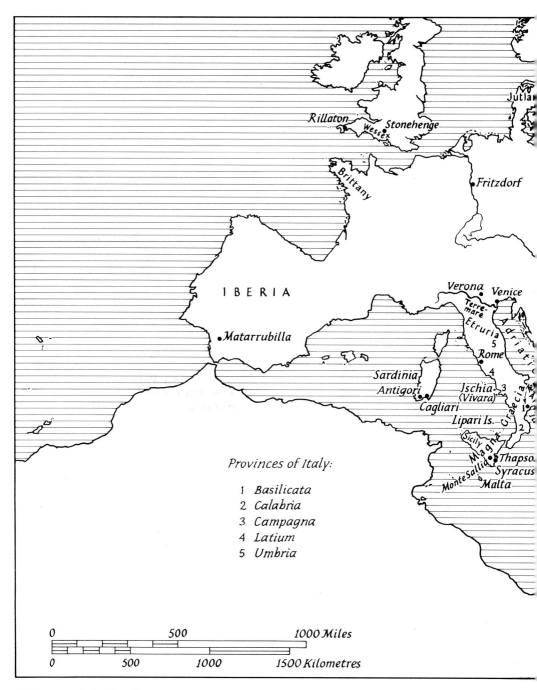

Provinces of Italy:

1 Basilicata
2 Calabria
3 Campagna
4 Latium
5 Umbria

0		500		1000 Miles

0	500	1000	1500 Kilometres

138 Europe and the Near East.

HUNGARY

ANATOLIA

IRAN

Ikos

Troy

Thebes

Chios

ae

Samos

Miletus

Melos

Knossos

Rhodes

Crete

Cilicia *Tarsus*

Kazanli

Mersin *ia*

Alalakh(Tell Atchana)

Cyprus

Ras Shamra

Vouni

R.Orontes

C.Gelidonya

Kition

Qatna

Enkomi

Syria

Byblos

Babylonia

Lebanon

Tell Abu Hawam

Palestine

Gezer

Lachish

Cairo

Gurob

E G Y P T

Tell el Amarna

H.A.S.

Obsidian

Lipari is rich in the black volcanic glass known as obsidian. The island was thought at one time to be a source of supply for the Mycenaeans of this valuable product, which could easily be turned into knife blades, scrapers, and other useful tools. But recent research and analysis have shown that none of the obsidian used by the Mycenaeans could have come from this area. Obsidian was not therefore a commodity of interest to them, but the Aeolian islands and other areas in the Central Mediterranean where Mycenaean pottery is found could have acted as centres for the exchange of goods including those that were much in demand on the mainland and elsewhere in the Aegean. Copper and tin naturally spring to mind. And there is evidence that some of the ports and settlements visited by the Mycenaeans, or with which they were in communication, had wide trade contacts, not only with their neighbours but also with Central Europe; Scoglio del Tonno (Taranto) is a case in point. After the fall of Knossos trade with Lipari was greatly diminished, though it continued to the very end of the Mycenaean period.

In LH III bronze was being used on an increasing scale and was becoming cheaper. Obsidian arrowheads at this time were being replaced by that metal. And there can be no doubt that an important factor in the sea voyages of the Mycenaeans was the search for the two metals that are used in the manufacture of bronze, i.e., copper and tin. Though tin constitutes but 10 per cent of bronze, it is very much rarer than copper. The Mycenaeans no doubt bought their tin through Syria, which appears to have controlled the supply of that metal in the Near East; but they would naturally look for alternative and cheaper sources and the nearest of these in the western Mediterranean may have

139 Gold cup of Vapheio shape from Shaft Grave IV. Ht (without handle) 6.3 cm. The gold cup found at Rillaton in Cornwall has the same horizontal flutings, though the shape is different.

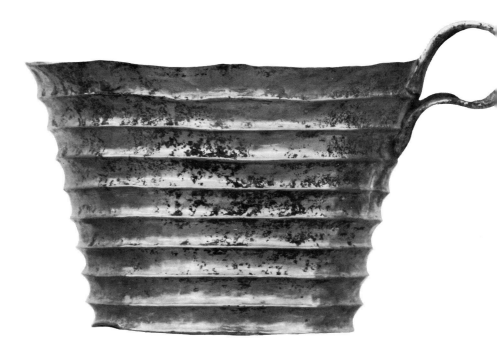

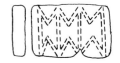

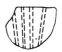

been the tin mines of Etruria which were exploited in Roman times. It is significant therefore that potsherds of the early Mycenaean period have been found on the island of Vivara (Ischia), on the route to Etruria. But the main source of tin in the West was almost certainly Cornwall. It would probably have been transported overland across France to the Mediterranean through the intermediary of merchants. Irish gold and other commodities may also have travelled by this route.

Contacts with the West

If pottery is a guide, the Mycenaeans sailed no further to the West than Ischia, but faint echoes of their influence reached as far as Britain. The Rillaton gold cup, if not a Mycenaean import, resembles the horizontally fluted cup from Shaft Grave IV. It need not of course have been brought in a Mycenaean ship. But the so-called Mycenaean dagger incised on one of the trilithons of Stonehenge is doubtful evidence. The hilt is unlike that of a Mycenaean dagger. There is perhaps some resemblance to the weapon engraved on one of the Shaft Grave stelae, which is certainly not a dagger and is probably a crude portrayal of the Type B sword. If, on the other hand, a Mycenaean inspiration of Stonehenge in its megalithic form is fanciful, a possible indication of trade relations between Britain and Mycenae is provided by the amber spacer-beads found at Mycenae, Kakovatos, and Pylos, all of the fifteenth century. The Mycenaeans may have prospected by proxy for tin in Cornwall, for, apart from the Rillaton cup, the fragment of a LH III sword (the 'Pelynt dagger') was found there in the tomb of a Wessex chieftain.

South Iberia was noted in antiquity for its tin and silver mines, but there is no evidence that these were exploited in the second millennium BC or earlier, and signs of Mycenaean contacts with that area are not strong. Of pottery there is none. There are mitre-shaped arrowheads that recall those found in the earlier Mycenaean tombs. From the dolmen of Matarrubilla come bone spacer-beads that are very similar in many ways to ones made of paste (glass) and found in Mycenaean tombs. The resemblance between the tholoi has been noted and some scholars believe that the Greek tholoi are derived from the Iberian ones, as the latter are mostly, if not all, older. It is of course possible that the Mycenaeans penetrated that far, but they have left little record – and that perhaps indirect – of their wanderings. Mention should be made of the segmented faïence bead. Great quantities of these were manufactured in Egypt round 1400 BC. Almost identical beads had a

140 Amber spacer beads from Mycenae.

139

116

140

141

142

141 Flint arrowheads from south Iberia.

142 Glass spacer bead from a chamber tomb, Mycenae. Length 2.9 cm; width 2.9 cm. LH I.

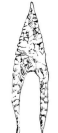
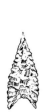

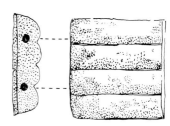

wide distribution: not only have they been found in Spain but as far afield as England and Brittany, the South of France, Hungary, and several countries of Central Europe. Largely because of the far-reaching extent of Mycenaean influence their dispersion has been attributed to Mycenaean initiative. The best evidence for this is that large numbers of these beads were found in the island of Salina (Aeolian Islands), not in association with pottery but with a great number of other beads of probable Mycenaean manufacture. It may be through the enterprise of these islands that such beads were disseminated farther afield.

Almost the only trace of Greek enterprise in Central Europe is the faïence segmented bead, if indeed the sale of this commodity can be definitely attributed to the Mycenaeans. More reasurring evidence is provided by one or two pottery cups, made locally, that reproduce the Vapheio type with a fair degree of precision (one such cup comes from the Terremare in north Italy); and a gold cup from Fritzdorf, near Bonn, appears to imitate the form of a gold kantharos from the Shaft Graves. But it is more than probable that the Mycenaeans were interested in these parts, for here were rich sources of copper. Another commodity that attracted the Mycenaeans was amber, which in the form of beads, often of exaggerated size, are so well represented in the tombs of LH I and II. The amber came from Jutland and the route of this lucrative trade can be traced thence across Europe to the head of the Adriatic. In Greece the greatest concentration of amber beads is along the west coast of the Peloponnese and so we may suppose that Greek ships had a share in the final transportation of this article, although there is no pottery evidence to support this assumption.

143

143 Gold kantharos from Shaft Grave IV. Ht 9.2 cm. A gold vessel from Fritzdorf in Germany seems to copy the form but without its elegance.

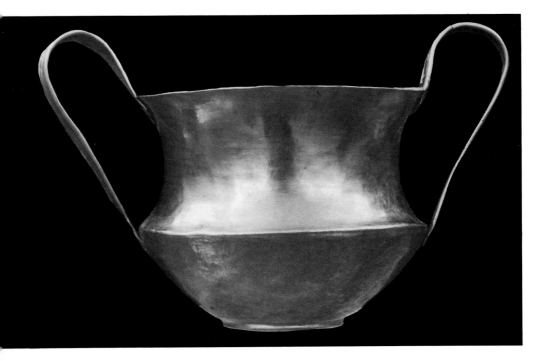

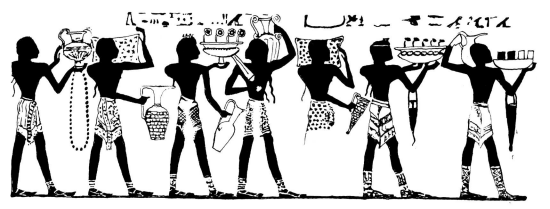

Egypt and the Aegean

Relations with Egypt were active during LH I and II and several vases belonging to those periods have been found in tombs there. Most of them are of the alabastron type. But a much broader picture of relations with the Aegean is presented·by the tomb paintings of the Eighteenth Dynasty (fifteenth century) where the 'men of Keftiu' (Cretans) are shown bearing 'tribute' to the Pharaoh in the form of diverse vessels of gold and silver, jewellery, copper ingots, textiles, and some articles difficult to identify. The tomb of Rekhmere, vizier of Thothmes III, which is some forty years later than the earliest in the series, may well fall within the period of Mycenaean domination of Crete. The ideograms on one of the Knossos tablets show two bull's-head rhytons and a Vapheio-style cup that bear a close resemblance to the portrayal of these objects in the Egyptian tombs. These are of metal, but the Vapheio cup was also reproduced in clay and countless examples of it have been found in settlements and tombs, and no example known so far is later than LH II. The richness and variety of the articles displayed in the Egyptian tombs is in strong contrast to what has survived in actual fact; the textiles have naturally perished, the precious and other metals have long since been looted and melted down. This serves to remind us how inadequate is the picture that we can reconstruct when we have to rely on the few objects that have come down to us. In Greece all that can be set against the 'tribute' to Egypt are a few scarabs of about this period, some decorative motives in art (mediated through Crete), and a large number of amethyst beads, the

144 Wall painting from the tomb of Rekhmere, Thebes, Egypt.

144, 121

145

145 Vapheio-type cups from an Egyptian tomb wall-painting.

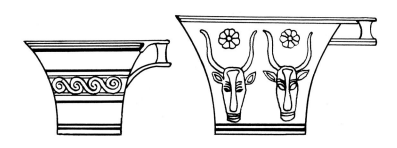

material of which is believed to have been imported from Egypt. This semi-precious stone was seldom worked in Greece after LH II.

It is surprising that the few finds of Aegean pottery in Egypt at this period should be almost exclusively Mycenaean in view of the long tradition of friendly relations between Crete and Egypt and the greater proximity of that island. One can only conclude that the exports from the two Aegean powers were of a different nature.

Anatolia, Rhodes, Cyprus and the Levant

The route by which Greece conveyed this pottery to Egypt, with a potentially hostile Crete athwart its path, would most likely pass through Rhodes which is known to have had Egyptian contacts. In its trade with the Near East Mycenaean ships would pass along the west and south coast of Anatolia and follow the eastern contour of the Mediterranean. Mycenaean contacts with western Anatolia were confined to the coastal regions and in certain cases settlements were established there, but not in Troy, though it received much Mycenaean pottery. A sword of LH I is known from Smyrna but without context. At Ephesus there is a chamber tomb of Mycenaean style but the burial was a cremation, an Anatolian custom. There is no doubt about a settlement at Miletus where there is a cemetery of chamber tombs. Miletus was originally colonized by Minoans in the MM period but they were superseded by the Mycenaeans in LH I. There is some evidence that the latter settled at Iasos and further south at Musgebi which is almost inaccessible except from the sea. As at Ephesus a chamber tomb has been found there but with a cremation. The pottery shows influence from Rhodes. This island was one of the earliest of the Mycenaean colonies; it is geographically part of Asia Minor and well placed for trade with Anatolia, Syria and Palestine. A settlement was established in Rhodes at Triandha in LH II in the neighbourhood of a Minoan colony that had arrived a little earlier and enjoyed, it appears, a certain amount of independence from the mother country. Relations between the two communities seem to have been friendly at first – at least the Greeks were tolerated by the early-comers. Later on, when the Mycenaeans had extended their power over the whole island, the Minoan settlement fades out of the picture. On the Levantine coast LH II sherds are found at Tell Atchana, Ras Shamra, and Byblos in Syria and at Gezer and Lachish in Palestine.

During LH III, after the fall of Knossos, the Mycenaean Age reaches its full vigour and prosperity. Chios and Cos and other islands of the Dodecanese come within the Mycenaean orbit. The settlement established in Rhodes spreads to embrace the whole island, and Cyprus, near the Syrian coast, is visited in strength, it being rich in copper. These two islands spaced away to the east from the Greek mainland enjoyed, as colonies do, a certain amount of independence (though Cyprus was only fully colonized towards the end of the Mycenaean era). The homogeneity of Mycenaean pottery throughout the Mediterranean argues for close relations with the homeland, but certain individualities in style and vase-form are found in Rhodes and Cyprus, and suggest that these islands had become centres of production (though some scholars believe on the basis of clay analysis

that this, like much else of Mycenaean pottery from the Levant, was manufactured in Greece). Rhodian and Cypriot style wares can be recognized in Syria, Palestine and Egypt, and even so far afield as Italy. The krater with pictorial scenes, the pilgrim flask, the shallow bowl, which are uncommon in Greece, occur in good numbers in the two islands and in the Levant; so also do vases that imitate Cypriot models. Kylikes and deep bowls, on the other hand, which are found so abundantly on mainland sites are rare in these areas. (Towards the end of LH IIIC the ceramic styles in both Rhodes and Cyprus diverge even more from those of the mainland, foreshadowing the break-up of the Mycenaean world.)

4, 9

7f, h, j

Macedonia, Thrace and Asia Minor

In LH IIIA and B, new areas are opened up to Mycenaean commerce and old trading stations developed. In the north, Thessaly (which with the exception of the coastal area had been backward in the early period) now comes within the Mycenaean *Koine*. In the northeast pottery is exported to Macedonia, Thrace, and Troy. A great fortification wall is built to protect Miletus. The coast to the north of Cyprus was visited. Mersin has produced a few sherds of the early period but nothing after that, but at Kazanli and Tarsus quite a considerable amount of pottery has been found, mostly LH IIIC. At Kazanli there is also LH IIIB and a cup fragment of LH IIA. Most of the pottery appears to have been made locally, but it testifies to close relations with the mainland. One is reminded of the legend of Bellerophon and his immortal steed Pegasus that has Cilicia as its background. But the overriding interest in Anatolian trade was surely copper, with which that territory was richly endowed.

The 'finger' of Cyprus points towards Ras Shamra; here and at Tell Abu Hawam on the Bay of Acre there were now important settlements, or so the large quantities of Mycenaean pottery from those sites would suggest. And trade was not confined to the coast but penetrated inland, particularly in Palestine. Except for one short and flourishing period, the pottery evidence from Egypt does not give any strong indication of active trade with the Mycenaean emporia. The exception is Tell el Amarna where the heretic Pharaoh Akhenaten built his palace – not destined to outlast him. It was abandoned in 1350 BC, after which naturally no pottery was imported; therefore this date provides one of the few basic props for the framework of Mycenaean chronology. About 1,350 fragments were recovered from this site, representing perhaps some 800 vases. A good percentage of them were pilgrim flasks that were quite possibly imported from Cyprus. It is to this short period that a mutual interchange of ideas is to be attributed, profitable to both parties. A new and free spirit in Egyptian art was stimulated at this time by the more intimate connections with the Aegean, and Mycenaean design in arts other than pottery was influenced by the exchange.

4

Though Rhodes and Cyprus play an important part in trade with the Levant, the Greek mainland would be well represented. There is much from Greece to show that she was particularly interested in the Syrian trade. This includes storage jars of Syrian manufacture, several faience

146 Faience lantern bead from a chamber tomb, Mycenae. Ht 1.6 cm; diam. 1.9 cm. LH III.

vases found at Mycenae believed to come from that area, bronze statuettes of the thunder-god, Teshub (Mycenae, Tiryns, Phylakopi and Delos), a bronze axe from the Vapheio tholos tomb, and cylinder seals. Then it is almost certain that Syria was the source of the ivory that Mycenaean craftsmen carved with superb skill for the adornment of caskets and furniture; and some of the motives and designs of these ivories betray Syrian influence. A type of pendant faïence lantern bead (fretwork technique and biconical in shape) is possibly Syrian but it might equally well be of Mycenaean manufacture. It occurs in Greece, Rhodes, Cyprus, Syria, *and* in Sicily.

Sicily

Of necessity Greece's primary interest was centred in the Near East, home of the most ancient civilizations; but the need for expansion to maintain the standard of luxury to which she had become accustomed led her further afield and principally towards the West. As we have noted, she already had a long-standing connection with the Lipari Islands. The trade in that area was maintained but on a reduced scale. While there is some evidence of earlier contacts – MH patterns on local pottery and recent reports of the finding of early Mycenaean sherds – it is during LH IIIA and IIIB that actual imports of Mycenaean pottery in Sicily appear, supplemented by jewellery including the lantern bead mentioned above. These are concentrated in the southeast area of the island around Syracuse, a region that was to become one of the great centres of Magna Graecia in Archaic and Classical times. That there were earlier Mycenaean contacts here is attested by several rapiers of local manufacture that imitate Shaft Grave models. Legend associates Sicily closely with Crete. Minos is said to have been buried there. Diodorus's description of his tomb corresponds closely with the plan of the Temple-tomb of Late Minoan II (LH II) discovered at Knossos. And yet there is no sure evidence, certainly not pottery, of the Cretans ever having been in Sicily at all. But this paradox would find a partial solution if Minos was a Greek! The locally made Sicilian pots are of coarse grey fabric and are known as Thapsos ware. (Thapsos is a promontory near Syracuse.) Some of the shapes of these vases show Mycenaean influence, but the decoration which is incised, scarcely any. Close to Sicily lies Malta. One LH IIIB kylix sherd is the only Mycenaean find from there so far.

147

147 Rapier from Plemmyrion, Sicily.

Sardinia

Sardinia in the Bronze Age was subject to many different cultural influences and one of these seems to have been Mycenaean. It was a source of copper. The island is dotted about with thousands of fortresses known as *nuraghi*. Many of them are of Cyclopean construction. The majority belong to a much later period, but at least one of them goes back to the fourteenth century according to radiocarbon dating. The art of Cyclopean building may therefore have been transmitted from Greece. Until very recently there was little Mycenaean ceramic evidence in the island and that completely without context. Now, however, sherds of LH IIIB and IIIC have been found at Antigori, a site on the southwest coast of Sardinia. Three copper

ingots of well-known form (they are shaped like an ox-hide) were found 121, 145
near Cagliari. On each of them is inscribed a sign: a double-axe, a
trident, and an angular P. All these signs occur as potters' marks on the
vases from Lipari referred to above and are thought to be in great part
of Cypriot derivation. These particular ingots therefore may have
originated in, or been intended for Cyprus.

Much copper in this form has been found throughout the Mediter-
ranean but the source of these ingots and their destination are a matter
of speculation. A great hoard of ingots was found in the palace of Hagia
Triadha in Crete (at that time, however, the island was controlled by
Mycenaeans). In 1960 another great hoard of ingots, also with signs on
them, was recovered from the bottom of the sea from a ship that was
wrecked off Cape Gelidonya. This is on the south coast of Turkey and
lies between Cyprus and Rhodes. The implication is that this was a
cargo from the Cypriot copper mines.

Italy

Up till now our knowledge of Mycenaean contacts with Italy has been
confined to the heel of the peninsula and to Ischia, but in the last few
years many new sites have yielded up sherds of LH IIIB and IIIC, the
latter period predominating; a few are said to be earlier. The most
northern find is a late sherd from a site near Verona. This seems to
imply that the Mycenaeans penetrated as far as the head of the Adriatic.
They were of course already familiar with the south Adriatic. The
locations extend from the north down to the toe of Italy (Calabria). Pot
fragments are reported from Umbria, Etruria (Luni), Latium, Cam-
pagna and Basilicata. In the last-named province a considerable
number of sherds of LH IIIB and IIIC have been found at Termitito,
which is near Metaponto and close to the Ionian Sea. But the greatest
number of sites with Mycenaean pottery are concentrated in the heel of
Italy. To those already known can now be added several others. Some
of these extend along the south Adriatic littoral as far as the Gargano,
the northern border of Apulia. But the most important new site is Porto
Perone-Satyrion which lies just south of Taranto on the Ionian Sea.
LH IIIA sherds have been found here as well as IIIB and IIIC and
some are said to be earlier.

Tradition relates that, after Minos's unsuccessful campaign against
Sicily, in which he perished, remnants of the expedition took refuge in,
and colonized, Apulia. The tradition concerning the identity of the
survivors is apparently belied, unless they had Rhodian allies, by the
considerable quantity of Mycenaean pottery found at Taranto of which
certain pieces are quite definitely Rhodian; Cyprus is also represented
there. Taranto, or Taras as it was called in Classical times, was
colonized in 706 BC and was the capital of Magna Graecia in Italy, but
its original foundation goes back to the fifteenth century. That from the
pottery evidence (LH IIB) seems to be the date of the first Mycenaean
contact. From there, it appears, a flourishing trade was conducted with
the north of Italy (the Terremare) and the products from that area were
transmitted to Greece. The evidence for this is not very strong, but
Terremare bronzes have been found at Taranto and a mould for
making a winged-axe of Terramara type was uncovered in Mycenae. 148

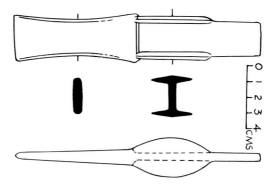

148 Reconstruction of a casting from a mould found at Mycenae.

The bronzesmith who used this mould may have been a Mycenaean who learnt his skill in north Italy or a travelling Terramara bronzesmith who worked at Mycenae. In either case there was a close connection.

Sea routes and ships

There is little definite that can be said about the sea routes taken by the Mycenaeans. In the Aegean where land is seldom out of sight there was no problem, but the sea voyage to the West is more precarious. In Classical times the route to Italy and Sicily was by the Ionian Islands, that is, up the west coast of Greece as far as Corfu and across the narrowing of the Adriatic. Very much the same route is followed today and no doubt the Mycenaeans used it too. The earliest representation of a ship is found very suitably on a Middle Helladic vase fragment

149 from Iolkos in Thessaly, for it was there according to legend that the Argo was built and from there that Jason and the heroes sailed in quest of the Golden Fleece, to the far-off Caucasus. The Iolkos ships – two of them are portrayed – are fragmentary and sketchy, but it can be seen that even at that period they had a ram (a prolongation of the keel), as was later the case in post-Mycenaean times. The ship could therefore be used for war and piracy as well as for trade. Oars are indicated and as with other craft of the period, for example, Egyptian, there is a great oar rudder at the stern. Representations on seal-stones and later vases show that there was a cabin and, as was to be expected, a sail. The draught was shallow and consequently the ship could be beached in wind-protected, sandy harbours. The famous 'Flotilla' fresco from the island of Thera represents more than one ship. There apparently different types were used for war and for trade.

It is unfortunate that the wreck of Cape Gelidonya cannot add further details to this meagre account. Only a small part of the hull, caught in a cleft, survived. Most of the ship and its contents had been swept away by strong currents. The principal cargo, as we have seen, was copper which on account of its great weight (half a ton) was not easily moved by the waters. With it were found bronze tools, a few scarabs, a cylinder seal from Syria, basketry (deep water is a wonderful preservative), domestic pottery, and part of the crew's dinner (inevitably fish!). The wreck is probably to be dated to the latter part of the thirteenth century.

Sources of wealth

We can be assured that the primary interest of the Mycenaeans was in metals. Greece has few mineral resources. There are lead and silver mines in Attica, which may have been worked in Mycenaean times. There is said to be copper in the Othrys mountains of Thessaly and there is the report of an ancient copper mine of unknown antiquity discovered at Nemea, north of Mycenae; but there is no evidence that these were exploited in prehistoric times. Gold mines may have existed but of those there is no trace today. Mycenaean gold is generally believed to have come from Nubia, a province of Egypt, but what had the Mycenaeans to offer in exchange? It has been suggested that Egyptian gold was earned by mercenaries fighting for Pharaoh Ahmose for the liberation of his country from the Hyksos in the sixteenth century, but there are objections to this theory and it would scarcely account for the astoundingly rich contents of the Shaft Graves, to mention but one example. What then had the Mycenaeans to offer in exchange for the goods of other countries to enable them to accumulate such vast wealth? The tablets perhaps provide some answers. Killen's detailed study of the Knossos wool tablets has shown what an important part wool played in the Cretan economy and, as Chadwick has pointed out, the archives testify to production on a very large scale. We may presume that conditions were not very different in Greece. Woollen textiles would find a ready market in the colder climes of Central Europe. During the MH period the Greeks appear to have concentrated on agriculture to the exclusion of foreign trade except on a small scale. There may well have been a surplus of cereals available for export. It would appear that towards the latter part of the MH period we are dealing with a developed hierarchical society with power in the hands of a few. The disposal of such surpluses organized by the rulers of the different communities of the mainland would involve them increasingly in international trade. The Greeks are merchants by nature. Their expertise would tell them where there was a shortage in one commodity and a surplus in another. For a consideration they would arrange to redress the balance.

On the Pylos tablets there is frequent mention of flax, *ri-no* (*li-non*, from which is derived our word, linen) and it is grown in Messenia to this day. We may recall the 'tribute' of textiles from the Keftiu portrayed in Egyptian tombs. For a later period, Chadwick draws

149 Reconstruction of a ship from fragments of a Middle Helladic vase from Iolkos.

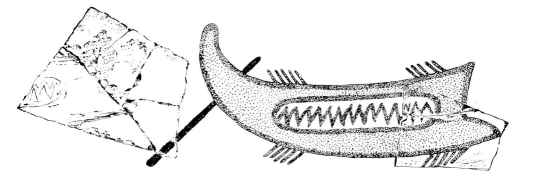

attention to the fact that the number of smiths employed at Pylos and the quantities of bronze allocated were far in excess of the requirements of the palace. Was the bronze being processed for export? The slave-trade may have provided an important source of income (see above). And the high quality of their pottery, as we have seen, found a ready market in both the Western and the Eastern Mediterranean. Three sites that have produced tablets refer to spices and this is of some significance. Spices were of considerable importance in antiquity and particularly in the form of unguents which were in demand by both sexes. The Mycenae tablets from the House of Sphinxes give the most complete list of ingredients used. (One in particular, coriander – the word has remained almost unchanged throughout the ages – provided a useful check in the decipherment.) 'Unguent-boilers' are quite frequently mentioned and one of the most suitable vessels for dispensing an oily substance is the stirrup-jar. Numerous examples of this jar occur in the Levant and especially at Tell el-Amarna. It is perhaps of some significance that few stirrup-jars are known from the backward areas of the Central Mediterranean.

13

All the great civilizations of the Near East – Egypt, Babylonia, the Hittites – had built up their great wealth from their own natural resources with which they had been happily endowed; they did not have to 'export or die'. But Greece has always been a poor country; its wealth has lain in the ingenuity, talents, and industry of its people. To compete with its neighbours it had had to turn these energies outwards. The rise to power and affluence of the Mycenaean civilization can be compared to the ascendancy of the Venetian republic whose prosperity was also founded on commercial enterprise. The analogy is only intended to emphasize that it was the same driving force behind the two cultures that raised them both from a humble status to a position of unimagined wealth and power. They differed widely in their political and social background.

The rise and fall of the Mycenaean civilization

Archaeology can provide the broad outlines of the rise and fall of a great civilization but by itself it is only able to give an anonymous record. The epics of Homer and many legends recounted by later authors are now generally recognized as having a historical foundation. They can be used to breathe life into the dull, scientific record, but it is not always easy to relate the archaeological facts to legendary persons and events. Any historical reconstruction of this kind must be tentative and in many cases different interpretations are possible. The Homeric epics in general, and many of the legends, speak of two heroic periods. In a very broad sense the earlier cycle can be assigned to the LH I and II periods and the second cycle to the latter part of LH III, but there will always be exceptions to any generalized rule.

When the Mycenaeans first appear on the scene in the early sixteenth century, the finds from the Shaft Graves show that their culture was already rich and complex. It exhibits evident signs of many and varied contacts with the outside world: amber from the North, ivory from Syria, gold presumably from Egypt, and – an invisible import – the Minoan impress on the artistic treasures in the tombs. The Cretan influence is more noticeable in Grave Circle A; the earlier Grave Circle B has a much larger percentage of Middle Helladic pottery. Danaos, according to some scholars, is associated with the Shaft Grave dynasty. If so, he would be an usurper. He is the eponymous ancestor of the Danaans, one of the names that Homer gives to the Greeks. Legend relates that he came from Egypt and established himself as king in the Argolid. He was not Egyptian but of Greek, even divine, descent. On his maternal side he may have been connected with the Hyksos royal family who were expelled from Egypt at this time (LH I) and one is reminded of certain Egyptian traits in Grave Circle A, though the dominant influence is Minoan. No constructions on the citadel at Mycenae can be definitely related to this early period. Later rebuilding of the palace has removed all recognizable trace of them. Perseus, a descendant of Danaos, is the traditional founder of the city. Pausanias says, 'that Perseus became the builder of Mycenae, the Greeks know,' but he obviously had no connection with the Cyclopean walls, which belong to LH III.

On the evidence of the late MH pottery found in the Koryphasion tholos (see p. 70) it is probable that Pylos was a flourishing centre in LH I, and there is evidence that Iolkos was a place of importance at that period also. According to legend, there was some connection between

the two areas at this time. Pelias and Neleus were twin brothers whose home was Iolkos. They quarrelled, and Neleus was compelled to migrate to Messenia where he founded a dynasty. His famous son, Nestor, was one of the heroes of the Trojan War. Pelias's half-brother was Aison, the father of Jason, who sailed in the Argo in quest of the Golden Fleece. This would have been an expedition to the Black Sea, but unfortunately it has left no archaeological trace. However, at this time, or a bit earlier, the Mycenaeans were already voyaging far and wide. LH I and II vases are found at Troy and Miletus and in the West in the Aeolian Islands, where they had already been preceded by their Middle Helladic forefathers. In LH II a settlement is established in Rhodes and from this base trade was developed with the Levant and Egypt.

The powerful realm of Minos lay athwart the direct route to Egypt and not until this dreaded rival was overcome could the Mycenaean kingdoms, among which we may count at this time Mycenae, Pylos, Iolkos, and probably Thebes and Orchomenos, enjoy undisputed sway over the Mediterranean. An unexpected natural, but calamitous, event offered them the opportunity to realize their ambitions. In about the late sixteenth century the volcanic island of Thera (Santorini), on the southern fringe of the Cyclades, erupted with devastating repercussions on the neighbourhood and with special intensity on the island of Crete. There is good reason to believe that the effects of this explosion brought about a disastrous, if temporary, decline in the economic fortunes of the island and thus made it an easy target for its enemies; and it is from about the middle of the fifteenth century that there are clear indications that Mycenaean influence, if not a buccaneer prince, was strongly established in the Minoan capital, Knossos. Admittedly a good part of the evidence is based on the military character of some of the tablets, the date of which has been challenged by some scholars, but there is other evidence independent of the tablets that supports this theory. There are the great Palace Style jars found only in Knossos and east Crete, whereas these vessels, and they are in the majority, are known from many sites on the Greek mainland. The alabastron, of which great quantities are found on the mainland, is rare in Crete; its popularity, however, seems to have increased after the conquest and copies of the Mycenaean Ephyrean goblet are now made on the island. Several tombs of this period (LM II) reproduce the plan of the Mycenaean chamber tomb which from their contents have merited the title of 'Warrior Graves'. Such graves are foreign to the Minoan tradition. Finally, there is a tholos near Knossos of pure Mycenaean construction and design; it shows little affinity with the earlier vaulted tombs of southern Crete.

The Greeks who dominated Crete at the end of the fifteenth century, while imposing their own predilections in burial customs and for certain types of vases, did not materially influence the existing, older and more advanced, Minoan culture. They received more than they gave. They learnt the art of writing (Linear B) and the benefits arising therefrom, including efficient, albeit bureaucratic, organization.

Whoever inherited or usurped the revered title of Minos was a power to be reckoned with in the ancient world. Is it to this period that

Minos's disastrous expedition to Sicily is to be assigned? A restless, ambitious, and adventurous Greek might well have attempted such an undertaking. The story relates that Minos went to reclaim Daedalus, the architect of the Labyrinth at Knossos, who had taken refuge in the court of King Kokalos in southern Sicily and there carried out many important engineering works for his new master; obviously a Leonardo da Vinci, whose services could ill be dispensed with. Minos perished in Sicily and the remnants of his ill-fated expedition settled and colonized Apulia in the heel of Italy. The archaeological evidence is ambiguous for the earlier periods (sixteenth and fifteenth centuries), but in the fourteenth century the influence in Sicily is unmistakably Mycenaean and noticeably so in southern Italy, where a Rhodian element can be recognized. Then there is the famous episode of Theseus and the Minotaur, indicating that Athens was tributary to Knossos for a while; and this is perhaps borne out by the recent excavations at Keos, an island off the coast of Attica, where many vases of LM I and II, coinciding with this period, have been found. The legend implies that Athens cast off the Minoan yoke. Was that city the leader in a revolt that was to crush a detested Mycenaean rival? Was not the moment perhaps opportune after the failure of the Sicilian expedition? Greeks were ever at war with one another in the Classical period and appear to have been equally contentious in earlier times. All we know is that Greeks in Knossos in the fourteenth century succumbed to an envious power and that after that there is rather more evidence of Mycenaean influence there, although the basic culture is always able to maintain its distinctive Minoan character.

Kadmos is another 'foreigner' who according to legend came from Syria and established himself in the fertile land of Boeotia, founding the renowned city of seven-gated Thebes. Many illustrious names are associated with this city, the best known perhaps being that of Oedipus who was a descendant of Kadmos. Thebes became one of the most powerful cities of Greece. Its foreign relations included the Near East (ivories, cylinder seals, lapis lazuli have been found) and Crete; many of the coarse stirrup-jars found in the palace have been shown to originate in that island. The success of its commercial enterprises aroused the envy and hostility of neighbouring kingdoms and gave rise to the famous war of the Seven against Thebes. This unsuccessful expedition, in which the sons of Oedipus perished, was organized principally from the Argolid. However, the succeeding generation, the Epigonoi, accomplished their objective and Thebes was destroyed – in the same generation as the fall of Troy according to Homer. Because the modern town of Thebes covers the ruins of the old, excavations have been very restricted, but it has been established that there were two palaces built on different orientations. The older one, 'The House of Kadmos', appears to have been burnt down in the first half of the fourteenth century, though this has been disputed by some scholars. The 'New Palace' was destroyed, it is claimed, in 1250/1240 BC and this is more in accordance with the traditional date.

A round figure for the destruction of Knossos is 1400 BC, though from the pottery evidence this seems more likely to have taken place thirty to fifty years later. But whatever the exact date, it marks the

beginning of the most flourishing period of the Mycenaean civilization. The cargoes from the Greek mainland circulate unchallenged throughout the Mediterranean, at least as far as Ischia in the West. The Cyclades, and notably Melos, bear the imprint of Mycenaean colonization. Trade with Egypt reaches its height during the brief reign of Akhenaten. There are mercantile settlements in Cyprus, from which the Levant markets are exploited. Rhodes, colonized in the previous century, acquires a semi-independent status; it has its own trading station in far-off Taranto. At Mycenae itself a new dynasty assumes power, the Pelopids. Pelops, the founder, is said to have come from Asia Minor. This in itself is indicative of the spirit of the times when any adventurous prince within the Mycenaean realm might hope on some fictitious claim, like William the Conqueror, to carve out a kingdom for himself, and best of all to establish himself in the seat of power; for Mycenae, though it might be accounted *primus inter pares*, was the most powerful of the Mycenaean kingdoms, and this is confirmed by the archaeological evidence.

But it is just about this time that historical records make some contribution towards the meagre information afforded by archaeology and legend. In the annals of the Hittite emperors of the fourteenth and thirteenth centuries mention is made of a Kingdom of Ahhijawa. Though there are certain philological difficulties in the equation Ahhijawa: Achaea, the identification is accepted by most scholars. In Homer the Greeks frequently call themselves Achaeans and no doubt they did so in Mycenaean times also. The Hittites in their documents, on the other hand, referred to countries rather than peoples. In the case of Ahhijawa it is clear that they refer to a sea power. A most important document is a long, and on the whole conciliatory, letter addressed by the Hittite emperor to the King of Ahhijawa who at that time appears to have been in the vicinity; and for that reason it has been supposed by some scholars that Ahhijawa must be Rhodes, one of the most powerful of the Mycenaean kingdoms, as we have seen. But there can be no question that the real centre of power was at Mycenae, to which the monuments in the Argolid, surpassing all others in Greece, bear witness. The Hittites, being a land and not a sea power, could have little knowledge of the territory that constituted the Achaean dominion or where its centre of gravity lay. Contact was limited to the areas where the two realms touched. In the present instance – the occasion of the letter referred to above – this was Millawanda (or Milawata) which is generally supposed to be the same as Miletus. A boundary dispute? Not altogether, but it emerges from the letter that Miletus and its hinterland were at that time part of Mycenaean territory, though temporarily occupied by the Hittite emperor. This suggests that the line of demarcation between the two powers was somewhat fluid. It has already been noted that Mycenae had a long trading connection with Miletus and later on had a colony there. It also had trading relations with Mersin, Tarsus and Kazanli in Cilicia, and a settlement at Ras Shamra. All these with the exception of the last-named are just inside the Hittite border, and Ras Shamra itself is close to the frontier. The two realms therefore touched very closely but it can be inferred from the Hittite archives that relations between them were on the whole

friendly, each recognizing its own limitations: the one all-powerful on land, the other in control of the seas.

On the eve of the Trojan War the might of Mycenae pervaded the whole of the Central and Eastern Mediterranean, but there is evidence that it had already passed its zenith. About the middle of the thirteenth century the capital city suffered some incursion that destroyed houses outside the citadel and these were never rebuilt. The citadel itself may have suffered to some extent at this time. In any event, after this disaster the fortification walls were extended and the secret cistern built. Whether this attack on the citadel is to be attributed to the enmity between the brothers, Atreus and Thyestes, sons of Pelops and rival claimants to the throne, there is no means of telling. Elsewhere in Greece fortifications were being strengthened and towards the end of LH IIIB a massive wall, Cyclopean-built, was constructed at the Isthmus of Corinth, parts of which are preserved at the southeast of the isthmus.

We do not know what was the cause of the Trojan War, for the abduction of Helen by a prince of Troy was merely used as an excuse. Dr Christopher Mee has made the interesting suggestion that the war may have been sparked off by a quarrel over fishing rights. In the late spring mackerel and tunny migrate to the Black Sea to spawn. They return in the late summer and 'are netted in the narrow straits of the Bosphorus and the Hellespont'. One need only recall the threatening disputes over fishing territory in our own time. Troy had enjoyed a period of almost unbroken prosperity for centuries. The basis of her wealth has been variously assessed. Trade may have contributed a good part of it. In spite of bordering the great Hittite empire on the northwest, she received no recognizable Hittite imports; her connections were exclusively with the West. The city, however, was not dependent on trade alone. Unlike the barren mountainous home of the Mycenaeans with its infrequent fertile valleys, the rich, productive plains of Troy (the Troad) provided ample food for the inhabitants and more to spare. The country, according to Homeric poems, was famed for its horses. Moreover, Troy had a thriving spinning and presumably weaving industry. The quantities of spindle whorls found there far exceed those discovered on any other site. Hence, the city may have been a serious competitor to the Mycenaeans in the textile trade.

Against this rival, considered formidable, gathered all the might of Greece with Agamemnon, 'king of men' as the poet describes him, at its head. The impressive array of kings and princes that followed him is recorded in the Catalogue of Ships (see Chapter 2). The war was long drawn out. Many heroes fell and many of those who returned to their homeland found much tribulation on the way. It seems to have been a Pyrrhic victory.

Whatever date is given for the fall of Troy VIIa (Priam's Troy) – and some would place it as high as 1270 BC – it occurred before the end of LH IIIB, for vases in that style were still being imported when this city was reoccupied after its devastation. Even if the LH IIIB style of pottery lasted longer, as it may well have done in certain areas, it is still not possible to accept the Greek traditional date of 1184 BC; for other momentous events in the Eastern Mediterranean, which have some

bearing on this period and are documented both by pottery and Egyptian records, would not admit of so late a date.

About 1225 BC restless migratory forces, referred to as the 'Peoples of the Sea' in the Egyptian annals, were threatening the western Delta. They were defeated by the Pharaoh Merneptah, successor to Rameses II. The names of the peoples taking part are listed and among them certain scholars identify the Danaans and the Achaeans, both names used by Homer for the Greeks. These interpretations present certain philological difficulties. Be that as it may, the Peoples of the Sea reappear some thirty to forty years later, greatly augmented in strength, and this time they attack Egypt from the east. The trail of their maraudings can be traced along the south coast of Asia Minor and the littoral of the Levant. Cyprus at this time suffered a second devastation. Alalakh (Tell Atchana) and Ras Shamra in north Syria fell to the invaders (c. 1190 BC). But once again they were repulsed on the borders of Egypt, and this time decisively, by Rameses III in 1191 BC (or 1186 BC according to others. Egyptian dates at this period are liable to a discrepancy of up to ten years). Among the defeated tribes were the Peleset (Philistines), who thereafter settled in Palestine. Shortly after they had established themselves in their new home, 'Philistine' ware appears and this has strong affinities with the Mycenaean IIIC style pottery being produced in Cyprus after its visitation by the Peoples of the Sea, referred to above. Now, this style of pottery originated at Mycenae after the disasters that overtook the Greek mainland and these cannot have taken place much later than 1200 BC if a modified version of the new (IIIC) style pottery was to reach Palestine via Cyprus shortly after 1191 BC. On these grounds, therefore, a date of 1220–1210 BC for the fall of Troy is preferred.

If the above account appears confusing, this is unavoidable, for the times themselves were confused and disturbed. Tribes were on the move, perhaps driven from their distant homelands by famine. For the Peoples of the Sea it was a mass migration. They brought their families and belongings with them and thus they are graphically depicted on the Egyptian monuments. The Hittite empire disintegrated in their path. Egypt was scarcely able to withstand the invaders, and the Mycenaeans were not to remain immune. But the danger to them seems to have come not from the sea but from troubles at home. The sea after all was their element, and it should be noted in passing that the Cyclades and the Dodecanese appear not to have been affected by the upheaval. In fact, Rhodes at this time was still trading with far-off Taranto and was exporting to Attica and western Anatolia (Turkey). But for the mainland the aftermath of the Trojan War was a melancholy story. In the *Odyssey* we are able to follow the fate of many of the heroes who survived the war. Agamemnon returned to Mycenae and was treacherously murdered by his wife Clytemnestra. Odysseus was compelled to wander for ten years before reaching his home in Ithaca. Other heroes suffered shipwreck and enforced settlement in other lands. Those that returned home very soon emigrated to seek their fortune in other countries. Libya, Sicily, Asia Minor and Cyprus are mentioned in the traditions and there is some archaeological evidence for the last-mentioned areas, particularly in the case of Cyprus. Nestor and

Menelaus were more fortunate in their homecoming and later tradition relates that the former was succeeded by his son and grandson. This creates a chronological problem, unless their reigns were short, for the palace of Nestor, according to Blegen, was completely destroyed by a devastating fire at the end of LH IIIB or *c*. 1200 BC. This is a period that saw the destruction and desolation of many sites. The great citadels on the mainland: Mycenae, Tiryns, Midea as well as Pylos suffered disastrous fires. Others such as Gla, Korakou, Zygouries, Prosymna, Berbati were either abandoned or destroyed about this time. Iolkos seems to have suffered a similar fate in LH IIIC. Athens alone of all the Mycenaean strongholds held out, and it was the proud boast of later Athenians that they were an autochthonous people and had repelled all foreign invason; and indeed archaeology seems to bear out their claim. But although there are no signs of destruction on the Athenian acropolis at this time (*c*. 1200 BC), earlier habitation near the foot of it was now left derelict and the succeeding period shows signs of impoverishment.

It is not to be supposed that these disasters occurred simultaneously; the events may have covered a decade or more. As to the cause of these calamities there is no general agreement. Some scholars would attribute it to the Dorian invasion, but according to a strongly held Greek tradition the Dorian tribes did not overrun the Peloponnese until two generations after the fall of Troy. Other authorities would ascribe the disorders to internecine wars among the petty kingdoms. Yet another explanation proposed is a deterioration in climate bringing drought and famine. But even before the fall of Troy there was a general malaise throughout the Near East. The Hittite power was losing its grip over its vassal states and the movements of the Sea Peoples brought disruption to the lands bordering the east Aegean, restricting the flow of trade which was such an important element in the creation of the wealth of the mainland.

The twelfth century saw a general dispersion of population. Some went overseas to start a new career in Cyprus. Others went further afield to Tarsus. The settlement of Lefkandi in Euboea seems to have had an increase in population at this time. Many of the inhabitants of Attica moved to Perati on the east coast; excavations by Iakovidis in that area show that they prospered there. Achaea on the north shore of the Peloponnese was now occupied and perhaps for the first time in any great strength, for the pottery from the tombs (almost our only evidence) is predominantly in the LH IIIC style. After the sack of Pylos many of the inhabitants of Messenia took refuge in the neighbouring Ionian islands and particularly in Cephalonia.

In all these areas LH IIIC pottery was now being produced exclusively. Mycenae continued to provide the inspiration of the new styles, of which the finest example is the so-called Close Style. For Mycenae recovered some of its strength after the general disaster, though its activities were now on a reduced scale. Its authority was almost co-extensive with the old territories, but the bonds of control were loosened and the commonalty impoverished. As witness for the former we have the local divergencies of style in the pottery, especially notable in Cephalonia, Achaea and Lefkandi; and for the latter, the

abandonment of settlements in the Argolid and the debased standard of workmanship in all crafts. No Linear B tablets are known from this period and it seems likely that the old system of records and control had broken down to give way to a more primitive form of government. A growing deterioration in the quality and design of the pottery is apparent and the simple and crude Granary Style (see p. 27) becomes increasingly popular. This style was very much favoured in Cyprus after that island suffered a second and major destruction some time about 1190 BC (see p. 160). This was followed by actual settlement, for chamber tombs of Mycenaean type are now introduced into the island for the first time.

Turmoil and unrest were once more returning to the Mycenaean world. The negative evidence for this is the abandonment of many cemeteries before the end of the period. Cist burials supersede chamber tombs in Attica, and Argolid, and Boeotia. Single or double interments replace multiple burial. The reappearance of the cist grave is difficult to explain, although its use never completely died out, but the contents of the tomb, other than pottery which reflects the old tradition, are no longer Mycenaean. Long bronze pins and fibulae (an elaborate safety-pin) are now fashionable; the ubiquitous Mycenaean figurine, which had become less frequent in the LH IIIC period, now disappears. But these changes were preceded by catastrophes that mark the end of Mycenaean power and its civilization. They are not on the scale of previous disasters, perhaps because there was less to destroy. In the north, Iolkos, the capital of the kingdom of Thessaly, was overwhelmed. At the eastern extremity of the realm, Miletus was burnt down and, at the very centre of all, Mycenae was finally destroyed. A round date for all these calamities would be in the region of 1120 BC.

Some authorities would associate the collapse of the Mycenaean civilization with the Dorian invasion, an event that is picturesquely referred to by the ancient sources as the Return of the Heraclidae (the descendants of Heracles) who became the leaders of the Dorian tribes. According to the legend Hyllos, a son of Heracles, slew Eurystheus, the last of the Perseid kings of Mycenae (and the one who had imposed the famous Twelve Labours upon his father), but Hyllos himself was later slain in a battle between the Heraclidae and a Peloponnesian force led by Atreus, son of Pelops, who had succeeded to the throne of Mycenae. The Heraclidae retired and were forbidden by the Delphic oracle to return for another 100 years. If the end of LH IIIC and of the Mycenaean period is taken as 1120 BC, an approximate figure, the introduction of Eurystheus and Atreus into the story is an anachronism, though this account would suit the circumstances better, if the Dorian invasion took place more than a hundred years earlier as some scholars believe.

Archaeology can be of no assistance here as the Dorians have left no recognizable trace. No pottery, jewellery, weapons or burial customs can be assigned to them. Their culture was either non-existent, inferior or a debased form of Mycenaean. One stimulating suggestion that prefers to ignore the tradition of the Dorian Invasion is that they were the submerged lower class of Mycenaean society who spoke a different dialect and were rebelling against their masters. The ultimate success

of these invasions – if they are to be attributed to the submerged lower class – may have been due to the connivance of a discontented and ambitious nobility, for the Cyclopean-built fortresses could only have succumbed to starvation or treachery.

The last phase is a melancholy period. The Mycenaean polity never really recovered from the disasters, whatever their cause, at the end of the thirteenth century. The elaborate administration that had maintained its power disintegrated, its trade which was its lifeblood was disrupted and the fabric of its society decayed to an inglorious end. We are on the threshold of the Dark Ages.

150 A snake, modelled in clay, found in the Room with the Idols, Mycenae. Cf. ill. 28.

Bibliography

Abbreviations

AA	*Archäologischer Anzeiger des Deutschen Archäologischen Instituts*
AAA	*Athens Annals of Archaeology*
AE	*Archaiologiki Ephemeris* (in Greek)
AJA	*American Journal of Archaeology*
Ant.	*Antiquity*
AR	*Archaeological Reports* published by Hellenic Society & British School of Archaeology at Athens
Archaeology	published by the Archaeological Institute of America
BCH	*Bulletin de correspondance hellénique*
BSA	*Annual of the British School at Athens*
CAH³	*Cambridge Ancient History*, 3rd edn, vols. I and II
Ergon	To Ergon tis Archaiologikis Hetaireias (in Greek)
Expedition	The Bulletin of the University Museum of the University of Pennsylvania, Philadelphia 1961
Hesperia	*Hesperia. Journal of the American School of Classical Studies at Athens*
JHS	*Journal of Hellenic Studies*
Klio	*Klio. Beiträge zur alten Geschichte*, Leipzig
SIMA	*Studies in Mycenaean Archaeology*, Lund and Göteborg

General

Archaeology 13, 1 (1960). A number that is devoted entirely to Mycenaean civilization

BOSSERT, H.T. *The Art of Ancient Crete*. London 1937. Includes a section on the Greek mainland, but is mostly a picture book

BOUZEK, J. *Homerisches Griechenland*. Prague 1969

CHADWICK, J. *The Mycenaean World*. Cambridge 1976

CHRISTOPOULOS, G.A. (ed.) *A History of the Hellenic World: I Prehistory and Protohistory*. London 1974

DIKAIOS, P. *Enkomi Excavations 1948–58*. Vols. I–III. Mainz 1969

EVANS, SIR ARTHUR *The Palace of Minos*. London 1921–35

FIMMEN, D. *Die kretisch-mykenische Kultur*. Berlin 1924

GLOTZ, G. *La civilisation égéenne*. Paris 1953

HOOD, M.S.F. *The Home of the Heroes*. London 1967

HOOKER, J.T. *Mycenaean Greece*. London 1976

HOPE SIMPSON, R. *A Gazetteer of Mycenaean Sites*. London 1965

HOPE SIMPSON, R. and O.T. DICKINSON *A Gazetteer of Aegean Civilisation*, Vol.I *SIMA* 52. Göteborg 1977

KARAGEORGHIS, V. *The Ancient Civilisation of Cyprus*. London 1969

LUCE, J.V. *Homer and the Heroic Age*. London and New York 1975

MARINATOS, S.N. and H. HIRMER *Crete and Mycenae*. London 1960

MATZ, F. *Crete and Early Greece*. London 1962
— *Kreta, Mykene, Troja*. Stuttgart 1956

MYLONAS, G.E. *Mycenae and the Mycenaean Age*. Princeton 1966

NILSSON, M.P. *Homer and Mycenae*. London 1933

PALMER, L.R. *Mycenaeans and Minoans*. London 1961

PIGGOTT, STUART *Ancient Europe*. Edinburgh 1965, Chicago 1966

SCHACHERMEYR, F. *Die ältesten Kulturen Griechenlands*. Stuttgart 1955
— *Die ägäische Frühzeit. Vol.II. Die Mykenische Zeit*. Vienna 1976

STUBBINGS, F.H. *Prehistoric Greece*. London 1972

TSOUNTAS, C. and J.I. MANATT *The Mycenaean Age*. London 1897. A comprehensive survey. Out of date but still valuable

VERMEULE, E. *Greece in the Bronze Age*. Chicago 1964

WACE, A.J.B. *Mycenae: An Archaeological History and Guide*. Princeton 1949

WACE, A.J.B. and F.H. STUBBINGS *A Companion to Homer*. London 1962

WARREN, P. *Aegean Civilisations*. Oxford 1975

WEBSTER, T.B.L. *From Mycenae to Homer*. London 1958

The following is a list of the principal and important book publications on Mycenaean excavations. It is necessarily selective. Those that are numbered are referred to again in the bibliography under the different chapter headings.

1 ATKINSON, T.D. *et al. Excavations at Phylakopi in Melos* (*JHS* Suppl. Paper no. 4). London 1904

2 BLEGEN, C.W. *Korakou*. Concord, New Hampshire 1921

3 — *Zygouries*. Cambridge, Mass. 1928

4 — *Prosymna*. Cambridge 1937

5 BLEGEN, C.W. *et al. Troy*. Vols III and IV. Princeton 1953–8

6 FRÖDIN, O. and A.W. Persson *Asine*. Stockholm 1938

7 GJERSTAD, E. *et al. Swedish Cyprus Expedition*. 4 vols. Stockholm 1927–1935, 1948

8 GOLDMAN, H. *Eutresis*. Cambridge, Mass. 1931

9 HEURTLEY W.A. *Prehistoric Macedonia*. Cambridge 1939

10 LOLLING, H.G. *Das Kuppelgrab bei Menidi*. Athens 1880

11 MURRAY A.S. *et al. Excavations in Cyprus*. London 1900

12 MYLONAS, G.E. *Proïstoriki Eleusis* (in Greek). Athens 1932

13 PERSSON, A.W. *Royal Tombs at Dendra*. Lund 1931

14 — *New Tombs at Dendra*. Lund 1952

15 PETRIE, SIR W.M.F. *Tell el-Amarna*. London 1894

16 SCHAEFFER, C.F.A. *Enkomi-Alasia*. Paris 1952

17 SCHLIEMANN, HEINRICH *Mycenae*. London 1878

18 — *Orchomenos*. Leipzig 1881

19 — *Tiryns*. Leipzig 1886

20 Tiryns. *Die Ergebnisse der Ausgrabungen des Instituts*. Vols.I,II. Athens 1912. Vol.III. Augsburg 1930. Vol.IV. Munich 1938 Vol.V. Mainz 1971. Vols.VI 1973. VII 1974. VIII 1975. IX 1980

21 VALMIN, M.N. *The Swedish Messenia Expedition*. Lund 1938

22 WACE, A.J.B. *Chamber Tombs at Mycenae*. Oxford 1932

23 WALDSTEIN, C. (ed.) *The Argive Heraeum*. Vol.II. Cambridge, Mass. 1905

In addition to the above consult

KARO, GEORG Mykenische Kultur. In *Pauly-Wissowa*, Suppl. VI (1935). Contains a very complete bibliography up to 1935

MOON, BRENDA E. *Mycenaean Civilization, Publications since 1935. Bibliography. Institute of Classical Studies, University of London, Bulletin Supplement* No. 3. 1957

— *Mycenaean Civilization, Publications 1956–60. A second bibliography. Institute of Classical Studies, University of London, Bulletin Supplement* No. 12. 1961

And for the latest and current publications consult the bibliographies in

BENNETT, E.L. (ed.) *Nestor* Vols. I–IV. University of Wisconsin

VITELLI, K.D. (ed.) *Nestor* Vol. V. University of Wisconsin

Introduction

BINTLIFF, J. (ed.) *Mycenaean Geography*. Proceedings of the Cambridge Colloquium 1976

BLEGEN, C.W. *The Mycenaean Age*. Cincinnati 1962. Includes an up-to-date account of excavations in Greece

CASKEY, J.L. The Early Helladic period in the Argolid. *Hesperia* 29 (1960), 285f.

CHADWICK, J. *The Decipherment of Linear B*. 2nd edn. Cambridge 1967. Chapter 2

DICKINSON, O.T.P.K. The Origins of Mycenaean Civilization. *SIMA* 49 (1977)

HAMMOND, N.G.L. *A History of Greece*. Oxford 1959. Chapters 1 and 2

MCDONALD, W.A. and G.R. RAPP (eds.) *The Minnesota Messenia Expedition*. Minneapolis 1972

MEYER, E. *Heinrich Schliemann Wechsel*. Berlin 1953

PAGE, DENYS L. *History and the Homeric Iliad*. Berkeley, California 1959. Chapter II

WACE, A.J.B. The Arrival of the Greeks. In *Viking*. Oslo 1954. (*Norsk Arkeologisk Selskap*)

For the excavations by the different foreign Schools consult the bibliography in

FURUMARK, A. *Mycenaean Pottery*. 2nd edn. Stockholm 1972, where the pottery found in these excavations is listed alphabetically under sites.

And for current excavation reports consult

BCH, *Chronique des Fouilles*, where an account of them appears in every issue.

Chapter 1

ÅLIN, PER *Das Ende der mykenischen Fundstätten auf dem griechischen Festland.* Lund 1962

BLEGEN, C.W. Troy VI *CAH³* Vol. II, pt 1. 1973

— Troy VII *CAH³* Vol. II, pt 2. 1975

COLDSTREAM, J.N. and H.G. HUXLEY *Kythera.* London 1972

DAVIES, N.DE G. *The Tomb of Rekh-mi-re at Thebes.* 2 vols. New York 1943.

DESBOROUGH, V.R. D'A. The End of the Mycenaean World. *CAH³* Vol. II, pt 2. 1975

DICKINSON, O.T.P.K. The Definition of Late Helladic I. *BSA* 69 (1974), 109–20

— The Origins of Mycenaean Civilization. *SIMA* 49 (1977)

FORSDYKE, SIR JOHN *Greece before Homer.* London 1956

FRENCH, E.B. Late Helladic Pottery from Mycenae. *BSA* 59–62, 64 (1964–7, 1969)

— The First Phase of Late Helladic IIIC. *AA* (1969), 133–6

— A Reassessment of the Mycenaean Pottery at Tarsus. *Anatolian Studies* 25, (1975)

FURTWÄNGLER, A. and G. LOESCHCKE *Mykenische Vasen.* Berlin 1886

FURUMARK, A. *The Chronology of Mycenaean Pottery.* 2nd edn. Stockholm 1972

— *Mycenaean Pottery.* 2nd edn. Stockholm 1972

HALLAGER, E. *The Mycenaean Palace at Knossos.* Stockholm 1977

HANKEY, V. Late Helladic Tombs at Khalkis. *BSA*, (1952), 49

HAYES, W.C. Chronology. Egypt to the end of the Twentieth Dynasty. *CAH³* Vol. I, pt 1. 1970

IAKOVIDIS, S. *Perati: The Cemetery.* Athens 1970

MYLONAS, G.E. Priam's Troy and the date of its Fall. *AJA* 33 (1964)

MAIURI, A. Jalisos. *Annuario della R. Scuola Archeologica di Atene* 6–7 (1923–4), 83–341

PENDLEBURY, J.D.S. *Tell el-Amarna.* London 1935

— Egypt and the Aegean in the Late Bronze Age. *Journal of Egyptian Archaeology* (1930), 75

PETRIE, SIR W.M.F. *Kahun, Gurob and Hawara.* London 1890

RUTTER, J.B. and S. The Transition to Mycenaean. *Monumenta Archaeologica* 4 UCLA 1976

SHERRATT, E.S. Regional Variation in the Pottery of Late Helladic IIIB. *BSA* 75 (1980), 175–202

STUBBINGS, F.H. The Mycenaean Pottery of Attica. *BSA* (1947) 1

— Some Mycenaean Artists. *BSA* (1951) 168

— Chronology. The Aegean Bronze Age. *CAH³* Vol. I, pt 1. 1970

TAYLOUR, W.D. *Mycenaean Pottery in Italy.* Cambridge 1958

WACE, A.J.B. Ephyraean Ware. *BSA* (1956) 123

— The Chronology of Late Helladic III B. *BSA* (1957) 220

WACE, A.J.B. and C.W. BLEGEN Pottery as Evidence for Trade and Colonisation. *Klio* (1939) 131

WARDLE, K.A. Excavations at Assiros. 1975–9. *BSA* 75 (1980), 229–67

For illustrations of pottery see also 1–23 under *General.*

Chapter 2

Linear B

BENNETT, E.L. *The Mycenae Tablets.* Philadelphia 1953.

— *The Mycenae Tablets II.* Philadelphia 1958.

— *The Pylos Tablets.* Princeton 1955

CHADWICK, JOHN *The Decipherment of Linear B.* 2nd edn. Cambridge 1967.

— *The Mycenae Tablets III.* Philadelphia 1963.

EVANS, SIR ARTHUR *Scripta Minoa I.* Oxford 1909

GODART, L. and A. SACCONI Les tablettes en linéaire B de Thèbes. *Incunabula Graeca* 71. Rome 1978.

KOBER, A.E. Inflection in Linear Class B. *AJA* 50 (1946)

MYRES, J.L. (ed.) *Scripta Minoa II.* Oxford 1952.

OLIVIER, J....P. *The Mycenae Tablets IV.* Leiden 1969.

PALMER, L.R. *Achaeans and Indo Europeans.* Oxford 1955.

RAISON, J. *Les vases à inscriptions peintes de l'âge mycénien et leur contexte archéologique.* Rome 1977.

VENTRIS, M.G.F. and JOHN CHADWICK *Documents in Mycenaean Greek.* Cambridge 1956.

Tradition

ALLEN, T.W. *The Homeric Catalogue of Ships.* Oxford 1921.

BOWRA, SIR MAURICE *Heroic Poetry.* London 1952.

— *Homer and his Forerunners.* Edinburgh 1955.

— *Tradition and Design in the Iliad*. Oxford 1930. (repr. 1958)

FINLEY, M.I. *The World of Odysseus*. London 1956.

HOPE SIMPSON, R. and J.F. LAZENBY *The Catalogue of Ships in Homer's Iliad*. Oxford 1970.

KIRK, G.S. *The Songs of Homer*. Cambridge 1962.

LORIMER, H.L. *Homer and the Monuments*. London 1950.

WACE, A.J.B. and F.H. STUBBINGS *A Companion to Homer*, part 1. London 1962.

Chapter 3

CASKEY, J.L. Investigations in Keos, 1963. *Hesperia* 33 (1964). Account of the discovery of the life-sized terracotta head and other figures

— Excavations on Ceos. *Archaeology* 16, 4 (1963)

CHADWICK, J. *The Mycenaean World*. Cambridge 1976. Chapter 6

FRENCH, E.B. The Development of Mycenaean Terracotta Figurines. *BSA* 66 (1971)

GUTHRIE, W.K.C. *The Greeks and their Gods*. London 1950

— The Religion and Mythology of the Greeks. *CAH³* Vol. II, pt 2. 1975

KARAGEORGHIS, V. Excavations at Kition, Cyprus. 1975. *Journal of Field Archaeology* 2 (1975), 399

KARAGEORGHIS, V. *et al.* Kition, Cyprus: Excavations in 1976, 1977. *Journal of Field Archaeology* 5 (1978), 105

KILIAN, C. Ausgrabungen in Tiryns. *AA* (1978), 460–6

MYLONAS, G.E. *Mycenae and the Mycenaean Age*, Princeton 1966. Chapter VI.

— The Cult Center of Mycenae. *Treatises of the Academy of Athens* 33 (1972)

— Mycenaean Religion. *Treatises of the Academy of Athens* 39 (1977)

NILSSON, M.P. *The Minoan-Mycenaean Religion*. 2nd edn. Lund 1950

PERSSON, A.W. *The Religion of Greece in Prehistoric Times*. Los Angeles 1942

PICARD, C. *Les religions préhelléniques*. Paris 1948

RENFREW, C. The Mycenaean Sanctuary at Phylakopi. *Ant.* 52 (1978), 7–15.

TAYLOUR, W.D. Mycenae 1968. *Ant.* 43 (1969), 91–7.

— New Light on Mycenaean Religion. *Ant.* 44 (1970), 270–80.

TAYLOUR, W.D., E.B. FRENCH and K.A. WARDLE (eds.) *Well Built Mycenae*, fasc. 1. Warminster 1982

Chapter 4

BLEGEN, C.W. *et al. The Palace of Nestor*. Vol. III 71–215. Princeton 1973

CASKEY, J.L. Royal Shaft Graves at Lerna. *Archaeology* 13, 2 (1960)

DAUX, G. Chroniques des Fouilles. Marathon. *BCH* 83 (1959), 583–6. For horse burial

DICKINSON, O.T.P.K. *The Origins of Mycenaean Civilization*. *SIMA* 49 (1977). Chapter IV.

HAMMOND, N.G.L. Tumulus Burial in Albania, the Grave Circles of Mycenae and the Indo-Europeans. *BSA* 62 (1967), 77–105

HOOD, M.S.F. Tholos Tombs of the Aegean. *Ant.* 34 (1960), 166

KARO, G. *Die Schachtgräber von Mykenai*. Munich 1930

MYLONAS, G.E. The Cult of the Dead in Helladic Times. In *Studies presented to David M. Robinson*. Vol. I. St Louis 1951

— Grave Circle B at Mycenae. *SIMA* 7. Lund 1964

— *Mycenae and the Mycenaean Age*. Princeton 1966. Chapters IV, V and VII

— *The Taphikos Kyklos B of Mycenae* (in Greek). Athens 1973

PELON, O. *Tholoi, tumuli et cercles funéraires*. Paris 1976. A very full account of monumental tombs

TAYLOUR, W.D., E.B. FRENCH and K.A. WARDLE (eds.) *Well Built Mycenae*, fasc. 1. Warminster 1982

WACE, A.J.B. *Mycenae: An Archaeological History and Guide*. Princeton 1949

WACE, A.J.B. and C.B. Holland Excavations at Mycenae. The Tholos tombs. *BSA* 25 (1921–3), 283–402

WACE, A.J.B. and F.H. Stubbings *A Companion to Homer*. London 1962. Chapter 16

See also 2–4, 6–7, 10–14, 21–3 under *General*

Chapter 5

BENNETT, E.L. (ed.) *The Mycenae Tablets II*. Philadelphia 1958. The introduction deals with the Houses outside the Citadel

BLEGEN, C.W. and MARION RAWSON *The Palace of Nestor*, Vol. I. Princeton 1966

BRONEER, O. Athens in the Late Bronze Age. *Ant.* 30 (1956), 9

CATLING, H.W. Excavations at the Menelaion, Sparta, 1973–76. *AR* (1976–7), 24–42

CHADWICK, J. (ed.) *The Mycenae Tablets III*. Philadelphia 1963. Sections on the West House, House of Sphinxes and Citadel House

DAUX, G. *Chronique des fouilles. Tiryns. BCH* 87 (1963), 761–5. A report on the underground springs at Tiryns

IAKOVIDIS, S. The Present State of Research at the Citadel of Mycenae. *Bulletin of the Institute of Archaeology* 14 (1970), 99–141

JANTZEN, U. VON (ed.) *Führer durch Tiryns.* Athens 1975

KENNY, E.J.A. The ancient drainage of the Copais. *Liverpool Annals of Archaeology and Anthropology* (1935), 189

LANG, MABEL *The Palace of Nestor*, Vol. II. The Frescoes

MCDONALD, W.A. Excavations at Nichoria 1969–71. *Hesperia* 41 (1972), 218–73

MÜLLER, K. *Tiryns. Die Ergebnisse der Ausgrabungen.* Vol. 3. Augsburg 1930 See also *Tiryns* 5 Mainz (1971), 8 (1975), 9 (1980)

MYLONAS, G.E. *Mycenae and the Mycenaean Age.* Princeton 1966. Chapters II and III

— *Mycenae. A Guide to its Ruins and History.* 6th edn. Athens 1977

RAPP G. and S.E. ASCHENBRENNER *Excavations at Nichoria.* Vol. I. Minneapolis 1978

SKOUFOPOULOU, N. Mycenaean Citadels. *SIMA* 22 (1970)

TAYLOUR, W.D., E.B. FRENCH and K.A. WARDLE (eds.) *Well Built Mycenae*, fasc. 1 Warminster 1982

THEOCHARES, D.A. Iolkos. *Archaeology* 11, 1 (1958)

THREPSIADES, J. Reports on excavations at Gla. *Ergon* (1955–61)

WACE, A.J.B. Excavations at Mycenae. Houses 74–103. Palace 147–282. *BSA* 25 (1921–3)

— *Mycenae: An Archaeological History and Guide.* Princeton 1949

WACE, A.J.B. and F.H. STUBBINGS *A Companion to Homer.* London 1962. Chapter 17

WACE HELEN and C.K. WILLIAMS *Mycenae Guide.* 9th edn. Meriden, Conn. 1976

For house plans see also 2,3,6,8,21 under *General*

Chapter 6

BENNETT, E.L. *The Mycenae Tablets II.* Philadelphia 1958. The introduction gives an account of important finds in the Houses outside the Citadel.

BLEGEN, ELIZABETH P. in *Prosymna* Chapter VII, Jewellery and ornaments. Cambridge 1937

CHADWICK, J. *The Decipherment of Linear B.* 2nd edn. Cambridge 1967. Chapter 7

— *The Mycenaean World.* Cambridge 1976. Chapters 5,7,8

IAKOVIDIS, S. On the use of Mycenaean 'buttons'. *BSA* 72 (1977), 113–9

KANTOR, H.J. *The Aegean and the Orient in the 2nd millenium BC.* Bloomington, Ind. 1947

KARO, G. *Die Schachtgräber von Mykenai.* Munich 1930

KENNA, V.G. Cretan and Mycenaean Seals. *Archaeology* 19, 4 (1966)

HOOD, M.S.F. *The Arts in Prehistoric Greece.* Harmondsworth 1978

LANG, MABEL *The Palace of Nestor.* Vol. II. The Frescoes. Princeton 1969

LORIMER, H.L. *Homer and the Monuments.* Chapter VI., Dress. London 1950

LOUD, G. *The Megiddo Ivories.* Chicago 1939

MCDONALD W.A. and G.R. RAPP (ed.) *The Minnesota Messenia Expedition.* Minneápolis 1972

MARINATOS, S.N. Excavations near Pylos, 1956. *Ant.* 31 (1957), 97–100

MYLONAS, G.E. *The Taphikos Kyklos B of Mycenae* (in Greek). Athens 1973

RODENWALDT, G. *Tiryns.* Vol. II. Athens 1912

— *Der Fries des Megarons von Mykenai.* Halle 1921

TSOUNTAS, CH. *AE* (1889), 129

WACE, A.J.B. *Mycenae: An Archaeological History and Guide.* Princeton 1949

WACE, A.J.B. and F.H. STUBBINGS *A Companion to Homer*, Chapters 18, 20–2. London 1962 See also 13,14,22 under *General*

Chapter 7

War

ÅSTRÖM, A. The Cuirass Tomb and other Finds at Dendra. Vol. I. *SIMA* 4 (1977)

CHADWICK, J. *The Decipherment of Linear B*, 2nd edn. Cambridge 1967. Chapter 7

— *The Mycenaean World.* Cambridge 1967. Chapter 9

CHILDE, V.G. *The Dawn of European Civilization.* London 1957

KARO, G. *Die Schachtgräber von Mykenai.* Munich 1930

LORIMER, H.L. *Homer and the Monuments.* London 1950. Chapter V

MOUNTJOY, P.A. *Opuscula Atheniensia* XV. *In press*

MYLONAS, G.E. *The Taphikos Kyklos B of Mycenae* (in Greek). Athens 1973

RODENWALDT, G. *Tiryns* Vol. II. Athens 1912

SANDARS, N.K. The First Aegean Swords and their Ancestry. *AJA* 65 (1961)

— Later Aegean Bronze Swords. *AJA* 67 (1963)

WACE, A.J.B. and F.H. STUBBINGS *A Companion to Homer*. London 1962. Chapter 19

Trade

BASS, G.F. A Bronze Age Shipwreck. *Expedition* (1961), 2

BASS, G.F. and P. THROCKMORTON Excavating a Bronze Age Shipwreck. *Archaeology* 14, 2 (1961)

BECK, C.W. Amber in Archaeology. *Archaeology* 23, 1 (1970)

BREA, L. BERNABÒ *Sicily before the Greeks*. London 1957

BUCHHOLZ, H.G. The Problem of Minoan Relations with the West at the Beginning of the Late Bronze Age. *Temple University Aegean Symposium* 5 (1980)

BUCHNER, G., M. MARAZZI *et al*. L'Isola di Vivara. Nuove Ricerche. *La Parola del Passato* 33 (1978)

CHILDE, V.G. *The Dawn of European Civilization*. London 1957

CRAWFORD, O.G.S. The symbols carved on Stonehenge. *Ant*. 28 (1954), 25

FRENCH, ELIZABETH A Reassessment of the Mycenaean Pottery at Tarsus. *Anatolian Studies* XXV, 1975

GARSTANG, J. *Prehistoric Mersin*. Oxford 1953

GOLDMAN, H. *Excavations at Gözlü Kule, Tarsus*. Princeton 1956

GUIDO, M. *Sardinia*. London 1963

HARDING, A. and H. HUGHES-BROCK Amber in the Mycenaean World. *BSA* 69 (1974), 145–72

JONES, R.E. and C. MEE Spectographic Analyses of Mycenaean Pottery from Rhodes. *Journal of Field Archaeology* 5 (1978), 461–70

KILLEN, J.T. The wool industry of Crete in the Late Bronze Age. *BSA* 59 (1964), 1–15

LO SCHIAVO, F. and L. VAGNETTI Micenei in Sardegna? *Atti della Accademia Nazionale dei Lincei* 35 (1980), 371–93

LO PORTO, F.G. Gli scavi sull' acropoli di Satyrion. *Bolletino d'Arte* 49 (1964), 67f

MARAZZI, M. and S. TUSA Die mykenische Penetration im westlichen Mittelmeerraum. *Klio* 61 (1979–2), 309–51

MEE, C. Aegean Trade and Settlement in Anatolia. *Anatolian Studies* 28 (1978), 121–55

MUHLY, J.D. *Copper and Tin*. Newhaven, Conn. 1973

PENDLEBURY, J.D.S. *Aegyptiaca*. Cambridge 1930

POWELL, T.G.E. *Prehistoric Art*. London 1966. The Rillaton and Fritzdorf cups

RENFREW, C. Wessex as a Social Question. *Ant*. 47 (1973), 221–5

STONE, J.F.S. *Wessex before the Celts*. London 1958

STUBBINGS, F.H. *Mycenaean Pottery from the Levant*. Cambridge 1951

— A Winged Axe Mould. *BSA* 49 (1954), 297–8

TAYLOUR, W.D. *Mycenean Pottery in Italy*. Cambridge 1958

THEOCHARES, D.A. Iolkos. *Archaeology* 11, 1 (1958)

WACE, A.J.B. and C.W. BLEGEN Pottery as evidence for Trade and Colonisation in the Aegean Bronze Age. *Klio* (1939), 131

WEICKERT, C. Die Ausgrabung beim Athena-Tempel in Milet. *Istanbuler Mitteilungen* 7 (1957) and 9,16 (1959–60)

See also 1,8,9,13,15,22 under *General*

Chapter 8

ÅLIN, PER *Das Ende der mykenischen Fundstätten auf dem griechischen Festland*. Lund 1962

BÉRARD, J. *La colonisation grecque*. Paris 1957

BITTEL, K. *et al*. *Bogazköy*, 4 vols. Berlin 1935–69

BLEGEN, C.W. Troy VII. *CAH*³. Vol. II, pt 2. 1975

BRONEER, OSCAR Athens in the Late Bronze Age. *Ant*. 30 (1956), 9

— The Corinthian Isthmus and the Isthmian Sanctuary. *Ant*. 32 (1958), 80

CARPENTER, RHYS *Discontinuity in Greek Civilization*. Cambridge 1966

CHADWICK, J. *The Mycenaean World*. Cambridge 1976. Chapter 11

— Who were the Dorians? *La Parola del Passato* 166 (1976), 103–17. Against the Dorians

DESBOROUGH, V.R.D'A. *The Last Mycenaeans and their Successors*. Oxford and New York 1964

— The End of the Mycenaean World. *CAH*³. Vol. II, pt 2. 1975

GARDINER, SIR ALAN *Egypt of the Pharaohs*. Oxford 1961

GREENHALGH, P.A.L. How are the Mighty Fallen? *Acta Classica* 20 (1978) 1–38. Pro-Dorians

GURNEY, O.R. *The Hittites*. Harmondsworth 1969

HUXLEY, G.L. *Achaeans and Hittites*. Oxford 1960

IAKOVIDIS, S. *Perati: The Cemetery*. Athens 1970

KERAMOPOULOS, A.D. The House of Kadmos. *AE* 1909, 57

— Excavations at Thebes. *Archaiologikon Deltion* 3 (1917)

MEE, C. Aegean Trade and Settlement in Anatolia. *Anatolian Studies* 28 (1978), 121–55

MYLONAS, G.E. Priam's Troy and the date of its Fall. *AJA* 33 (1964)

PAGE, DENYS L. *History and the Homeric Iliad*. Berkeley, Cal. 1959

PENDLEBURY, J.D.S. *The Archaeology of Crete*. London 1939. Chapter V

SANDARS, N.K. *The Sea Peoples*. London and New York 1978

SCHAEFFER, C.F. *Mission de Ras Shamra, Ugaritica*. Vols I–VI. Paris 1936–69

— *Alasia I*. Paris 1971

SNODGRASS, A.M. *The Dark Age of Greece*. Edinburgh 1971

STUBBINGS, F.H. The Rise of Mycenaean Civilization. *CAH³*. Vol. II, pt 1. 1973

— The Expansion of Mycenaean Civilization. *CAH³*. Vol. II, pt 2. 1975

SYMEONOGLOU, S. *Kadmeia I. SIMA* 35 (1973)

List of illustrations

Unless otherwise acknowledged, photos are by the author.

Frontispiece: Gold funeral-mask. The so-called Agamemnon. Photo Max Hirmer.

1 Greece and the Aegean. Drawn by H.A. Shelley.
2 Middle Helladic pottery. After Wace and Stubbings *A Companion to Homer*, fig.8.
3 Greek dialects about 400 BC. After Wace and Stubbings, *ibid.*, fig.1.
4 Stirrup-jar, pilgrim flask, alabastron and spouted jug. LH IIIA. Photo Josephine Powell.
5 Palace Style jar from tholos tomb in Messenia.
6 Ephyrean goblet. After Wace and Stubbings, *ibid.*, fig.16c.
7 Mycenaean pottery. LH IIIA and IIIB. After Wace and Stubbings, *ibid.*, fig.18.
8 Kylix. Zygouries style. Photo Josephine Powell.
9 LH IIIB krater from Cyprus. After Wace and Stubbings, *ibid.*, fig.19.
10 LH IIIC bowl of 'Close style'. After Wace and Stubbings, *ibid.*, fig.20.
11 Fragment of 'Octopus' stirrup-jar. After Taylour *Mycenaean Pottery in Italy*, pls.12–14.
12 'Incense burner'. After Ventris and Chadwick *Documents in Mycenaean Greek*, p.337.
13 Tablet Ge 606 from the House of Sphinxes, Mycenae. After Helen Wace and C.K. Williams *Mycenae Guide*, p.4.
14 Linear B. Some ideograms. After Chadwick *The Decipherment of Linear B*, fig.10.
15 'Kober's triplets'. After Chadwick, *ibid.*, fig.8.
16 Comparison of signs in Linear B with Classical Cypriot. After Chadwick, *ibid.*, fig.7.
17 Ventris's 'grid', 28 September 1951. After Chadwick, *ibid.*, fig.13.
18 Linear B tablet dealing with tripods and vases. *Greece and Rome* IV, pl.clxxix.
19 Seal impression from Knossos. After Nil-

sson *The Minoan-Mycenaean Religion*, fig.162.
20 Painted limestone tablet from Tsountas's House, Mycenae. Photo Professor Jessen, Deutsches Archäologisches Instituts.
21 Plan of the acropolis summit, Mycenae. After Tsountas *Praktika* 1886, pl.iv.
22 Terracotta head of goddess, Keos. After Caskey *Archaeology* 16, 4 (1963).
23 Plan of two cult areas, Mycenae citadel. After Taylour *Ant.* 44 (1970), 271.
24 The temple, Mycenae, from the south.
25 Female idol (found in situ in the temple).
26 Isometric drawing of the temple. After Taylour *Ant.* 44 (1970), 273.
27 Room with the Idols as uncovered during excavation.
28 One of two snakes found in the Room with the Idols.
29 Idol carrying some cult object.
30 Male idol.
31 Idol with hammer-axe.
32 Room with the Fresco, viewed from the west.
33 Fresco as preserved in the Nauplia Museum.
34 Altar with fresco.
35 Fresco of the smallest goddess.
36 Ivory lion from the Room with the Fresco.
37 Ivory head of young man (?) found in Room with the Fresco.
38 Goddess on a dais in the Shrine attached to the Room with the Fresco.
39 The little goddess from the Shrine.
40 Goddess holding her breasts. From the temple.
41 The Cult Centre of Mycenae. After Mylonas *Praktika* 1972, fig.2.
42 'The Lady of Phylakopi'. From a recently excavated sanctuary on Melos. After Renfrew *Ant.* 52 (1978), frontispiece.
43 Phi and psi figurines. After Blegen.
44 Gold-plated silver ring from Mycenae. After Evans *Tree and Pillar Cult*, fig.58.
45 Gold signet ring from Mycenae. Photo Max Hirmer.

Index